In and Out of Focus

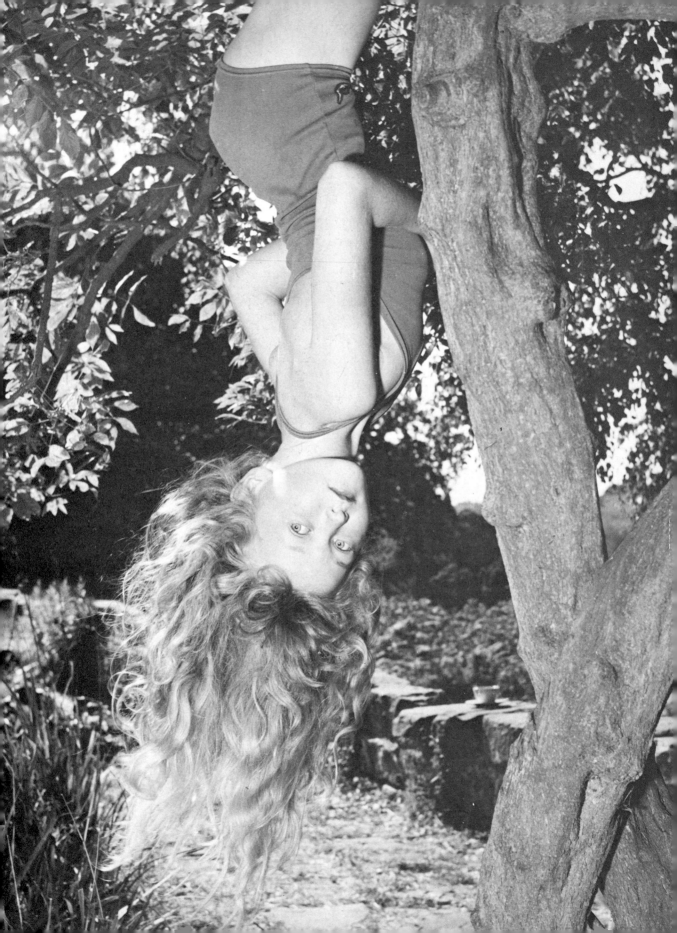

TOM BLAU

ELM TREE BOOKS · LONDON

To my dear children
Nikki and Jon

First published in Great Britain 1983
by Elm Tree Books/Hamish Hamilton Ltd
Garden House 57–59 Long Acre London WC2E 9JZ

Copyright © 1983 by Tom Blau

Book design by Norman Reynolds

British Library Cataloguing in Publication Data
Blau, Tom
 In and out of focus.
 1. Blau, Tom
 2. Photographers—England—Biography
 I. Title
 770'.92'4 TR140.B/
 ISBN 0–241–11058–0

Filmset by Northumberland Press Ltd
Gateshead, Tyne and Wear
Printed in Great Britain by
Fletcher & Son Ltd, Norwich

Contents

I would like to thank Donald Chapman who has worked with me for more than three decades and without whose help this book would not have been possible.

All photographs not specifically acknowledged are by Tom Blau.

CHAPTER 1

About the Author

IT IS AS if two large, heavy portals that are closed, but not locked, and have rusted together, hold back all that has happened to you in the past; or perhaps it is just a big trunk that you have to sit upon in order to make it close, and then it grows rusty before you can open it – that certainly is how I feel when I look back upon the time before I came to England.

It was the spring of 1935. I had come on a two-week holiday and it was the fulfilment of a dream, brought about by sheer unpredictable luck. I had a cousin who worked in the film industry in Britain and had greatly benefited from my mother's generosity when he was trying to make a living in Berlin. He had come to lunch and to dinner practically every day and even then he found it hard to make ends meet. I didn't really like him very much: he was Austrian, pompous, vain, good-looking and much too aware of his heavy, fleshy good looks; but when he invited me to London all that was forgotten. I came by the cheapest route available and with joy and curiosity in my heart. (Oddly, the cheapest means of reaching England from Germany then was by Soviet steamer from Hamburg, driving right up Hays Wharf in the dockland of London. My choice of a Russian ship was an indication not of political conviction, but merely a way of paying half of what it might otherwise have cost.) The English language, England and the English had from early boyhood been my aim and major preoccupation. It was a wonderful chance, and I took it with both hands.

Until then I had been employed in the Berlin office of the photographic department of the *New York Times*, as a caption writer. I had been introduced to the Hungarian-born head of the office by another Hungarian and close friend of my family, who worked as a freelance for World Wide Photos, the name under which this picture department of the *New York Times* operated legally as a separate entity from that great newspaper organisation. I got the job because I had been good at English at school, and they needed somebody who could translate captions from German into English and from English into German. This picture agency was a highly intelligent and original set-up which, as far as I know, only the *New York Times* had devised and operated. Needing coverage of what went on in the world, not only by written word but also by the (increasingly popular) illustration of events through press photography, they set up offices in all major capitals – London, Paris, Berlin, Stockholm, Rome (or it may have been Milan), Madrid – everywhere where experience told them worthwhile photographs, necessary for the coverage of world news, could be taken. The originality of the idea lay in this: each office not only supplied New York, that is the *New York Times*, but also each other, so that each had first-class picture material which compared well with photographs from other sources. Thus it came about that these branch offices of World Wide Photos became financially self-supporting, or even profitable, and the *New York Times* in New York had photographs exclusive to themselves for free. In each office they needed caption writers who were fluent in English and of course in the language of the country where the office

was situated. When I was introduced by Ladislas Farago, the freelance journalist from Hungary who lived in Berlin, to Mr Bolgar, the Hungarian head of the Berlin branch of World Wide Photos, the fact that I was of Hungarian birth was one of the very few occasions when being Hungarian turned out to be an asset.

Actually, my Hungarianness was ever so slightly shaky. Both my parents were Hungarian, but I was born in Berlin. My father was a plumber from the then small town of Miskolcz. My mother came from a village in the heart of Hungary called Mezokeresztes. My father was friendly with my mother's brother, Bela, also a plumber and, together, they decided to travel in search of greater working opportunities. They journeyed on foot to Budapest, worked for a while, saved a little, walked on to Vienna, and from there into southern Germany, finally ending up in Berlin. On the way Bela persuaded my father that his younger sister, Sarika, would make him a good wife. They both returned to her village, where my mother's parents, rather than my mother, thought it was a good idea – and those were days when a bride-to-be did as she was told. The two young people were married. My mother was eighteen, my father twenty-two. He remained in Mezokeresztes for long enough for a little girl to be born, then he and his brother-in-law went back on their travels. Bela decided to emigrate to America but my father thought he could do better in Berlin, the thriving capital of expanding, imperialist Germany with its seventy-five million people (Hungary then had about one-tenth of that population) and with its ambitious, thrusting ruler, Kaiser Wilhelm II. My father set up a workshop and my mother came up from Hungary to join him, and there I was born, in the Berlin working-class district of Neukoln. It made me no more German than the son of an English civil servant born in Bombay was Indian. All the food and drink, all the talk and all the views that I was fed were Hungarian, rarely, I ought to add, pro-German, but my sister and I obviously picked up the German language more quickly and thoroughly than my parents and in effect we had bi-lingual conversations most of the time. My parents spoke Hungarian and we replied in German.

A turning point in our lives occurred when my father had a terrible accident. He fell off some scaffolding, broke two vertebrae in his back and would most certainly have died there and then had it not been for an experiment tried by a German specialist, who inserted two silver vertebrae into his spine. Medically, it was regarded as quite sensational that my father's body accepted such substitution. He survived, though not in very good shape, and was excused war service in the 1914–18 war. When he was well enough he was drafted into an arms factory where it was found he was good at the drawing board and so, between long intervals of hospitalisation, he was able to earn a little money – but not nearly enough to keep his wife and two children. Fortunately, my mother found a way out. She was not merely a good cook but an exceptional one, and though the raw materials became scarcer and scarcer in a Germany gradually starving under the blockade by the British Navy, her ingenuity in cooking and baking became known in the district and beyond until finally, when the war ended, someone put up the money for her to start a café – the Café Blau. Here she did everything; she baked delicious pastries and gâteaux; she even made better coffee than anybody else; she served at table and on weekends she somehow managed to travel back to agricultural Hungary and return with raw materials for cooking and baking that could not be obtained in Germany at that time. Most of it she smuggled back safely packed in grease-proof paper hidden against her body in a manner which was heroic and successful beyond belief. She had so much spirit and courage, so much skill and personality, that she got away with it every time – or, if she didn't she must have shared what she smuggled in with the customs men who had discovered her secret; she never told anyone just how she was able to survive in such perilous circumstances.

My father felt deeply humiliated. Hungarian macho dictated that he should be the breadwinner and all he could do was keep the books and walk about the café as le patron, talking to the customers. His was not an enviable task, but there was no alternative. The business grew, my mother paid for her sister and later her younger brother to come over and help in expanding the bakery, and with the serving in the café.

Meanwhile my sister and I went to good

schools where we passed the entrance examinations well enough to be given grants. My own scholastic career took off when I was ten years old. Until then I had been placed in the middle of the class; this was post-war Germany, but everything still ran on traditional German lines, and in every form of every school pupils sat in number order according to their performance. In a class of some thirty or forty I came fifteenth; but when I was ten something woke up in me and I made a meteoric rise to the position of second in the class.

The school, with a name unpronounceable in English, was the Luisenstaedtisches Realgymnasium. It maintained tough standards of performance and discipline and later on I heard, I don't know how authoritatively, that it was widely looked upon as being among the half-dozen most successful schools of its kind in Berlin. It was very much the equivalent of an old English grammar school, and we were brought up on a very broad curriculum with no nonsense about picking subjects of our own preference. Everyone had to learn Latin, then French, then English, of course German and German literature, mathematics, physics, geography, biology, apart from having instruction in music, painting, artistic appreciation and obviously gymnastics. I did well and when I was eleven I became first in my form. These positions were described in Latin – I was primus, and primus I remained until I left the school at eighteen-and-a-half.

My father was somewhat naïvely proud of me and, to my intense embarrassment, when chatting to people who came to the Café Blau, would often call me out to show off my school reports. It was a blush-making performance – I'm sure the clients hated it, and I certainly did. I have never been able to understand what could have caused my father to do it.

But I was soon to discover how desperately he clung to anything that he could fairly claim to be at least in part to his own credit; and of course I was his son, and he had at least fifty per cent of my school success to be proud of. Otherwise, his life was not good. To justify himself and his lack of earning power, he would take out of the till money that, sensibly, should have been saved; and he started backing horses. Gambling was certainly in his blood, because even before he

went in for horse-racing in a relatively big way, he liked to play cards and, of all things, dominoes. There was a small Hungarian colony of artisans where we lived, who used to meet almost nightly in a basement where they could smoke and curse and gamble to their hearts' delight. My father, a short, muscular man, was bent over slightly after his spinal operation, so that he appeared shorter; that made no difference to his impressive Hungarian cursing power, and Hungarian is a rich and resourceful language in the field of swearing. It was, of course, brought into Europe by Attila the Hun, the fierce horseman who overran Asia and Europe, fighting, pillaging, robbing, raping and evolving a blood-curdling vocabulary of swear words which no-one with any sense would want to translate into English. My little father used all the profanities and did so in the company of people four times his weight, and in front of me, whom he had commandeered to go along with him to the gambling den. I sat on his knee as he called everyone within hearing cheats, robbers, murderers, but in language superbly pictorial and free of all restraint. The one thing he didn't do was smoke or drink alcohol, but coffee or lemon tea, which together with a bad hand of cards, were enough to fire his passions, and I was certain, time and again, that his opponents would at any moment get up and knock him to the ground. In fact, they didn't; and I think the richness of his vocabulary, and his smallness, gained him much popularity.

On weekends he would grip me by the neck and steer me out to call a horse-drawn cab in which, in style, we rode out to Berlin's racecourse. There he would bet away what my dear mother had earned in the café, and the more he lost, the higher he put the stakes.

In the end, when I was only twelve, his debts, of which my mother knew nothing, had mounted so greatly that he could see no way out but to shoot himself.

He and my mother had not been very happily married. There were constant rows, because gambling was not my father's only vice. The business had grown, we employed several maids, and it must have been quite often that my mother discovered her husband in questionable situations – proving to himself, I assume, that at least his virility had not suffered

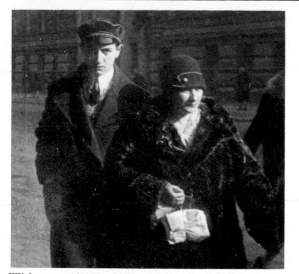

*With my mother in Berlin. I was about fourteen
when this snap was taken. She taught me to look
people straight in the eye. I don't think she ever
knew the enormous influence she had over my life,
to this day.*

when the silver vertebrae were put into his
spine. They fought, my mother literally doing
what one saw in early American domestic
comedy films – throwing cups and plates at him,
scratching his face. On one occasion, when my
sister and I came back from the pictures, he
smiled ruefully at us and said, 'Do you really
think I'm such a bad man ...?' But I was too
choked to tell him that I was on my mother's
side.

He survived his suicide attempt by two days,
having been found in the Tiergarten, the Hyde
Park of Berlin, and, despite his failings as a
husband, my mother was terribly upset.

I don't think I have mentioned before that
ours was a Jewish family. It didn't affect us very
much because my father was an atheist and,
though my mother had strong religious lean-
ings, girls in Hungary at that time had no kind
of religious upbringing. I often discovered her
locked in a small linen cupboard, where she had
lit candles as she had seen them in her own
family home. She bent over the candles, gently
beating her breast and chanting a gibberish
mumbo-jumbo which she assumed the Lord
would accept as substitute-Hebrew.

Before he committed suicide, my father had
given religion its first and last chance. He went
to a synagogue not far from home on two occa-
sions, but found nothing there that gave him
solace or the will and strength to carry on.

He left a letter to my mother in which he told
her of debts he had run up and advising her to
repudiate them, but also expressing the view
that in the circumstances nobody would come
to claim them. Alas – here, too, he was quite
wrong. There were claimants by the dozen
and my mother, ill-advised, innocent and
honourable, accepted all of them and undertook
to repay them. Only in later years did she find
out that if she had not accepted my poor father's
assets (a gold watch, three suits and an overcoat)
any mediocre lawyer would have been able to
ensure that she could have continued her life
without the terrible burden of the heavy debts
which had driven my father to do away with
himself.

As it was, she paid them off, and I had to go
and see the various debtors and the income tax
people to negotiate bearable instalments. 'Look
them straight in the face, straight in their eyes,
and do not be afraid. No one will hurt you, and
no matter how angry they may be you will be
able to make some arrangement.' I was a boy of
just over twelve, but I learned this lesson, which
proved just about the most useful I could have
been taught for my future as a photographer.

When at school I earned quite a lot of money
by acting as a tutor. It was a well-established
principle in German schools at that time that
older boys, but only those among the top six in
each form, should take on paid work teaching
younger ones or even their contemporaries,
where they needed assistance, in any of the
many subjects taught. I was often recommen-
ded and, by the time I was seventeen, practi-
cally all my afternoons were spent going from
one private home to another, giving lessons in
Latin, French, English or whatever else was
required. When there was offered more work
than I could handle – and this happened fre-
quently – I preferred to give after-hours lessons
in English, and this I think gave me a most use-
ful grounding in grammar and extending my
vocabulary.

Most Hungarians are filled with admiration
for England. This is in part due to the generous

welcome given to the Hungarian patriot Lajos Kossuth, who had led a revolution in 1848 against the Imperial Austro-Hungarian Government in Vienna, and was in favour of Hungarian independence. He had to flee Hungary and he chose England as his haven; the English lionised him. He was a handsome, romantic figure and the British took the cause of Hungary to their hearts. Ever since then England had been admired among true Magyars. When, at the end of World War I, the *Daily Mail* took up the cause of Hungarian independence from the Austro-Hungarian Empire, the grateful Hungarians offered a throne to the owner of the paper, Lord Northcliffe. He modestly declined, but the *Daily Mail* continued to support Hungary.

My dear mother was fond of singing, mainly music-hall type songs, among them several praising the British and the noble art of self-defence. How, with all that work and all her troubles, she found it possible to be lighthearted enough to sing, I don't know; but I do remember many of the songs to this day and in fact I draw on the vocabulary of them as a kind of stand-by Hungarian dictionary. Of all the vast ramified family I had in Budapest and in the countryside – the great majority had been exterminated in concentration camps, mainly at Auschwitz – there now remains only my nephew, Tamas Szirtes, a successful stage director at the prestigious Madács Theatre. When I visit him it is a subject of amusement and admiration that old music hall songs which are now almost totally unknown in Hungary come pat from my lips, and though, through lack of schooling my Hungarian conversation can be sadly ungrammatical or run out of vocabulary on technical subjects, these old songs are rendered with accuracy and fluency. They confirm my long-held belief that for young children to learn things parrot-fashion is not such a bad thing at all.

Oddly, in retrospect, I found time between visiting different homes to give private tutoring lessons, to sit down in a little square near to where we lived, and such intervals I used for thinking. It now seems unbelievably pompous to say so, but it really was true. I was thinking of problems to put to the kindly rabbi who came once a week to take charge of the very liberal religious education of the three or four Jewish boys in my form. As the one hour allowed was too short to teach us a great deal of Hebrew, we were invited by Dr Rosenthal to ask him questions on matters which might be puzzling us. No-one was puzzled particularly except by the existence of anti-Semitism, which even then, after the First World War and long before Hitler, was strongly manifest at all levels of society. In the circumstances it was fair and admirable that at school I got such good marks – though at the end of my school years, in 1931, I was not offered the opportunity, automatically offered to all other boys at the top of their class, of addressing the school gathering to celebrate the occasion. It was pointed out to me that '... hmm ... it was a little awkward to explain ... hmm, it was not in the tradition of the school to let such an address be made by anyone of ... hmm ... "foreign extraction".' The honour was given instead to a tall, dim, hardworking school-leaver who intended to make Theology his life's work. The pain of this blatant piece of injustice has not quite left me to this day.

Meanwhile, when I sat down sometimes for half an hour in the square near home (it was called Donhoffsplatz), I tried to think up problems for our teacher on Judaism, often elaborate, always thorny, and totally unanswerable, and discovered a method of argument (I later learned it was called 'Socratic') akin to cross-examination in a British court of law. When the hour for religious instruction arrived I usually had a problem ready.

'God is powerful, is He not?'

'Yes, of course, my son, He is all-powerful, He is the Almighty.'

'And He is intelligent?'

'But of course, my son, His intelligence goes far beyond our understanding. He is, in fact, Omniscient.'

'Does this mean He knows in advance what is going to happen – or does every sudden decision by a human take him by surprise?'

By now the good rabbi began to see how this was going to end, but I continued mercilessly:

'If, then, God knows in advance what is going to happen, is it possible for any human to make a decision that God has not already foreseen? And is it not then a fact that by foreseeing it He has "fixed" it – for, were one to act other than He

had foreseen, surely that would prove Him wrong and He would no longer be Omniscient? Again, if what He foresaw He didn't like, is it not He alone who, being Almighty, could change the course of action and all the side effects?'

I knew it was cruel to put this to the poor man; I knew there was no answer, but I had more such questions:

'Adam and Eve were the first people? And they had first two sons and then later one more? How is it that the human race continued? Did Eve have offspring from her own sons ...?'

I never got less than top marks in religious instruction, and it speaks well for the kindly nature of my teacher that he forgave me my precocious impertinence.

Another incident from my childhood often comes to my mind. During the 1914–18 war there had been a few air raids, I think all by British planes, over Berlin. They made a deep impression on even the most patriotic Germans, who previously never believed their Emperor would permit such things to happen. On one particular day – I must have been four years old, so it was around 1916 – I see myself with my mother, who is washing my hands under the cold tap (not that there was any other). My hands were frozen from playing in the snow. There was a sound of aircraft overhead and my mother cried out, 'It's another raid!' I knew better. 'Of course it isn't, it's just a Zeppelin. You *are* silly, Mummy!'

At this, my mother let go of my hand, looked at me in shocked amazement and burst out crying. 'That I should live to hear my own son call me silly,' she managed to say through her sobs and tears. 'My own child to call me ignorant ...'

I understood immediately how much I had hurt her. Children in those days could not call any action of their parents silly, even if they dared to think it was the right word to describe them. It was like blasphemy. I pressed my arms around my mother and cried into her apron, begging her forgiveness. I never called anything she did or said 'silly' again. This small episode somehow, I think, contributed to my deep and sincere love for her, and for the great caring and mutual affection we had for each other throughout her life.

Many years later, in 1951, I acquired a beautiful house at Worthing, in West Sussex, and my wife and I very much wanted my mother to come and join us. The British Home Office had no objection to her joining us so I wrote to the Hungarian Ambassador and to the Hungarian Prime Minister of the day, Rakosi; my mother filled in numberless forms – all to no avail. She was in poor health, incapable of earning a living and having to manage on what I sent her from London, but they would not give her a passport or a visa to leave the country to which she was in no way a special asset. She died.

Eighteen months after her death a letter was received at her flat (which had become the property of my sister), inviting her to go and collect her passport, which had now been 'processed' so that she could leave the country.

I had arrived in Britain in the spring of 1935. Before my two-week London holiday was up the Nazis had closed the World Wide Photos office in Berlin, and I was stranded in London.

Hungary was the only country that had given diplomatic acknowledgement to Nazi Germany. In return, for the period from 1933 to 1935, I was protected in Germany by a little badge of the Hungarian coat-of-arms worn in my buttonhole, and which acted on the Nazis as the holding up of the Cross is supposed to act upon Satan. To be Hungarian, Jewish or otherwise, meant, at least for that brief period, that you were not molested. All that changed when, in Hungary, a Nazi-type government took over; but in 1935, when I came to London, it was still effective.

Obviously, finding myself in England, where since the age of eleven I had always wanted to be, I had no intention of going back. I applied to the Home Office and obtained permission to stay on as a freelance – the *New York Times* in London, to my astonishment, supported my application but did not offer me a job.

In freelancing I began to discover sources of photographs available which had not previously been tapped by anyone, especially from the Soviet Union which could be picked up freely at the Intourist office. Quite a few of these were sold through the *New York Times* in London and were used by their various branches and also by the Head Office in New York. I spread my net wider and found all manner of interest-

ing photographs; in fact, hardly a day passed without my bringing into the *New York Times* in London photographs of all manner of interesting subjects: film stars, picturesque stage scenes and scenics from foreign countries, also of major industries in Britain and elsewhere. They were all give-away publicity stuff, and so nobody bothered with them. I was more than welcome. Perhaps – how could one tell – I might even get them published? I did.

Six months went by before the general manager of the London office, a Mr Wohlfeil called me in. He looked a little like Henry VIII as immortalised by Charles Laughton. 'You're earning too much money,' he said. 'We'd better take you on the staff.'

I eagerly agreed because I thought the kind of freelance discoveries I had made were beginning to dry up; but the wage I was paid was pitiful, and I had to support my mother and save enough to make it possible for my mother and my sister to leave Germany and return to Hungary.

To work hard in that sleepy, huge open-plan World Wide Photos office in Salisbury Square, EC4, was not all that popular among the rest of the staff. Enterprise and new ideas stir up too much dust, and perhaps I was a bit aggressive on finding so much opposition. I was therefore quite glad when, two years later, in 1937, the Keystone Press Agency offered me a job in which I really learned a great deal about news coverage. I made up my mind that when eventually I had become a naturalised Briton I would launch an independent feature agency which should have as little as possible to do with the hectic and impossibly competitive life in news photography, where twenty-five photographers from different agencies and newspapers would cover, for instance, the arrival of Marlene Dietrich in London, which was worth maybe ten publications at most.

At the end of 1938 a portly gentleman of military bearing, a Captain Davies, called on me at Keystone, and in the waiting room he told me – in a booming voice intended to be confidential – that on behalf of an American film lighting expert from Hollywood, Lee Garmes, he wanted to entice me away from Keystone to set up and manage a photographic press agency for Mr Garmes. The circumstances were delici-

ously conspiratorial. I had no idea how this Mr Garmes could ever have heard of me, and I promised to reply within twenty-four hours.

I went to the head of the Keystone Press Agency – again, as was then frequently the case in photojournalism, a Hungarian, Mr Bert Garai – to tell him truthfully what had happened. I was getting more money at Keystone than at the *New York Times*, but though I worked like a beaver I had come to the end of my earning capacity in that firm. I told Mr Garai of my personal circumstances – about my mother and sister in Berlin – but he was completely negative. 'Stay here. This is a big pond and in it you may grow into a big fish. If you accept this crazy offer you'll be a big fish right away, but in a tiny pool which will dry up.'

So I left.

I named the new organisation Pictorial Press.

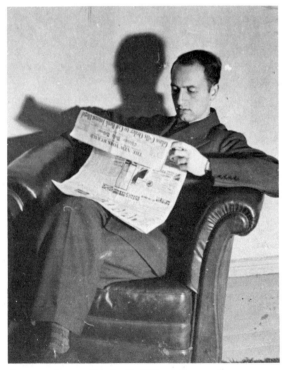

In 1935 in my digs in Guildford Street. I was working for the New York Times, *but I am reading the* New York Herald, *the NYT's great rival. The snapshot was taken by Ralph Crane who, like myself, had previously worked with the* New York Times *World Wide Photos in Berlin but who, unlike myself, decided to go on to America.*

We first had a ludicrously luxurious office at the Aeolian Hall in Bond Street, but soon afterwards I moved into Racquet's Court, a lovely, cosy, down-at-heel turning off Fleet Street, where the company took root and prospered. Lee Garmes had promised through Captain Davies to make me a partner and director; he didn't.

War broke out and I was not accepted in the fighting forces except in the very minor capacity elsewhere described, with the ARP, so I put all my energy and imagination into building up Pictorial Press. Strangely, my earlier freelance work in collecting free photographs from Intourist enabled me, when the Nazis invaded the Soviet Union, to get pictures from there – and eventually Pictorial Press was the only photo agency in Britain to have daily telephotos from the Eastern Front. Nothing could have built up my name and that of the agency more effectively, especially during the time of the successful Red Army counter-offensive and the Battle of Stalingrad.

My office was bombed out and we moved to Poppins Court, another little alley nearer to Ludgate Circus on the same side of Fleet Street, and Pictorial Press earned a lot of money for its far-away absentee proprietor basking in the sunshine of California. Lee Garmes was a man of principle – the principle of not answering letters. He stuck by it.

When I was naturalised in 1947 I left him and set up Camera Press.

I am not telling my story in chronological fashion. Within months of arriving in London, by the autumn of 1935, I met the girl, Doris Chapman whom eventually I married. When we met and made friends neither of us thought of marriage. It was a time of great promiscuity and an affaire, as it was then called (not a 'relationship') among progressive young people was not all that exceptional.

Chappie, as everybody called her, had a charmingly piquant face, was a very good dancer and had a circle of friends to which, with some quite considerable misgivings, I was admitted. Chappie was so very English, born in Newport Pagnell, Buckinghamshire, of what could be called 'yeoman stock'; I, with my glib, slightly quaint vocabulary, was mainly tolerated because of her. But she and I got on

extremely well. We assured each other that marriage was out of the question but eventually, and because we both earned very little, we decided it would be modern, as well as economical, if I moved into her flat in a narrow little house in Princeton Street, off Red Lion Square, and we shared all expenses. It was certainly better than the boarding-houses where I had stayed, which were all within a stone's throw from Red Lion Square but intolerant of visitors (especially female ones) and where breakfast was served, abundant but of terrible quality.

We lived together for ten years till 1945, often talking about marriage but always deciding that we were so different it couldn't possibly work; and we continued like this, with occasional disagreements, but held together by the economic advantages. Without realising it we grew closer than either of us knew. Chappie finally got tired of the arrangement, and when she put the question to me I waffled about love and liberty and individualism. She packed up and went. Within two days I couldn't bear to be without her. I rang her at the pub in Cornwall where we had previously gone for holidays and where she had now taken a temporary job as a barmaid. She came back, we were married and lived happily ever after for another twenty-five years.

When war broke out I was in Finland where, accompanied by a professional photographer, Leslie Baker, I had arranged a series of appointments, sponsored by a major now-defunct magazine, *Illustrated*. My colleague and I had just returned to Helsinki from a visit to Toivola to photograph and talk to the great Sibelius when, on 1 September 1939, Hitler marched into Poland. It took us five days to get out of Finland. When we arrived at an emergency airport at Shoreham in Sussex I had the greatest difficulty in getting back into the country. Fortunately, a year earlier, during the great Munich crisis of 1938, I had on repeated applications been put by the Home Office on a list of aliens with special qualifications and had written to the Army, Navy and RAF to express my eagerness to join up in case of war. There were already war clouds over Europe when I left for Helsinki, and I had taken the sensible precaution of carrying copies of my letters and the replies in my breast pocket. I also declared that I was engaged to an English girl. Finally, under

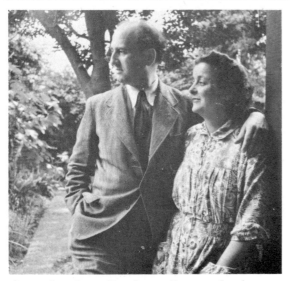

A snapshot of myself and my wife was taken by Yousuf Karsh on a visit to our house at Worthing. This comes under a rare category of 'snapshot by Karsh' who, if he takes any other snapshots, never shows them to anybody.

a sky covered with Blimps, I was let in, although Hungary was a neutral country and the immigration officer emphatically advised me to go back there as food would at any moment become very scarce in Britain.

Nothing can describe my delight at being back in England. I hastened to meet Chappie, who had moved in with one of her brothers in Hammersmith, where we stayed for a month; and then we moved back to the heart of London. We took two small flats next to each other in a block of flats intended for London students and then standing gapingly empty – Russell Court. Our flats were numbers 400 and 401, and I live at No 400 to this day.

Immediately on my return I wrote to the Admiralty, the War Office, the Air Ministry, to offer my services. They all turned me down, saying I was a neutral and they could not accept me. After some six weeks I wrote again – and I wrote again and again, but without success or encouragement. I felt very badly about it as, of course, if ever there was a war in which I should have fought, this one, against Hitler, was it. I joined the Air Raid Precautions (ARP) post in a building next to Russell Court, was taught how to put out incendiary bombs, did duty on the roof of the flats armed with a bucket and a long spade, together with a device with which to cover inflammatory bombs with water. Oddly enough – and fortunately – although I was on roof duty twice each week, all I could do was stand there watching the German bombers drop bombs in circles over different parts of London; an eerie, frightening, but strangely fascinating and unforgettable experience.

All the residents in the building, under orders, stayed in air-raid shelters in the basement. Whenever the alarm went everyone went down to their allocated bunks until the all-clear was given. The basement had been separated into some twelve independent but corridor-connected compartments with heavy, fireproof wooden doors and in some compartments the inhabitants had bricked in tins of food in case of emergency, should the building be hit and collapse. But – though we were hit twice – nothing penetrated more than one floor and we were quite safe in the shelter. Many bombed out in the area were brought in and room was made for them. We heard of frightening experiences people had undergone.

During the late afternoons one would see masses of people carrying suitcases and bedding into Russell Square Tube Station, where some 400 steps beneath the street surface they formed a nightly community, establishing a camaraderie and way of living that quite a few enjoyed more than they had their normal humdrum lives. Inside Russell Court itself the discipline of walking down (the lifts were cut off for the sake of economy) into the shelter relaxed more and more. Many people stayed in their flats, though others loved the companionship of the basement shelter, where there was much playing of cards and quite a few amorous, if temporary, alliances.

I walked to work in Fleet Street, often passing great craters made by bombs, and was once bombed out in our office in Poppins Court myself when it was hit by an incendiary bomb which did not penetrate the roof, but weakened the structure at one particular point. The damage was worsened by severe rainfall. The water finally seeped through the ceiling two floors above where I was working. Some hours later a lot of water began to come through my

own ceiling, on the second floor. We called in the fire brigade and they arrived within minutes. To my bemusement, before they did anything, I, as manager, had to sign a slip saying that we would in due course pay for the brigade's work. That done, they very quickly managed to pierce the ceiling and the water poured in, destroying just about everything in the rooms we occupied – photographs, negatives, equipment. However, I and the ten people who worked with me there, for Pictorial Press, were in no physical danger.

It was during this time, but before we had to give up the offices, that a Scotland Yard detective started calling on me in a jovial, if heavy-handed manner. He was 'just checking up' that I was all right, being, after all, an alien. His ten-year-old son, as it turned out, collected foreign stamps and he wondered if I had any.

'Lots,' I said, 'help yourself,' and opened a drawer in which I kept stamps from abroad. He looked at them carefully, and was particularly interested in those from Yugoslavia. I invited him to take whatever he wanted and then asked him out for a cup of tea. He came willingly enough and when we sat down I said to him, 'Look, I'm as pro-British as any man can be. I've done my damndest to get into the armed forces, but a friend of mine at the Admiralty, Bernard Sendall, warned me to lay off sending letters of application because the authorities were beginning to think I was some kind of spy.'

The detective laughed and said, 'Well, that's really what I'm here for, but I'm quite satisfied that you are OK. We wondered whether you did any business with a particular Yugoslav publication called *Politika* which we know to be pro-Nazi, and with whom I'm now satisfied you have no dealings.'

I told him that I wrote articles in my spare time for the Ministry of Information, that I belonged to the ARP, that I had applied to join the Home Guard, then just formed, and that I would like nothing better than to give up my work and fight the Nazis, but at the Front in France, not in the Pioneer Corps in faraway Scotland or Yorkshire, where a number of aliens had been accepted (I think in 1943) by the Army, more or less for digging ditches and washing up the washing up they had themselves created.

By early 1945, as already described, Chappie and I had got married; and within a week or so of the ceremony at the Russell Square Registry Office my wife received a notice from the Home Office telling her to report to the Aliens' Office as she was now Hungarian. She wrote on the letter, 'Don't be so damned silly,' sent it back, and we never heard another word.

CHAPTER 2

Millionaires & Power

I HAD £2,000 when I started Camera Press, and no first-class photographer would risk his career to join me – and anyhow I didn't have the money to entice anyone worth while away from what he was doing. There was nothing for it but to learn to take pictures myself.

I had accompanied photographers on many assignments and had a well-developed instinct for the type of photograph needed to tell a picture-story. My editorial training in writing captions fortunately had educated me to see in almost any situation what was needed to keep up a convincing narrative. In writing captions I had often felt that even famous photographers omitted pictures that would have been useful to the cohesion of a photo-feature, and I was of course very pleased to find that from the moment I took my first professional picture I knew what I should take for picture two, and for the next and the next and the next. My subconscious mind (with which, I think, on account of my happy marriage, I was on excellent terms) prepared for me what was required next.

I also found it was helpful to be able to say to the subject, 'This situation is now exhausted. Let's go on to something else.' There was no awkward pause, and I never had to say, 'Do you think there is anything else here to photograph?' – which invariably ends a sitting because the other side is almost honour-bound to reply, 'Oh no, I think you've done plenty,' and that meant I would be politely expected to pack up my equipment and leave.

Knowing that I was equipped with this happy knack, and gaining confidence in the handling of my Rolleiflex camera, I went to see picture editors of every kind: I did assignments for women's magazines – *Woman, Woman's Own, Everywoman, Beauty, Woman's Weekly, Woman's Journal* – and for general interest magazines like *Illustrated, Picture Post, Everybody's,* various daily and Sunday newspapers. With each assignment, my self-assurance grew and my arms grew stronger from carrying two heavy bags full of collapsible equipment, which took me at first twenty minutes to set up, until, with practise, I could eventually do it in eight minutes.

The set-up period in the presence of the sitter is nerve-racking. He may be impatient to get the job over with and I, as a photographer, was anxious not to lose the sitter's goodwill. Even this presently worked out, in that as I set up the lighting equipment and the tripod there would be conversation, I could observe the person, whether politician, musician, writer or whatever, so that when I was ready to shoot I had a good idea of what angles to try for; and when you gain that certainty your sitter relaxes and is much easier to portray.

Little by little, alongside the running of the agency, my photographic work became acceptable to important publications, the most important among them being the American periodical, *Saturday Evening Post.* They were rich, powerful, conservative and employed very good writers. It is thanks to the *Saturday Evening Post* that I was able to get close to millionaires and other people of power. Outstanding among these were the two great rival multi-millionaires, Aristotle Onassis and Stavros Niarchos.

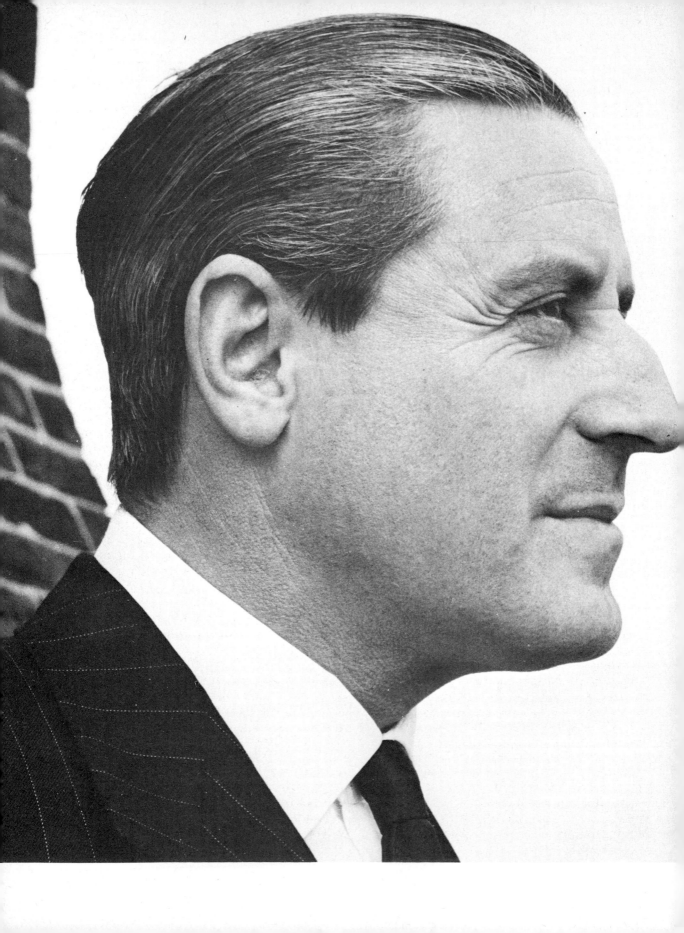

Eugenie Niarchos. A fine looking elegant Greek beauty used to immense wealth all her life. She died under mysterious circumstances.

LEFT
Niarchos in profile. His dominant nose matches the rest of his features – the jutting chin, the penetrating eyes, and the air of complete confidence.

 ★ ★ ★

'Now let's all keep calm,' said multi-millionaire Stavros Niarchos as he emerged from the inner recesses of his private penthouse on top of the Dorchester Hotel. He nervously fingered the buttoned-up collar of his white made-to-measure shirt. 'Don't let's get nervous.'

As he had kept me waiting for twenty-five minutes I was no longer nervous. I looked at him with keen curiosity as I had only recently photographed his close rival and brother-in-law, Aristotle Onassis. Of the two, Niarchos was by far the more photogenic – with finely chiselled autocratic features, lively but hard dark-brown eyes. Both were dapper, about five

feet six in height but Niarchos in better shape. His sumptuous apartment overlooked Hyde Park and beyond it wide stretches of London. I photographed him from all angles, then his beautiful wife, Eugenie, joined us for a few minutes. She was the sister of Tina, then the wife of Onassis. Their ship-owner father, Livranos, was rumoured to be richer than Niarchos and Onassis together although, unlike his much better known sons-in-law, he always kept well out of the limelight. Niarchos invested heavily in art treasures – Fabergé eggs, Renoirs – a huge collection of art that caused him to employ as private secretary an art historian who acted as a curator for these priceless possessions, Miss James.

He was impatient of small talk, and quite unwilling to engage in more substantial conversation for which, like some but not many photographers, I always prepare myself; but he was affable enough, and quite liked to be photographed in profile. There was about him the air of a captain – captain of industry, a naval captain or a capitano of the Borgia days – dark, handsome, proud, silent, unpredictable, a man capable of imperious sudden rage. He was nice to me, though, but after fifteen minutes, he had no more time and said he would try to come back after lunch. Miss James said, 'Would you like a cup of coffee and some sandwiches; saves you finding an eating-place in this expensive part of London.' I agreed, and asked if I could have some smoked salmon sandwiches; we were, after all, at the Dorchester. 'Would ham do? The lunch is on me!' replied Miss James, with an embarrassed smile.

Niarchos did not come back; the incident reminded me of his equally wealthy, but very different brother-in-law's approach and lifestyle.

Onassis then lived in the south of France, near Cannes, at the grandiose Château de la Croe – where the previous temporary tenants had been the Duke and Duchess of Windsor (after his abdication) and King Leopold of the Belgians (also after his abdication). I was on assignment (in both cases) for the *Saturday Evening Post*, one of the great American weeklies of that time, and so in Cannes I stayed at the costly and prestigious Carlton Hotel. Onassis sent a car for me once a day whenever he could

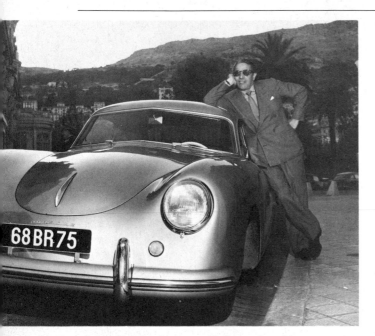

Aristotle Onassis, 1954. Hollywood could not cast a more suitable man to play the part of a millionaire shipowner. Aristotle Onassis (Ari to his friends) here poses in the deepening dusk of Cannes, leaning against his Porsche – at that time the latest German-made wonder car. Sitting behind the wheel, Onassis would allow no one to pass him on the road. He preferred to wear double-breasted suits which more readily accommodated his powerful, compact body.

must have turned into our main road seconds ago. In no time at all, Onassis had overtaken him. He then relaxed and turned to me: 'Just can't bear anyone in front of me.' And a little while after the same thing happened a second time.

When we got to the corner of the Carlton, he turned to me smilingly: 'It was much more pleasant than I had anticipated. Tell them at the Carlton to put your bill on my account,' and before I could thank him he was gone, to overtake yet another car.

The Carlton was expensive, so his generous gesture was much appreciated and I looked forward to treating myself to a really lush dinner. One of the dishes I asked for was an orange lettuce salad, a dish I think I have invented, and which horrified the French waiter who called over the head waiter to remonstrate with me for asking for such a barbarity. 'A layer of lettuce, covered by slices of orange cut horizontally and then covered lightly with sugar; two layers of the same, then put into the deep freeze for a few minutes.' Sugar with lettuce? No salad oil? – Obviously, another mad eccentric from l'Angleterre! ... At this moment, not far from where I sat, Onassis entered the dining room with a party of friends. He recognised me, saw a bowl of caviar and a bottle of champagne on my table, and two waiters bending over me, worried but reverential. He winked, smiled, waved his hand.

Aristotle Onassis was a most interesting man to photograph. He looked powerful if a fraction overweight, preoccupied but always courteous. For my sake he called in his wife Tina, and his children, Alexander, then about five, and his daughter Christina, three. They both had huge dark eyes and strangely heavy features. I observed them closely and thought: poor man, with all that wealth he's got mongoloid children. Maybe that's why he smiles so sadly, and wears these dark glasses! Which was rubbish of course but whilst I obviously could

fit me in; I saw him five times, for brief periods of from five to fifteen minutes, and Signora Rocca-Sera, his private secretary-cum-valet, looked after me generously during the waiting times. At the end, when he had enough of being photographed, Onassis said, 'Jump in, I'll take you back to Cannes.' He drove the then new Porsche, an elegant and powerful car; suddenly he stepped on the accelerator and the car shot forward with such ferocious speed that I was really frightened: I did not know how fast this terrifying car could accelerate and I had no idea what had possessed Onassis who was looking suddenly grimly determined. He cursed softly in Greek. I gripped the arms of my seat, and asked if anything had happened. 'See that son-of-a-bitch in front, I simply cannot tolerate anyone driving in front of me.' He referred to a car whose red back lights were just visible; it

Onassis photographed on the manicured lawn of the Château de la Croe, near Cannes. His every gesture indicated wealth and the self-assurance of a man with the ability to make money.

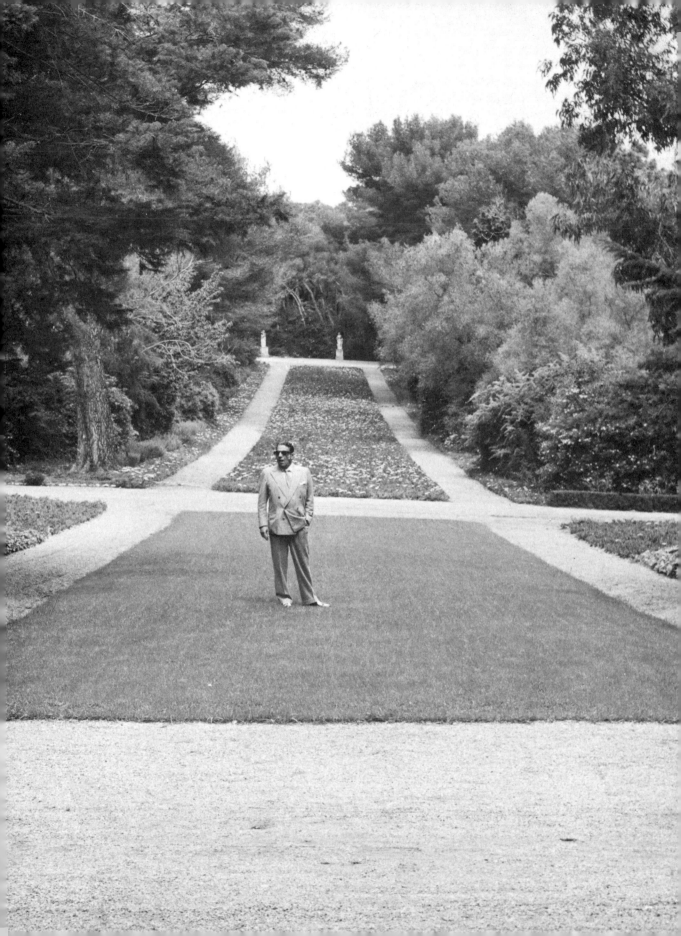

not ask about the children, I asked Onassis whether he would oblige me by taking off his heavy sun glasses. He did – 'I wear them because I have such heavy bags under my eyes,' and he was right. Even at that time his eyes gave him trouble. Later he had to use some aid to prop up his eyelids.

One day, after some pictures indoors against the heavy Baroque splendour of the château, he got up and stood in the open doorway. Guests were sitting on the terrace chatting and playing bridge. Without a word to anyone, he walked down the elegant wide terrace steps, down the vast parkland, out of sight. He did not come back at all. A helicopter, I was told, was always at the ready on the estate; without telling anybody he had flown off to Hamburg to inspect progress on some tankers that were being built for him. He was back in the small hours.

<p style="text-align:center">* * *</p>

Sir Ernest Oppenheimer, the diamond and gold king of South Africa, was even more of a multi-millionaire than Niarchos and Onassis, but very

Onassis and his daughter Christina, then between three and four years old.

Sir Ernest Oppenheimer with Lady Oppenheimer at Bluebird Farm. He invited me to a charming and informal salami sandwich luncheon. His house, two hours by car from Johannesburg, bursts at the seams with treasures.

different in just about every way except that he, too, was just under middle height. His house was situated in the middle of the veldt; I hired a car in Johannesburg; the drive was supposed to take about two hours. There was no sign posting, there were no roads and hardly anyone, anywhere, to ask the way, except occasionally a cart driven by two oxen stirring up clouds of fine red dust. We were two hours late.

Sir Ernest was not in the slightest bit perturbed. 'Everyone who comes here is two hours late. Come in and have some salami.' We had salami, salad, coffee and fruit drinks, and gripping a tall shepherd's stick with the kind of curved and carved handle bishops use, he showed me the house with its many paintings and sculptures, which you would never have expected to find so far from civilisation: there were Renoirs, Degas, Matisses, Picassos, Chagalls. There were sculptures in precious metals, obviously priceless.

He then showed me his fantastic model farm. Angus steers had been flown over from Scotland, as had horses from many parts of the world and bison from North America, all of the best breeds obtainable. He grew things experimentally to try them out in South African soil. He also showed me a model design for a black worker's home, way ahead of the kind of places South African blacks lived and still live in.

Sir Ernest Oppenheimer was soft and mildly spoken, with a faint German accent (he was born in Frankfurt), and entirely willing to discuss God and the world. His friendliness had dignity and warmth. There was nothing pretentious about this multi-millionaire who decided the price of gold and of diamonds on the world market.

'I have a thousand pounds to invest,' I ventured to tell him as we were munching open salami sandwiches. 'What would you advise me to put it into?'

'How soon do you want dividends?'

'No hurry. I don't mind if it takes years.'

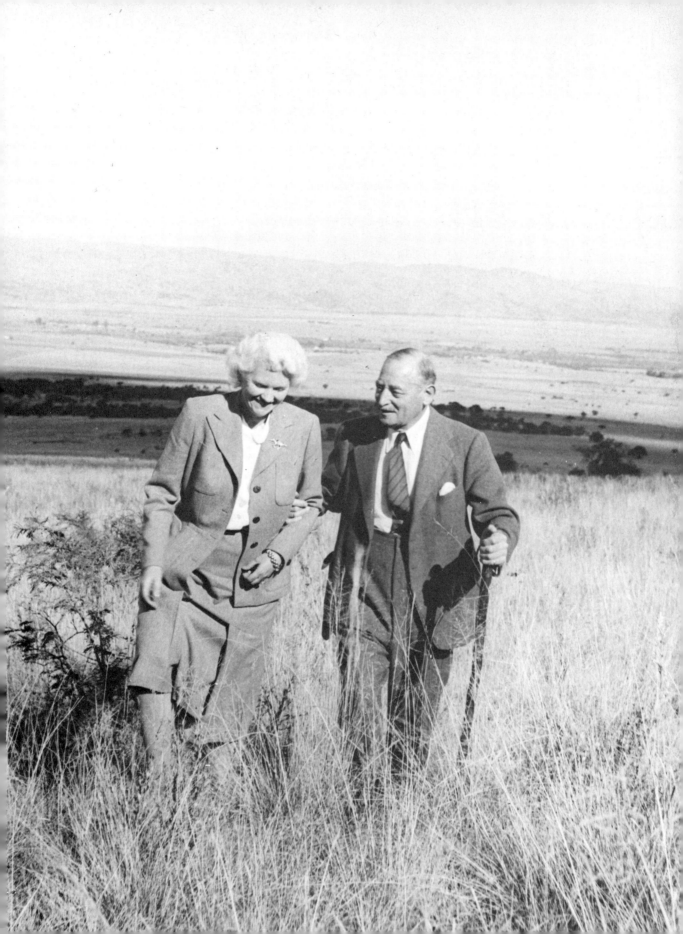

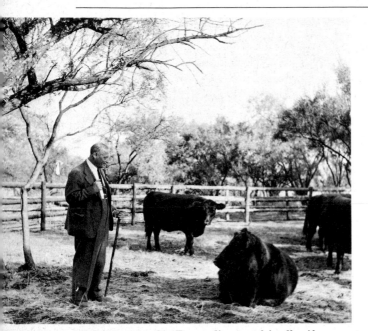

Cattle breeder Sir Ernest directs a friendly, if slightly timid, smile towards the imposing all-black Aberdeen Angus which he had had flown into South Africa for his model farm, Bluebird.

'Buy shares in Newfoundland,' he said, 'it's crammed full of iron ore and all manner of worthwhile minerals, all that is lacking at the moment is transport to get it away, but that will of course come, although it may be in three or four decades.'

On my return, I did as he had counselled. There is a Canadian company, Hollingers, that holds mining rights on fifty per cent of the island's minerals; so far the shares have not moved but I have grandchildren.

* * *

I met a millionaire of quite another kind, also in South Africa, in Soweto, the Black township of Johannesburg. His name was Richard Maponya. He was a huge fellow exuding a charming, naïve bonhomie. He lived in a villa of the kind of which there are thousands in the suburbs of London, and he was delighted to be photographed. 'Yes, I am a millionaire,' and he smiled proudly.

'How did you make your money? I did not think it was possible for a black man under apartheid to become rich.'

'Well, I was a clerk, but when I finished work I went out to buy secondhand clothes and cloth. These I sold on the street corner. I bought cheap and I sold at a profit, I did not spend much and soon I employed other salesmen, and so it all grew. When I had enough I bought good furniture and things of gold.' Proudly, with glittering eyes, he showed me his desk, his bedroom, the kitchen and the little garden in front of his house.

'I have a supermarket which my wife runs, so there is new income all the time.'

He was a councillor at the Soweto Council which met periodically to voice grievances and requests. It had no executive power. The Government presented councillors with academic-looking robes of dark-green with gold edges in which they looked and felt important.

'What are your aims, now that you have so much money. What would you like to happen?'

'I would like to have a little say in what goes on in my country – not just have a green gown, a car and a little garden.' He smiled, and there was a little pathos in his pleasant, unenvious face.

'You look a big strong fellow, did you, in your youth, take part in any sport?'

'Yes, I was the Black Heavyweight Champion of South Africa. I am still quite strong.'

'Do some push-ups,' I said. He got down on his hands and knees, the ideal black citizen with no rebellion in him, the kind of black bourgeois the Afrikaaners would obviously like to develop. He tried; he could not manage even one press-up – all fight had gone out of him.

* * *

Millionaires are men of power; even Mr Maponya has much power in the community of Soweto; but power of a totally different kind, entirely unconnected with money, makes

Maponya's winning ways. He shares with most Black South Africans the gift of good humour; his face indicates his astute quick-witted intelligence and good nature. He is unflappable, happy and relaxed and thoroughly enjoys his status as a very rich man.

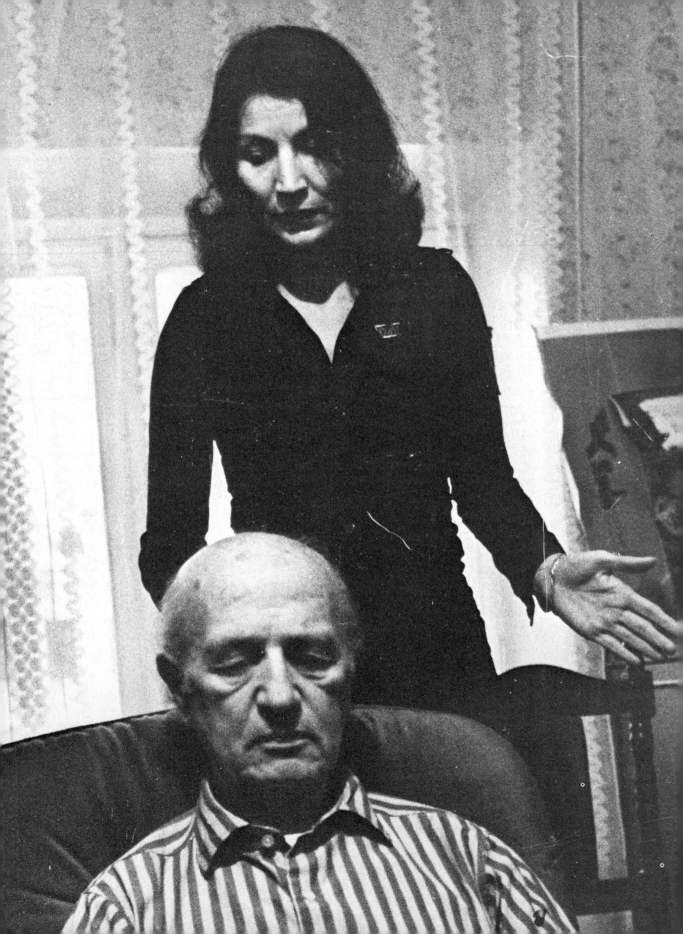

Dzhuna Davitashvili one of the most remarkable people in the world and certainly puts her in a class of her own. Her power lies in her fingertips, from which she claims power emanates that can heal. I met her, as a great privilege, through an American journalist friend, Henry Gris, who normally writes about film-stars in Hollywood, was born in Latvia and speaks perfect Russian.

On a visit to Moscow he discovered that Dzhuna was the woman who had – at least temporarily – healed the great Leonid Brezhnev, the Chairman of the Presidium of the Soviet Union, when photographs and reports indicated that he was at death's door. He did in fact die at the end of 1982. He was reported to have suffered from heart trouble. Dzhuna, almost overnight, had put him right – at least for a period.

I also suffer from heart trouble, and so I asked Henry Gris if he could arrange for me to be treated by Dzhuna. To my utter amazement, he managed it. I went to Moscow in 1978.

Rarely can power have been invested in one so fascinating in appearance. Dzhuna Davitashvili is about thirty-four, five feet seven inches, curvaceous in the right places, with dark eyes and black hair, and the long, elegant hands and fingers of a great pianist. She came from Tbilissi, where she had made a local name for herself as a nature healer before being whisked off to Moscow to treat Brezhnev. I was avid to see her.

She works in a small flat overcrowded with friends, family but especially people hoping to be treated by her. At least a dozen people are spread over the heavily furnished Victorian-type sitting room, all having tea, cakes, sweets, jam, all talking animatedly, with Dzhuna joining in conversation whilst she is treating whoever is next, and who lies on the couch. When it came to be my turn, I like the others only had to take off my jacket and my shoes. She sat at the foot of the old-fashioned velvet-covered sofa, making circular movements with one hand two inches away from the soles of my

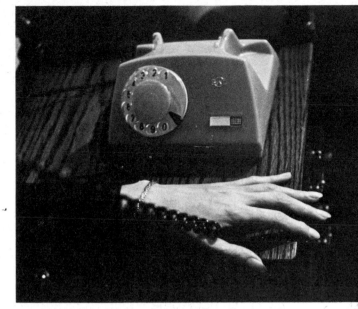

Her hands are long, slim, elegant, with well-manicured finger nails. It is from her hands that she radiates healing power.

Dzhuna and myself. I feel a strange tingling sensation of warmth as she moves her hands round my head. This was the third day of my treatment. Two days later I began to feel quite extraordinarily improved and within a week I walked and looked a lot better.

feet. After some forty circles she wipes her hand against the other and starts afresh. The phone rings, she answers, holding the receiver in her free hand, she laughs, smokes a cigarette, joins some argument sharply, and all the while she heals.

I watched her closely; she was free from any inhibition, or pretence. Her conviction in her gift was absolute; but I felt nothing. She then made me sit up and moved her hands over my head, alongside my front and back, never touching me. 'Come back tomorrow at twelve-thirty,' she said to someone who spoke a little English, and when I arrived the place was more crowded than before.

She beckoned me to go into the kitchen where I was given tea, and had a spoonful of caviar, smoked fish and exotic chocolates, then I had treatment. Each day she looked at me eagerly and asked if there were changes. There were none, but after five days there was a remarkable improvement. My feet which for months had been very cold at night were cold no more; my walk had more energy, I felt more enthusiasm, more *joie de vivre*, and the whole world was

transformed for the better. In front of all her patients she embraced and kissed me, and promised that after three weeks she would make me well and feel and look twenty-five years younger; she did not quite succeed in doing this but the changes were certainly exciting.

I saw her every day for three weeks, including Saturdays and Sundays. My improvement was steady and continuous, she was extremely pleased but in no way surprised, except surprised that it had taken five days for the improvement to set in. She told me, again through an interpreter – there was always somebody there who spoke either English, French or German – that locked in the soles of the feet were nerve centres that had been largely overlooked by orthodox medicine. But even had they not been overlooked, only some strange indefinable power, like hers, could mobilise them. This was her task in life, she said, to make people better and she is trying to persuade the Soviet State to let her set up a novel academy of healing for, in her view, everyone has fragmentary, undeveloped powers of healing which she could bring out. She was not really Georgian, although she came from Soviet Georgia but belonged to a small surviving tribe of Assyrians who spoke a language of their own, Assuri. She had very few words of English – Yes, No,

Better? And her joy in seeing me so much better was charming and infectious.

I had brought a good many traveller's cheques; there is nothing much you can spend them on in Moscow, and of course during my treatment I kept asking her how much I owed her; each time she just brushed off my question and told me, 'Come into the kitchen and have some caviar.'

To the end, she would not accept a single kopeck. It was all entirely, totally free. When I returned my Harley Street cardiologist was amazed to see me so much more cheerful, optimistic and self-assured – although there was no objective change in X-rays or the electrocardiogram.

Dzhuna proved to me that you do not have to be a money millionaire to have real power over life. She is worshipped by the hundreds, perhaps thousands of people into whom she has pumped new powers. But for her mysterious gifts, they would still be miserable and sick. And she uses these gifts in an endearingly natural, generous way. She is deeply religious, there are ikons and primitive religious paintings and sculptures in her small crowded flat, yet she heals anyone, of any religion – like a millionaire handing twenty pounds notes indiscriminately to all who write to him.

CHAPTER 3

Profile of Karsh

HE IS OF medium height, bald (and he has been bald ever since I met him in 1943) with grey fringes on either side and slightly curly hair at the back; his eyes are black and expressive. They can be soft, emotional, penetrating or demanding. He holds himself very straight but moves at times with astonishing speed, yet with elegance and grace. He is altogether a most striking and unusual figure. His speech, accented on account of his Armenian origin, is florid but always to the point. I have not met an eighteenth-century French ambassador but that is the type of person Karsh makes me think of no matter how often we meet. His mind is like a rapier – steely, flexible and swift. He has a determination that belongs to another age. If he gives his word he keeps it punctiliously, and has a set of standards which would have been respected and highly regarded in any era and in any part of the world.

His background accounts for a great deal. He was born in the Armenian part of Turkey and the Turks were periodically staging massacres of the Armenian minority. When one such massacre threatened to occur his parents sent the fourteen-year-old boy to his uncle in Quebec, who ran a small passport photo shop. Yousuf showed so much skill in all matters photographic that his uncle passed him on to a famous Armenian-born photographer in Boston, where again he absorbed all he could learn, then went back to Canada to set up in Ottawa as an independent photographer because he thought it was likely to become a place where he could meet interesting personalities. In this, at the age of nineteen, he showed remarkable foresight.

Soon he was invited to photograph figures in Canadian society; the Governor-General and the Prime Minister. The Prime Minister, Mackenzie King, a man of undistinguished features, was transformed by young Karsh's

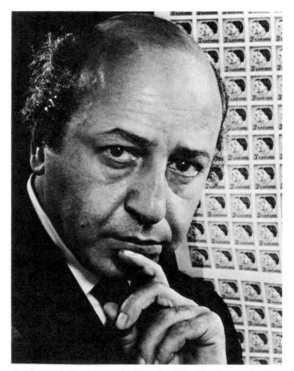

Self portrait of Yousuf Karsh. His dignity and what the Ancient Romans might have called gravitas, are self evident. What is less obvious is that he has a strong sense of humour and loves to laugh.

pictures to look like a noble statesman and, in gratitude, Mackenzie King dragged many important visitors in front of Karsh's camera. When in 1941, Winston Churchill visited Canada and addressed the Canadian Parliament, it was Mackenzie King who took him by the arm and led him into a small room where Yousuf Karsh had established a makeshift studio. Overnight, Karsh made his name taking the immortal portrait of wartime Churchill that is frequently referred to as 'the Bulldog Churchill'. The expression on Churchill's face of

Wise, world-weary, ripe with wisdom, mellow with statesmanship, Karsh's second Churchill. To me and anyone around, Sir Winston merely looked under the influence of too much brandy and long past his prime. Only Karsh could see the difference.

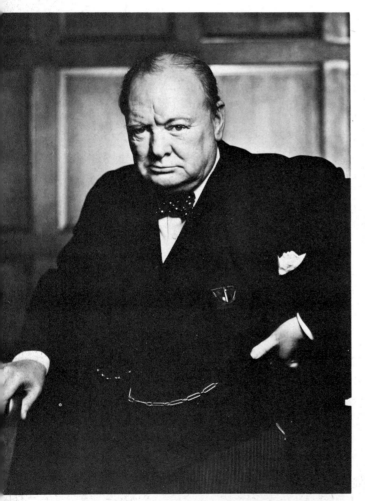

The Bulldog Churchill. Karsh took Churchill's cigar away and produced this famous, immortal portrait – but it was not something he had anticipated doing beforehand. Instinctively, courteously and firmly, he just took the cigar and murmured, 'Allow me, Sir.'

challenge, defiance and commanding presence was due to Karsh having quite innocently taken away the heavy cigar Churchill was smoking, because it seemed to be in the way of the ideal composition of the picture.

This naïve bravura in the execution of his work is a hallmark of this master of portraiture.

In 1956, an American organisation named Williamsburg founded an award for the most important contribution to world peace; the first prize went to Sir Winston Churchill. Karsh – who had been trying repeatedly to be allowed to photograph the great man at No 10 Downing Street after the war, and was refused with the traditional reply – 'You've done so well the first time, Sir Winston doesn't think you ought to try again' – was delighted to be invited by the organisation to come to London and take new portraits of Sir Winston at the Drapers' Hall in the City of London. I, with my own assistant, went along with Karsh to assist him. With our help he put his equipment into a small room on the first floor, tested the lighting, and all was ready.

Sir Winston, by now at a very advanced age, was helped up to the grandiose dining room. He had clearly celebrated before coming; his gait was unsteady and he offered no resistance when his hosts manoeuvred him into the small side room where Karsh and I were waiting. The Grand Old Man, having climbed one flight of stairs, was only too glad to sit down in a comfortable armchair, but looked with astonishment at the lights around him. His eyes were watering and I felt certain that he was in no shape to be 'Karshed'. But that was not the impression of Yousuf Karsh himself. In the bloodshot, weary and exhausted face of the old gentleman, he saw possibilities which I am certain no other photographer could have seen. He took four or five pictures before Churchill, who was not at all pleased with the abduction, unsteadily rose to his feet, mumbling irritably. He

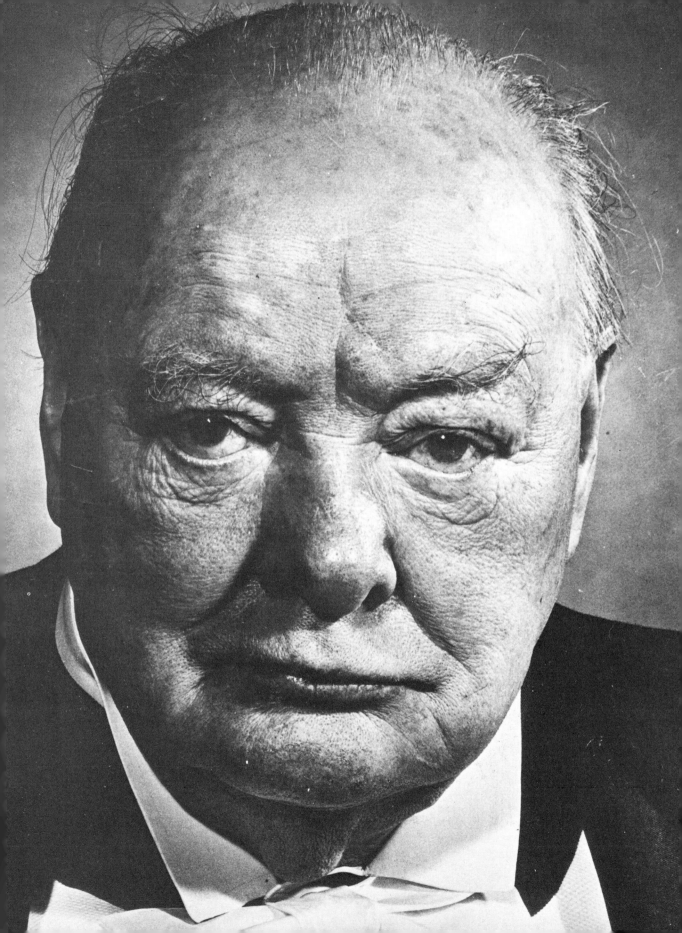

had only been seated about two or three minutes, but by that time Karsh had taken enough exposures on his $10'' \times 8''$ camera to make him feel the trip had been worth while. The photographs that came out of this brief session showed a man ripe and mature with wisdom, looking not, as I had feared, quite befuddled, but regarding the world with profound sagacity and experience. I had of course been observing his face with the keenest interest because I had not met Churchill in the flesh; I stood right next to Karsh, but the incredibly fast selectivity and co-ordination between his eyes and his hand, closed around the nineteenth-century rubber ball release, saw what no-one else there could have regarded as feasible. They were again quite marvellous studies of a great man – as I said before – of ripe and mature wisdom.

Before the dinner and the presentation of the award there was a reception at which Churchill sat passively while his hosts introduced some fifteen important guests to him. He would nod, putting a limp hand towards the person presented. The presenter said, 'Field-Marshal Sir Bernard Montgomery,' followed by all the honours Montgomery had bestowed upon him. Churchill sat up sharply and said, 'You don't have to introduce Monty to me – come and sit next to me, Monty.' For a few minutes they had a lively conversation.

At the dinner, in the magnificent hall, richly ornamented in the heavy elegant gold decor of these wealthy City institutions, Churchill sat in the seat of honour, his head drooping and seemingly unaware of the speech which was made to introduce him to the hand-picked, highly select audience. When the introductory speech finished, Churchill rose, fully in command of himself, and delivered a beautifully-timed speech of wisdom and wit. During the ensuing ovation he sat down again, his head bent between his shoulders, tears flowing from his eyes. No photographs were allowed.

After Churchill had spoken many other guests of distinction recorded how he had saved the civilised world from German barbarity. After some fifteen minutes of this, during which he sat bowed and silent, his eyes half-closed, he suddenly sat up and called across to his son, Randolph, 'You coming? I'm going home.'

He shuffled to his feet and left, amidst enormous applause.

* * *

During the War Karsh came to London to take pictures for *Life* magazine of the leaders of Great Britain, and was granted a session to photograph King George VI. He was given the customary courtesy of selecting the exact spot where to take his pictures and the right chair for the monarch. All the available backgrounds seemed to Karsh to be too cluttered, so he borrowed from the Canadian Army two large, rough grey army blankets and had them tacked to a light wooden frame, and put a throne-like armchair in front. The King, a man of charm, shyness and modesty, came in and Karsh bowed him to the chair. Diffidently King George surveyed the scene. He sat on the edge of the chair and looked at Karsh and his massive ($10'' \times 8''$) camera, the black velvet cloth with its scarlet lining which Karsh, to this day, uses for portraiture. But the photographer was not happy; he went over to His Majesty and, in his unique, fluent and foreign-sounding manner, indicated to him that he was not sitting as he, Karsh, would like him to. Would His Majesty permit his humble subject to show him what he had in mind? The King, astonished but much too polite to refuse the request, got up and Karsh sat in the chair. He sat fully back, leant on his right arm and looked, with purpose in his eyes, into the middle distance. The King obediently followed his example and a wonderful, truly regal portrait was born.

Later I heard from Baron, the able, likeable and public-school-educated Court photographer of the late forties and early fifties that the King, after a photographic session for Baron, told him over a drink what an ordeal he had gone through when Karsh photographed him; but there can be no doubt as to whose portrait will live in history.

HM King George VI. The portrait, once Karsh had demonstrated to the King how he wanted him to sit, shows a unique combination of regality and modesty.

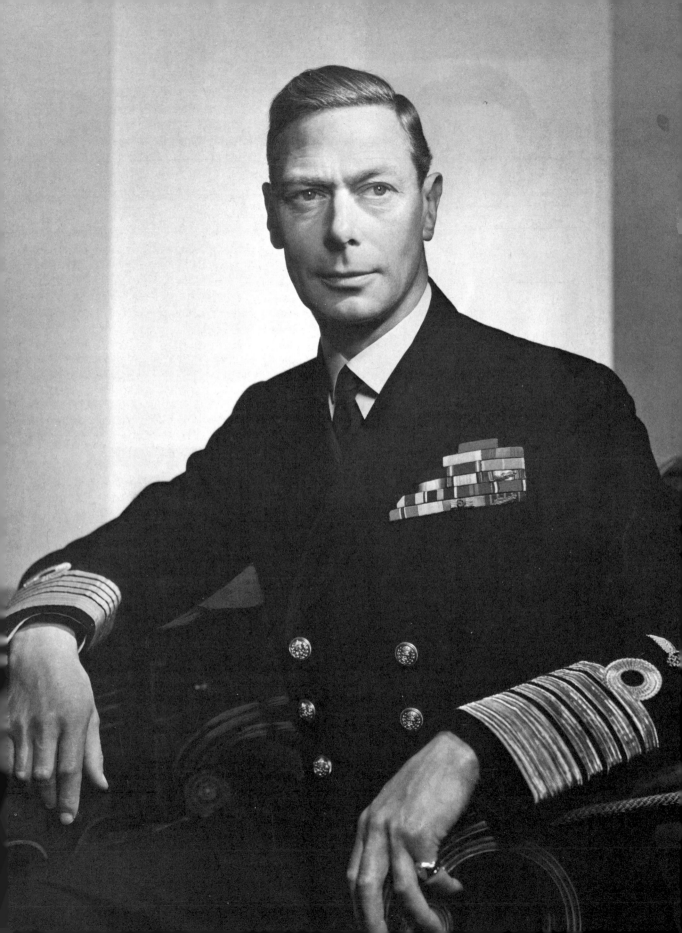

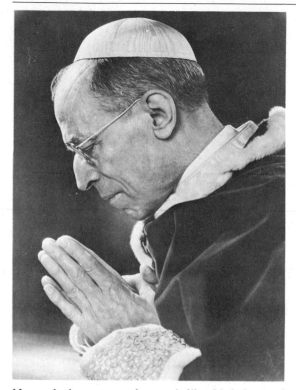

No one had seen a papal portrait like this before and Pope Pius XII, an austere, ascetic figure, had no idea that he would pose for the camera in this manner until Karsh, with temerity and tact, showed him the pose for the Pope to copy.

On another august occasion, this time in 1951, Karsh obtained permission to photograph Pope Pius XII at the Vatican. The Pope, austere, ascetic and wearing large glasses, sat as he had sat for scores of portraits. This was not what Yousuf Karsh had in mind for His Holiness. He wanted to show the Pope in prayer, and said so – a totally unprecedented and unorthodox piece of boldness. But he expressed himself so skilfully and carefully that it gave no offence. However, the Pope did not really understand, and so Karsh knelt down, put his hands together, bent his head over them and showed the Pope how to pray. Again, as with King George, such was the manner and obvious sincerity of Karsh that the Pope simply had to do as he was shown.

When the pictures were submitted to Pius XII for his approval, the Vatican ordered an unprecedented number of copies – so many and so heavy in weight that, with the Vatican's consent, Karsh chartered an aircraft to fly the prints to Rome. Ever since then, he has been Court Photographer to the Vatican, photographing Popes John XXIII and Pope Paul VI; and his portraits of the present Pontiff, Pope John Paul II, taken early in the Pope's succession to the highest office in the Catholic Church, have been reproduced in all parts of the world, not hundreds but many thousands of times.

No photographer has photographed so many people of worldwide fame – among them George Bernard Shaw, H. G. Wells, Einstein, Sibelius, Somerset Maugham, Picasso, Anthony Eden, Eisenhower, Tito, Thomas Mann, Bertrand Russell, Clement Attlee, Nehru, Ingrid Bergman, Lord Mountbatten – and these are no more than a few highlights among hundreds. Posterity, and the teaching and comprehension of history will be enriched by Karsh's work.

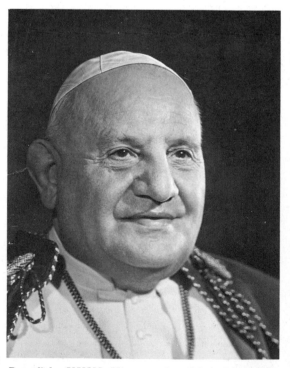

Pope John XXIII. His warmth and humanity made him the most beloved Pontiff in many years. He lives again in Karsh's portrait.

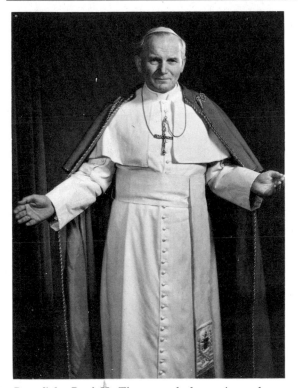

Pope John Paul II. The strength, humanity and wisdom of the first Pope from the East has caused millions of Catholics and non-Catholics alike to look upon him as the greatest figure in modern religious history. Among many thousand portraits, Karsh's is the definitive likeness that conveys the power of the Pope's personality.

their image, or else the contrast between their everyday selves and their portraits by Karsh would be embarrassing. So they simply have to become Noble, Farsighted and Benign as Karsh's portraits show them to be – a useful by-product of his work.

The only two monumental figures of his lifetime not portrayed by him were Stalin and Hitler. If they had been 'Karshed', I once suggested, he might have shamed them into being a little nicer. But Karsh does not think so. He says the camera cannot lie, and he does not set out to flatter anybody; his aim is both to relax and to heighten the personality of his sitter. To do this he prepares himself most painstakingly for each sitting. I have often, at his request, assisted in preparing not merely biographical and anecdotal notes, but also by suggesting a series of relevant and provocative questions to help his subject to forget he is being photographed and to be simply interested in replying. Armed with all this preparation, it is rare for Karsh to make

He regards it as his vocation in life to portray the great in our time; he is a hero-worshipper and believes strongly that it is great individuals that shape our destiny. Since he became so famous that to be 'Karshed' became a status symbol, especially in America, his influence, as I have often told him, on 'captains of industry' must have had a most beneficial effect. By the time a man reaches the top of the ladder his face reflects the ravages of the unending battles that took him to the top. Thin-lipped, hard-eyed, no-nonsense tough businessmen can afford to assign Karsh to portray them, and then have the portrait hung prominently in their private offices. I maintain that this must have an educational effect as these chairmen of the board, presidents, managing directors, have to live up to the nobility with which Karsh has imbued

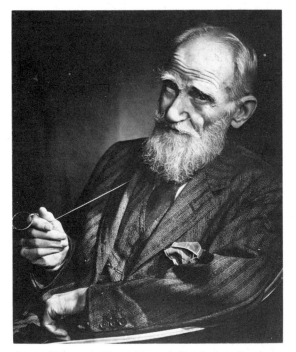

George Bernard Shaw. He and Karsh found a topic in common: early photography. They spoke about the emulsion applied to the photographic glass plate in the early days of photography.

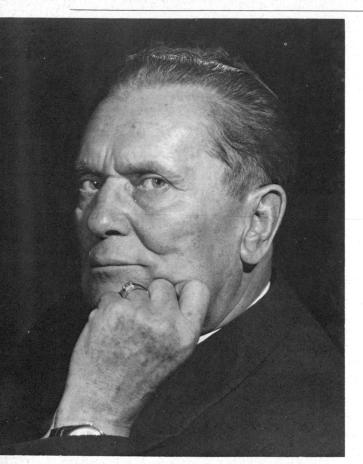

*Marshal Tito by Karsh. (Josip Broz – who like
Stalin changed his name and was known worldwide
as Tito.) The face of a fighter, of a self-made, self-
taught, major statesman who dared to defy the power
of Soviet Russia and who prevailed. This is one of
Karsh's sculpture-like portraits which by lighting
and posing his sitter provides not merely a physical
likeness but deep psychological insight. Tito liked
Karsh's pictures and invited him and his wife to
spend a holiday on his private island, Broni.*

use of any of the prepared conversational
matter, but it gives him a feeling of assurance.

By now, however, Karsh is frequently the
more famous of the two, and it is the subject
being photographed who looks forward to the
meeting as a major occasion.

Although he had not photographed Hitler or
Stalin, he did photograph Krushchev in
Moscow. This was most unexpected because
the Russians had never permitted Western
portraitists to come to the Kremlin. It took

weeks of application and when finally Karsh
arrived in Moscow it was several more weeks
before he came near Nikita Krushchev. The
Russians fed him writers, geographers, scien-
tists, minor cabinet ministers (among them, in-
cidentally, Leonid Brezhnev), but finally, at
last, he met Krushchev. The Soviet leader was
elegantly dressed in a well-cut, lightweight
summer suit. He posed in a good-humoured and
cordial manner with his wife, who had once
been an English language teacher, and who
acted as interpreter.

Having taken the photographs Krushchev
had more or less expected, Karsh said, 'Might I
not photograph Your Excellency in a fur cap?
We in the West associate Russia with snow and
cold ...'

Krushchev turned to his wife. 'Ho-ho, he
wants to see me in furs. Go, darling, and fetch
my winter hunting outfit.'

It was duly produced, taken out of mothballs,
and consisted of not just a fur cap but layer upon
layer of fur, and made one of Karsh's most
memorable portraits.

Krushchev adored being photographed by
Karsh, and invited him to his dacha in the coun-
try, where Karsh's wife, the slim, elfin, highly
educated and articulate Estrellita – the second
Mrs Karsh – quickly made friends with Mrs
Krushchev. Estrellita is a frequent and vital
companion on many of his photographic trips.

★　　★　　★

Having met so many people of great influence
and having had his work published and accepted
probably more widely than any other photo-
grapher since photography was invented, there
are still occasions when people whom Karsh very
much wants to photograph will say no. This
happened in the case of the ageing Sibelius, who
turned down the request even from the Cana-
dian Ambassador after he had ignored applica-

*Fidel Castro. Karsh was struck by the impressive
physical presence of the Cuban leader and its
contrast with his relatively light voice – in tenor
rather than bass strength. His portrait shows much
more than mere fanaticism – eloquence,
persuasiveness, will-power and imagination.*

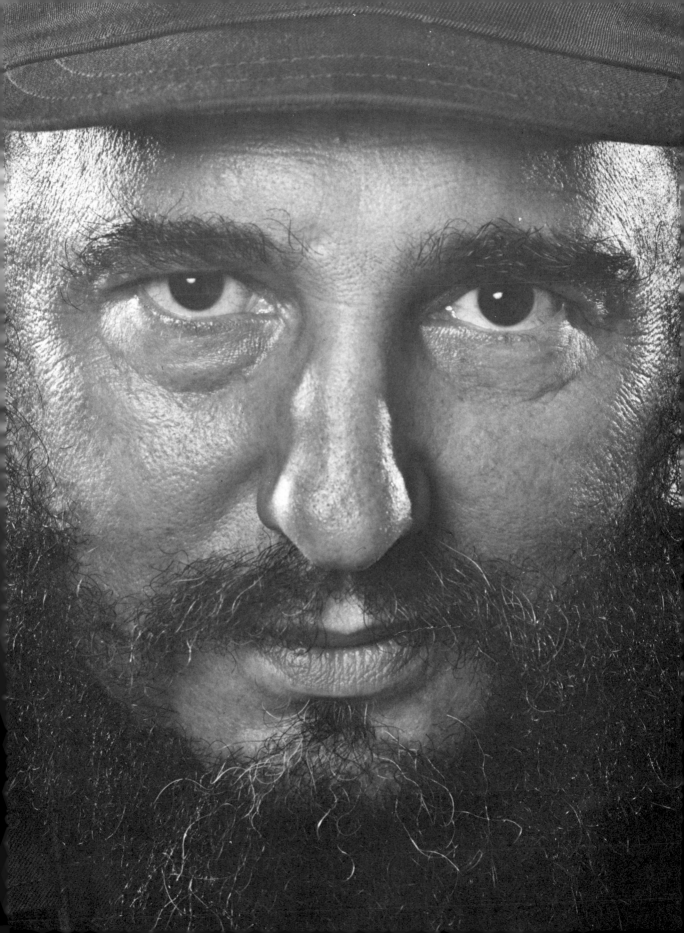

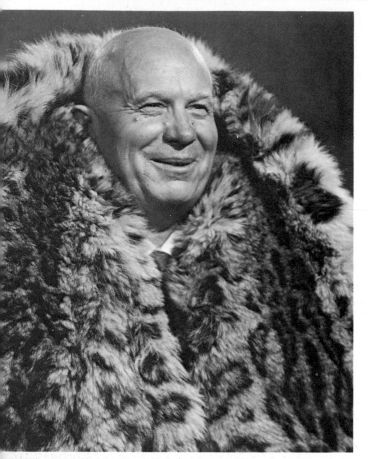

Nikita Krushchev in his furs. He smiles good-naturedly and later expressed his admiration in a note to Karsh.

tions from *Life* magazine and other publications of international prominence.

Karsh hit upon the idea of telephoning the chairman of Shell; he had just portrayed him and a whole gaggle of deputy, vice and associate directors of the company. Shell is of course one of the world's most influential multinational companies. Karsh hoped they might have influence even in Finland. After a moment's reflection the chairman said, 'I think we can help you. One of our directors in Helsinki is married to Sibelius's daughter; I'll ring him now.' In ten minutes the daughter had persuaded Sibelius and an appointment was fixed.

*　　*　　*

I don't want to leave the reader with the impression that there is anything hypnotically terrifying about Yousuf Karsh. He is a gentle, kindly, concerned man of quite unusual wisdom. A few years ago, when he suffered a severe heart attack, he did what very few people would think of doing; he thanked God (Karsh is a very religious Coptic Christian), and then went to bed, where he lay motionless for six weeks, relieved and delighted to be thus compelled by fate to lay off work for a period of time. He did not fret or complain or bemoan his fate – he just lay peacefully and patiently until his doctor told him he could now get up. Then he got up, and was completely cured.

CHAPTER 4

Beautiful & Interesting Women

WHEN YOU TELL other men that you are a photographer they are apt to lick their lips or wink or leer, and generally convey what a lucky dog you are. There are few highly-paid photographers of pin-ups that reach *Playboy* standards; I am not among them. I have, however, photographed some strikingly, even startlingly, beautiful women.

The Italian actress, Elsa Martinelli, was in London filming opposite Trevor Howard in a film called *Manuela*. I was let on to the 'floor'. The scene was set for Manuela to go to sleep in a bunk aboard a ship. The actress, with flashing eyes, high cheekbones, a delightful nose and beautiful lips and teeth, was lying on the bunk, her head supported on her hand. The publicity man said, 'There she is. Do what you can – I can't help you any further.' He and the rest of the staff were terrified of the tempestuous young Italian, and nobody dared waste her time taking photographs for the magazine press. She had not been warned, and had certainly not agreed to be photographed. She had in fact turned down any number of requests to be photographed.

A small half-circle of technicians and the usual hangers-on in a film studio stood around, at a respectful distance. I pushed my way through, armed only with a Rolleiflex camera and a flashlight. After a minute or so I gathered courage and tiptoed across the open space to the bunk. I could see from her face that at the sight of my camera she was going to burst into indignant, imperious refusal, but before she could open her lovely lips, I said in a whisper, just in her own hearing, 'You are the most

beautiful woman I have ever seen in my life.'

She turned to me and said, 'What?' – even just the one word was heavily accented. I went closer and repeated, 'You are the most beautiful woman I have ever seen. Please allow me to take some photographs.'

She sized me up, her eyes beginning to look

Elsa Martinelli. 'You are the most beautiful woman I have ever seen.'

less angry, and finally said, 'Alla-right. What-a do you want?'

Of course, one never knows exactly what one wants to photograph. The inspiration has to come to you as the opportunity occurs. I said, 'Just stay as you are,' and photographed her from different angles, asked for a wooden chair for me to stand on and, having happily established a different atmosphere, I turned round and said loudly, 'Could I please have some special lights?'

To my delight, one of the chaps brought two light stands and offered to produce more if necessary. When I had finished with the bunk shots, I asked what they were to shoot next, seeing active preparations in progress. I was told that Manuela had just been fished out of the sea and the captain of the small rescue boat, Trevor Howard, had lent her a huge pullover with a roll-top neck, which came down almost to her knees. It looked as if she had nothing on underneath.

Mr Howard was most helpful and at once agreed, when I suggested it, to let me photograph a scene I envisaged which would be visually attractive, though it did not form part of the film.

On the table were oranges. I quickly peeled one and gave it to Elsa. 'Please eat this, segment by segment, but give each second piece of orange to the captain.' (He was now sitting on the floor next to her.) At the last segment I asked them to start eating from either end of the segment so that finally their lips met and they kissed. It went well, everyone was entertained and Elsa, who hated cameras, said, 'Anything else you want?'

'The Italians have a very vivid sign language,' I said. 'Please demonstrate some gestures with meanings attached, and I'll photograph them; please tell me afterwards what they mean, for a caption.'

She got up and consulted with her sister, who always accompanied her as secretary, confidante and general help; they laughed uproariously and Elsa whispered something in her sister's ear. There she stood, dressed in the seductive pullover, demonstrating Italian sign language so rude and crude – and funny – that everyone in the studio burst out laughing and applauded. There was no need for inter-pretation. This produced two very saleable sequences of photographs, though not all the gestures she demonstrated were published in the more high-class glossies.

* * *

The most elegant and chic lady to come before my camera was Marie-Hélène Arnaud. She was the most celebrated photographic model at the time in Paris, and had that combination of haughty sexuality and a way of wearing her clothes that one could find only in France, and then only in the most elegant quarters of Paris.

She was used to being photographed, and we had no difficulty, but while we were waiting for the sitting to begin she was full of high tension, walking, sitting, leaning, bending, and in whatever she did there was a unique degree of elegance.

'Before we do anything, please permit me to photograph you doing things the right way and the wrong way – how to stand and how not to stand, how to sit and how not to sit, how to walk upstairs and how not to.'

By the time we had finished, I had a little textbook in pictures of the art of controlling your body in the most elegant manner in these ordinary everyday activities.

Marie-Hélène (hardly anyone knew her surname) was the favourite of model Madame Chanel, and later took over the running of her world-famous fashion house for a period.

* * *

I had an interesting brief experience of aristocratic superiority when photographing the then Lord Mayor of London, Sir Denys Lowson. He was the subject I had been sent to portray, but his wife, whose beauty and bearing were unmistakably English and County, came into his private office and was persuaded to let me photograph her with her husband. His hobby was collecting stamps and he had a huge comfortable chair in which, in his spare time, he liked to sit at his desk and work on his collection. I asked Lady Lowson to stand by the chair and look over his shoulder at the stamps. She did so, rather awkwardly, seeming altogether too erect to convey the notion that she was looking at

stamps worth thousands of pounds.

'Please bend your head slightly towards me, madam,' I said, softly and, I hoped, persuasively.

She turned her beautiful face towards me, her neck ramrod straight, looked at me contemptuously and uttered these words: 'I bend my head for no man!' then turned her gaze away. I had to chat them into changing their positions so that Lady Lowson sat and leaned towards the stamps, ever so slightly, while her wealthy, round-bodied, admiring husband bent down beside her without protest.

* * *

I had occasion to photograph the greatest British film tycoon in his day, Sir Michael Balcon. He was interested in my work, and asked me if there were any subjects I had difficulty in organising. I said, yes, I would very much like to photograph a charming, beautiful, typical English debutante, and did not really know how to set about it, beyond looking at the pictures published in *Tatler*.

'You have come to the right man,' he said. 'I know just the girl and her parents have put me *in loco parentis* in their absence, so I think I can fix it up for you.'

The girl's name was The Hon. Jennifer Lowther. She proved wonderful – the personification of all that the world imagined an English debutante of that time should look and act like. I photographed her driving wildly in the countryside with an attractive hon. undergraduate from Oxford in a tremendous open sports car. He drove at terrifying speed and the little debutante laughingly and excitedly encouraged him. If someone on the road far ahead looked as if he were about to cross it, she would gaily cry, 'Plough him in, plough him in, he's only a peasant.' But she was really sweet-natured, quick-witted and, like Marie-Hélène in Paris, the very essence of style, this time in the English manner. Though her tongue was caustic, she was kind and warm-hearted.

* * *

As an active photographer, it was always vitally important to keep trying even if the chances of

Marie Hélène Arnaud. How to sit – self-assured, upright and smiling.

success seemed absolutely remote.

I had just photographed Harold Wilson at 10 Downing Street when the many stories about his private secretary, Marcia (now Lady) Falkender, broke and I wrote to her to ask if I could take a sequence of pictures of her, also at 10 Downing Street. I knew she had turned down a lot of people – newspapers, periodicals and photographers who had portrayed the Royal Family – but I was utterly amazed and, of course, pleased when she sent me a charming note saying she would be delighted. She had liked my portraits of the Prime Minister and from the first, in the early and conversational stage, we got on extremely well. I hope it does not sound patronising to say that I was profoundly impressed with her knowledge on a great variety of subjects we touched on before and during the taking of the photographs; and that she carried her knowledge lightly and with good humour. She was vastly more attractive than I had assumed from the many, and distressing, snapshots and flashbulb pictures

The office of Lady Falkender at No 10 was next to the Cabinet room. Her position at the time was Private and Political Secretary to the Prime Minister. Her large desk, was tidy and well-ordered and she was clearly on top of her job and untroubled by its complexities.

My Fair Lady was on at the Theatre Royal, Drury Lane, with the charming decor designed by Cecil Beaton. The title role was played by a new and unknown star, Julie Andrews. One of the women's magazines sent me to photograph her at her parents' home at Kingston-upon-Thames.

She was a delightful girl to meet with an electrifying radiance and a beauty strangely enhanced by a very slight cast in the eyes. She was at the beginning of one of the most brilliant careers on stage and screen and had enormous success in the role in both London and New York. Her freshness, the Englishness of her manner and appearance became celebrated throughout the world, and it must have been very difficult indeed for her to find, even twenty years later, a different kind of role. It is astonishing how this great singing star, made even more world-famous with *The Sound of Music* and *Mary Poppins*, remained practically unchanged for a quarter of a century.

When chosen for *My Fair Lady* she had already gained recognition in England for her lovely clear singing voice, and so had, from an even earlier age, Petula Clark.

* * *

Pet Clark was most jealously guarded against premature press publicity. She had begun on radio and it was about twelve years later that I had an opportunity to photograph her, in the first photographic session I had at Tony Armstrong-Jones's studio in Pimlico, which I had taken over from him in 1961 when he moved to Kensington Palace. She, too, has remained enchantingly young and was a joy to photograph because she seemed to have an intuitive understanding of how she would look to the camera.

taken of her. Her face reflected wit, alertness and a modern outlook. Being photographed with lights all over the place did not bother her at all. She was so nice (a term few commentators at the time applied to her) that she approved all the pictures I had taken. I greatly valued this approval because there are few women in their mid-thirties who like the pictures taken of them. I thought at the time that she would probably have made a considerable success of being in charge of 10 Downing Street herself – and this at a time when no-one had yet thought of a woman in England as Prime Minister.

Petula Clark. A star at seven, she was even more of a star at twenty-seven when I photographed her. The picture was taken at Lord Snowdon's studio at 20 Pimlico Road when I took it over in 1961. Pet Clark is petite, even tiny, although from her photograph you would never think that. She has a most agreeable mixture of serenity, vivacity and intelligence.

* * *

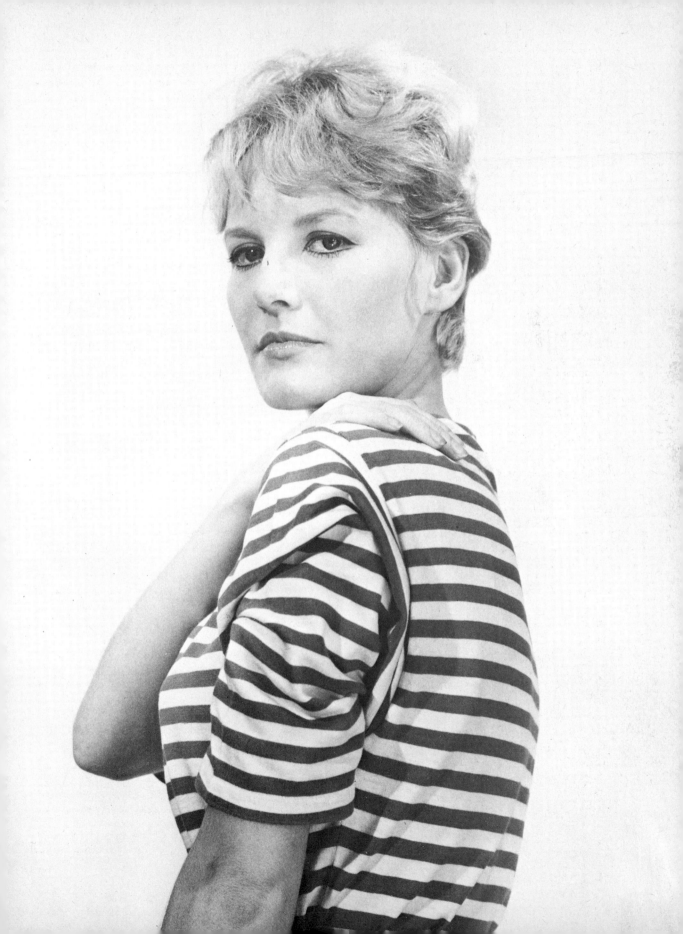

Russian, sexy and provocative. Olga Vardashewa, vocal star of the music hall show in Leningrad. She wears with verve and style the early nineteenth century military uniform of the hussars.

When the sitting was over, I realised the penalty of having succeeded Tony in his studio. There were half a dozen reporters at the door because it was assumed that not I, but Armstrong-Jones, was photographing a famous visitor.

* * *

I was on a visit to Moscow, invited by Moscow TV, who wanted to make a contract with my company to supply them with photographs, especially portraits of people prominent in public life in Britain, America, France. There was, from my point of view, no real need for such a contract, but as I had not been to the Soviet Union I gladly accepted the invitation and took with me a draft of the required contract. I thought we would talk this over for an hour, and then sign it; but that was not their style. After three fruitless days in Moscow the people at Moscow TV asked, to my surprise, if I would like to see Leningrad, and of course I said yes. When next day I got there by comfortable wagon-lit, my guide and interpreter, a pleasant young woman who had travelled a great deal and had a good command of English, asked if I would like to go to a variety show. I said, 'Not particularly,' but it was already booked, and for that same evening, so we went.

The experience was overwhelming and totally novel. In Russia, within twenty-four hours, one gets used to seeing thickset women with dour expressions walking along with a grim determination, and you wonder what happened to the Anna Kareninas of Russia. The girls I saw on the stage in Leningrad did not look like how I envisaged Tolstoy's heroine, but they were startlingly pretty and electrifyingly sexy.

The variety show (it is, in Russian, called the English name of 'music hall'), had a huge stage. The girls looked like the Rockettes at Radio City in New York or a modern troupe of show-girls at the London Palladium, and their

military-style costumes added to their allure. They were backed by a large orchestra, playing hotly jazzed-up Russian folk music which everyone in the audience knew and reacted to. The girls were well-drilled, disciplined, and kicked their legs in unison to chin height. When the interval came, I asked my guide to let me meet the producer of the show, in the hope that he would let me take photographs. She took me backstage and explained to the short, square, almost cubic, broadly grinning and unmistakably Jewish director-producer who I was and what I wanted.

'Sure,' he said, 'When do you want to come? Tomorrow?'

I had been in the Soviet Union for four days and we still had not signed a simple contract, which should have taken twenty minutes anywhere else, and here I found co-operation beyond anything I could have hoped for in a Western theatre. Smilingly, with many tokens of goodwill, we fixed the following Tuesday.

He had the entire theatre company, with full orchestra and complete lighting equipment at the ready.

'I only need a dozen girls,' I said.

'Well, pick them.' He lined up all the girls, forty-five of them.

I said, 'Won't those I don't select be offended?'

'Nonsense, you choose who you want and I'll fix everything.'

I went down the line, nodding at each girl who looked specially photogenic, and in the end had fifteen. They were full of vitality and laughter. I mounted a pair of steps and addressed all of them through my interpreter to say that they were all exceedingly beautiful, and I was deeply embarrassed at having to make a choice. They all cheered and no-one was offended. I photographed the fifteen onstage, dancing, rehearsing, lined up and, backstage, relaxed, dressing up, outside the stage entrance. I wrote down their names, interests, made notes on their education and when I asked if they had any hobbies, each one separately and individually replied with laughing enthusiasm: 'Boys!' I called the photo feature, 'The Sexiest, Sauciest Soviet Show.'

At the end of ten days in Moscow, and after daily meetings and discussions, there was still no contract, so I returned to London. Eighteen months later a delegation of three dignitaries from Moscow Television visited me in London, offering me a draft for a contract. It was in all essentials identical with the stage we had reached in Moscow on day six. I was asked to study it, reply in due course, visit Moscow for a second time for the official ceremony of signing. I signed the draft there and then – and with the draft signed, the connection between my firm and Moscow Television began to wither away, incomprehensibly and with no explanation, and in spite of many friendly protests on my part.

* * *

Not pretty but interesting, important and hardly ever photographed before, who had granted me a sitting shortly – as it turned out – before her death, was the great Marie Stopes. It was

With Cherry, her black chow, Dr Marie Stopes is standing by one of the imposing white pillars of Norbury Park, outside the winter garden of her impressive mansion. Her literary output was considerable: more than forty scientific books and memoirs, six plays, a travel book, a novel, two collections of verses, several fairytales and, principally, thirty sociological works, the first of which was Married Love.

My daughter has from the earliest babyhood been remarkably well-proportioned. She was always a little woman with none of the babyhood deformities of large tummies or heads as compared to the rest of the body which disappear in the course of growing up. Nikki was always perfectly shaped and here she is walking up dilapidated stone steps into a dark area of mystery.

she who had fought for sex education for women and boldly published books now regarded as classics, albeit outdated, on the subject of sex. Throughout her life she had been attacked and persecuted, but she had made a real difference to women's sexual equality and to birth control, and could well be regarded as the founder and originator of Women's Lib. Yet she lived alone and forlorn in a kind of stately mansion at Norbury with two huge dogs as her only companions in a vast, neglected, down-at-heels Victorian manor.

No-one answered when I rang the bell and I had to ring for a long time before Marie Stopes herself came down the grand staircase which could be seen through the glass-panelled front door. There was no conversation; I tried and tried to rouse her interest, but to no avail. Although I had come on a clear and firm appointment she was distant – not aloof but simply far away and out of reach. The very dreaminess and unreality of the occasion conveyed to me a sense of her feeling of desolation, perhaps of having lived too long. It was eerie. When she felt she could bear being photographed no longer, she silently turned and, followed by her two great dogs, went upstairs again. I packed up my equipment and left with a curious sensation, as if I had photographed somebody physically present, but spiritually a million light years away.

* * *

I have left the prettiest little woman till the end of this chapter – my daughter Nikki, photographed aged three, on holiday at a farm in Normandy.

CHAPTER 5

Cecil Beaton

THE ANCIENT ROMANS always had some outstanding personality to whom they gave the honorary title of Arbiter Elegantiarium; it was he who decided what was fashionable, acceptable and elegant in all matters from togas to marble columns, inlaid tables to etiquette.

Cecil Beaton was the Arbiter Elegantiarium of his day and age. He was born in 1904 and died in 1980, educated at Harrow and Cambridge and had quite remarkable talents for photography, writing, stage and costume design. I didn't know him well enough to know which of these was closest to his heart and mind, but I think it was stage design. He was acclaimed for his designs and decor in the splendid productions of *My Fair Lady*, both for the stage and later on the film; for *Gigi*, the opera *Turandot* and *The Importance of Being Earnest*. Knowing so much about stage production and writing, he once tried his hand at writing a play. It was called *The Gainsborough Girls*. To his great sorrow, it was the one thing he had done which flopped.

In appearance he was tall, impeccable and immaculate. In conversation he was perceptive, sharp-tongued, with a leisurely delivery and, though he could be mildly catty, he was a most kind and helpful person who, with exclamations of despair and despondency, would invest much of his time in helping young, struggling photographers and artists. This combination of crisp sharpness and a wide vocabulary, unfailing courtesy and attentiveness made it a major privilege to be with him. He always seemed grateful for my advice, appreciative of my judgement and professional counsel and, unlike

Cecil Beaton goes out. Taxi waiting, he turned round at my request, in bowler hat, velvet collared, knee-length overcoat, cane and gloves. The glazed look on his face concealed a warm-hearted, hard-working artist of international stature, in photography, stage design and decor, and in the world of letters.

many other photographers, he never made a fuss about the quality of his own work; in fact he admitted almost eagerly that the technicalities of photography were far beyond his grasp, and without an assistant he could do little except use a Rolleiflex in the open, with available lights.

He told me frequently that he was not at all sure about exposures, let alone the processing of negatives. Essentially he was like a film or stage director who knew how to get his subjects in the right mood, knew when they looked right according to his assessment of their personalities and viewed through the filter of his sharp and keen observation. I suspect that in the majority of cases he did not even 'press the button' but told his assistant when to do so, and was quite unembarrassed by his own non-involvement in these minor technicalities.

The bane of his life was the vulgarity and banality of modern commercial taste. He would never surrender his own standards and often, when revisiting places like Algiers he decried in his books the way everything – except nature and flowers – continually got worse.

I approached Beaton in 1964 to ask if I could represent him. I knew his work had been handled for years by Associated Press, the world's most important news and photographic news agency. I thought that an artist of his calibre ought to have much more personal representation – namely, me. He received me with some curiosity and, I think, because he himself felt that his representation should be personalised. When we met he made me talk about other photographers of note whom I already represented, and I did my very best to persuade him. From having been polite but distant he became

LEFT
My Fair Lady. *It took days of practice before actresses learned to move gracefully while wearing the magnificent Ascot hats. Photograph by Cecil Beaton.*

RIGHT
Cecil Beaton at his elegant town house, 8 Pelham Place, South Kensington. In his study as elsewhere, books, flowers, paintings; Beaton himself at all hours immaculately tailored, with hand-made shirts and shoes, white handkerchief in breast pocket, waistcoat, white cuffs showing up to two inches.

HM Queen Elizabeth, the Queen Mother. A portrait taken in the 1930s by Cecil Beaton.

are accepted and welcomed in all circles and circumstances from rowdy, noisy pop to the most select gatherings of high society.

When his hair became sparse he took to the habit of wearing broad-brimmed hats, mostly in beige or champagne colours, and wore them indoors as well as out. I was once present in his charming, narrow Georgian house at 8 Pelham Place when he had his hair cut. The hairdresser came regularly. I saw no need for any attention to his neatly brushed, if thin, fine hair, but he was dedicated to total tidiness in regard to his appearance. He sat in his bedroom of red velvet, the barber's towels round his shoulders, and discussed with him the everyday events that hairdressers like to introduce while practising their art. The work took no more than a few minutes, and Beaton tipped his man in princely fashion.

He photographed more people of consequence in British society than anyone before him or since. There was not a lady in the land who could rest happily until she had sat in front of this delightfully chatty and socially knowledgeable figure who, as has become the case with a handful of other highly successful photographers, was often more prominent socially than the socially prominent figure before him.

His writing was diligent and clear, and revealed a devotion to nature quite extraordinary in a man who seemed so completely a town-dweller and was a guest at every major social party. He really knew the flora of wherever he found himself, and knew it with a delicate appreciation rare in our time. In many ways he was the English equivalent of the French all-round artist and writer, Jean Cocteau.

One of the most remarkable events in a life filled with event was his love affair with Greta Garbo. None of his books (he wrote about a dozen) dealt with his private emotions towards the opposite sex, but when he described the way he courted the divine Garbo it was both touching and astonishing. The ultimate physical contact between them, according to his account,

interested, asked many questions in particular about Karsh, and when he was satisfied that I knew what I was about, he asked me to stay for a delicious salad luncheon.

After about a year, with the turnover on his photographs improving steadily and quite impressively, he proposed that we should address each other by our first names. That, I felt, was a great privilege; when he was knighted I wrote a brief note of congratulations: 'To no-one more worthy.' I was told he was pleased and moved.

A very successful fellow photographer of his, Terry O'Neill, once told me that Cecil Beaton was one of those exceptional personalities who

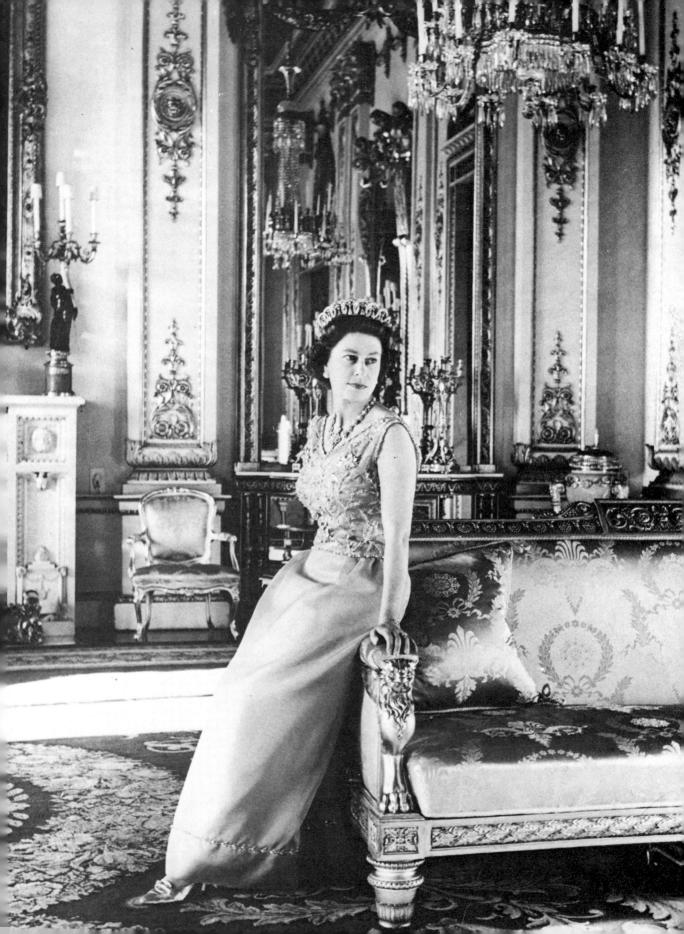

Cecil Beaton on Fifth Avenue. Elegant as ever, wearing his famous broad-brimmed black hat, he is seen against the imposing skyscrapers of the world's most expensive shopping avenue.

was when he ran his hand up and down her spine. Garbo, it seems, though deeply fond of him, did not respond sufficiently; and though there are vague dark hints at his male associations, my own conviction is that he was asexual, an observer from the outside.

Beaton's instinct for theatrical effect and design was well illustrated in his epoch-making portraits of Queen Elizabeth, now the Queen Mother, taken in 1938. They, like many of his early portraits, were like Gainsborough paintings. Later on he went for classical simplicity in much the same way as did Lord Snowdon.

Amidst general applause he became Sir Cecil Beaton in 1972. Among his achievements were many books; he had photographed a thousand beautiful women, and men of distinction,

and had shown an unexpected toughness and bravery during the war when, on behalf of the wartime Ministry of Information, he went to China, where the Chinese were battling with little success against the Japanese.

On a visit to his house and office in South Kensington, I had an opportunity to look at his war photographs. Among them was one of a Chinese quite unconnected with the war, but with such force and personality that one thought one was looking at the face of God. When I pointed this out to Cecil he was delighted and surprised. It had been one of a great variety of snapshots that he had forgotten, but looking at it again he eagerly agreed. There were, of course, occasions when in his role of photographer he came up against competition, and when it was American competition the contrast between his charming, naïve yet effective style and the frenetic, inexhaustible American photographers and all their gadgets made him feel wounded and out of place. It was so when he took pictures of Barbra Streisand. The shooting took place in England and left him exasperated.

He could not bear the famous and experienced director, George Cukor, but suffered almost physically from the presence of a successful American photographer, Lawrence Schiller, who brought with him a pantechnicon of equipment. Plaintively he protested against the existence of such people. When I told him that the director's surname Cukor meant 'sugar' in Hungarian, he burst out laughing – almost the only time I saw him laugh outright. He was a man of smiles rather than belly laughs.

It was a tragedy when, in his early seventies, Beaton suffered a severe stroke. For a long time he was unable to speak. Beatrix Miller, editor of *Vogue*, told me of her visit to his bedside. Tears ran down his face and he could not talk – he, the master of elegant, entertaining conversation lay helpless and speechless in hospital, and few people expected him to recover.

But recover he did. A life force and energy, a toughness and resilience that no-one had antici-

Mick Jagger as a young man – the Byron of Pop, as some have called him. Photograph by Cecil Beaton.

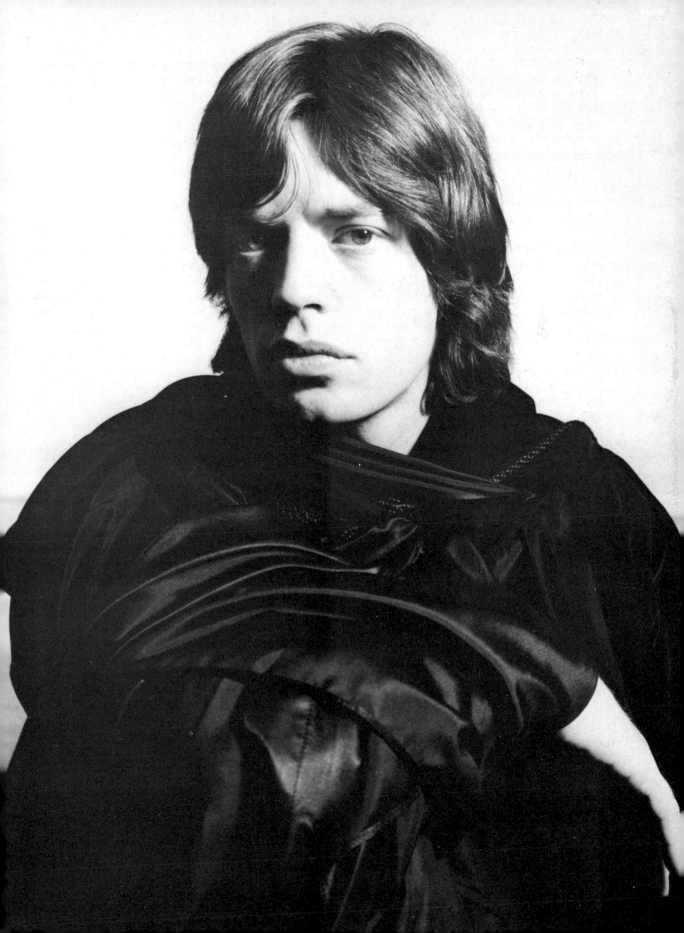

pated asserted itself. He found his speech again, albeit at first haltingly; he could move a little and was allowed to go home to his country house in Wiltshire, at Broadchalke, near Salisbury. Attended by the best medical care and his devoted, efficient and effective secretary, Eileen Hose, he came back to life sufficiently to make a most extraordinary and skilful sale of his work to Sotheby's, the auctioneers. It gave him financial security and he had the shrewdness and acumen to sell all except his photographs of the Royal Family.

We had been handling all his work; after his deal with Sotheby's we had to pay the fifty per cent commission due to Beaton, not to him but to Sotheby's – except on Beaton's Royal photographs, and these, as he may well have surmised, remain healthy and rewarding; and will no doubt continue so for a great many years to come.

Slowly and steadily Cecil improved in health and, to everyone's amazement his recovery was such that he began taking photographs again. I asked him if I could visit Redditch House at Broadchalke to photograph him in the act of taking pictures, and he agreed.

He wore a contraption that enabled him to move his right leg and when he posed for a picture there he was, elegant as ever, with a broad-brimmed hat, the Rolleiflex on a tripod, holding the long trigger release while observing me photographing him, inside his beautiful house. After lunch he showed me round the property, which was split in half by a fairly busy road so that part of the large garden was on the other side.

I said to him: 'I'm filled with admiration for your bravery in making such a remarkable comeback at your age.' He looked at me, his eyes troubled.

'Brave? My dear Tom, I would have been braver and much more sensible had I allowed myself to die.'

The photographs he took live after him. They filled the walls of a major exhibition at the National Portrait Gallery in 1968. There was nobody, from the Hon Mrs Fellowes, Marilyn Monroe, Somerset Maugham, Evelyn Waugh and Lady Diana Cooper to Prince Charles in his pram and Mick Jagger with the Rolling Stones (somewhat satanically lit from beneath), who was not represented. Beaton spoke well, though not at length, of these great, grand and wealthy people, but he had a frequently voiced complaint about some members on the outskirts of the Royal Family who invited him to take new photographs and then expected to be supplied with free copies to an extent which made him wince. Yet he remained at all times ardently in favour of the monarchy – and they were always pro-Cecil Beaton.

Every Christmas he sent me a card in his own writing, which was immediately recognisable. It looked intellectual, artistic and slightly barbed. I sent him boxes of delicious Swiss truffle chocolates – he loved good food and could describe it (and fine wine) with the pen of a true gourmet. At home he had a cook of distinction, and meals and wine were served by a formally dressed, discreet and efficient butler. Cecil Beaton's style of living was truly patrician.

CHAPTER 6

Writers & Artists

MY WIFE AND I were in Nice to get over the sad and sudden loss of our first child. We were walking about in the sunshine when I spotted an elegantly dressed, dignified elderly gentleman with a younger man, and immediately recognised him as Somerset Maugham. We were both avid readers of his work. My wife nudged me and said, 'Quick, go over and ask him if he will let you photograph him. I know his house isn't far from here.'

I am a bit shy when talking to illustrious personages simply because I recognise them in the street, so I said, 'Let's just walk close behind him and perhaps a moment will occur that is opportune.' She was not very keen but that is what we did.

Maugham and his companion, who later turned out to be his secretary, Mr Alan Searle, stopped outside a shop selling porcelain and antiques, and we decided to wait and then approach them as they came out. The only trouble was, they never came out! We waited almost an hour, my wife berating me for my cowardice. We decided to go back to our hotel, and as we turned a corner we bumped into Maugham, who had left the shop by a side door. When I accosted him he eyed me coolly, with that wonderfully wise turtle face.

'All right,' he said. 'Ring me at this number next Wednesday to make an appointment for the following day.' The number was that of the local post office at Antibes, where the postmistress had an arrangement to accept his calls and to keep you waiting while she asked Mr Maugham whether he wanted to speak to you. He did, and at 11 a.m. the following day there

W. Somerset Maugham, photographed at the door of the Villa Mauresque at St Jean Cap Ferrat on the Côte d'Azur. Above the stately door is the Moorish sign of good luck which also appears on the imprint of all his books.

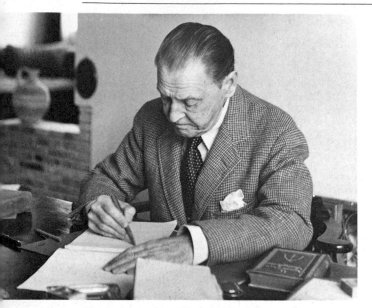

W. Somerset Maugham in his study; he wrote all his novels in longhand.

we were at the famous Villa Mauresque, with its glaring warning posters on the outside walls telling would-be burglars that detectives with fierce dogs were lying in wait for them.

'I shall give you sixty minutes, but during that time I am at your disposal.' He showed us over the house and we stopped in each room, where there were objets d'art collected on his travels, held together not stylistically, but by Maugham's own personality. In his bedroom there was a beautiful and no doubt priceless Renoir of a gleaming pink nude stepping out of the bath, her rose-coloured bottom towards the observer. Mr Maugham showed us the Graham Sutherland painting of him as an oriental story-teller. It had just been finished and he was immensely pleased with the work (in contrast to Winston Churchill, who did not at all like Sutherland's portrait of himself).

Mr Maugham had twin mini poodles which stood on their hind legs to have their heads stroked. He stroked them with charming tenderness and they reappeared at intervals throughout the hour we spent there. He was invariably loving kindness and patience towards them.

There was hardly any conversation. My wife was smoking and he asked her, with seeming significance, how many Gauloises she smoked per day. She said, truthfully, thirty. In what little conversation there was his occasional stutter showed itself spasmodically, and it was admirable how he calmly, and with detached indifference, went through it and ignored it. I asked him where he did his writing.

'In a penthouse,' he said, and led us to it up a perpendicular flight of steps, as in a ship; it was a large, blue and white, peaceful room furnished with an elegant desk and a lectern on which rested a great Webster dictionary. He explained that there was no telephone here, and once he was in his workroom he was to be bothered only if something very important happened. He sat down, calm and composed, and started writing in long hand, but after three minutes got up and leant on the lectern to check on the *mot juste* he needed. Looking for one word led to references to others. This was a matter of ultimate significance, and he took his time. Then he took us out on to the wide balcony, with its antique statue of Apollo. The view was of the azure blue Mediterranean.

We were reaching the end of our sixty minutes; he took us down the elegant staircase, the walls covered with paintings and sketches of theatrical events and then, without consulting a watch or a clock, but exactly sixty minutes after our arrival, led us through the main door and said goodbye. Above the door I noticed the Moorish 'good luck' sign which is stamped on all his book covers.

We were deeply impressed by his bearing, dignity and modest self-assurance; and when, a few weeks later, I photographed Moira Shearer – then a great ballet star and a well-known London society figure (the wife of Ludovic Kennedy, of book and television fame) – I told her I had recently photographed Somerset Maugham at his house.

'Oh, that terrible man!' she exclaimed. 'I can't bear him.'

'But why?'

'We gave a party recently to which I invited him. There were about two dozen guests, a lot of them well known. When I told him in the hall who some of the other guests were he was furious. "I thought I was your guest of honour.

I'm not staying." And he turned round and walked out.'

That wonderful storyteller, in my view the greatest of the twentieth century, had, as I found out over the years, many admirers but at least as many people regarded him, to my utter amazement, as a monster of selfishness.

* * *

On a business visit to New York in 1962 I followed up a letter I had on the off-chance sent to P. G. Wodehouse who, I knew, lived on Long Island, New York, in a comfortable estate near the small town of Remsenburg.

In some ways his was a kind of exile. When World War Two broke out he was arrested by the Nazis at Trouville in 1940; but when they realised how famous and popular their prisoner was they cleverly treated him with great care and finally persuaded him to speak on the radio on some totally innocuous, non-political subject such as 'Contemporary Literature'. There was an outcry in Britain. The man who had made (and continues to make) millions laugh, giggle and gurgle with delight, suddenly became a traitor.

When I looked at this tall, innocent-faced man, with his well-meaning smile, courteous and obliging, it seemed unbelievable to me that he could have committed treason against England. He could not have been more English; no-one was less likely to betray his country.

He was eighty-four at the time that I photographed him, and I commented on his remarkable fitness.

'Oh,' he said, 'that's easily explained – I do exercises. They're very simple exercises. I stretch my arms up, then sideways and out, then I bend down and try to touch my toes. I do that six times, morning and evening, and it seems to do the trick.' He demonstrated the exercises with an endearing clumsiness, then chased a black cat from his favourite chair, saying, 'I've

P.G. Wodehouse. In his early eighties he shows me the secret of his good health – the simplest, most basic of exercises. Taken on his estate on Remsenburg, on Long Island.

just got to finish the end of this chapter,' and typed away with skill and speed, stopping every so often to correct himself by crossing words out and writing others above them. Then we went in to have lunch.

His wife, who called him Plummie, was obviously very happy married to him. When I packed my things they saw me off arm-in-arm, then walked away, still arm-in-arm, a picture of relaxed contentment.

A little later the Queen bestowed an honour upon him. His innocent wartime offence was forgiven and forgotten and one could again, with good conscience, laugh at and admire P. G. Wodehouse's immortal Bertie Wooster and his ingenious butler, Jeeves.

<p style="text-align:center">★ ★ ★</p>

Bertrand Russell lived in a spacious house in Richmond, Surrey. Then at the age of eighty-three his proud, eagle-like, ascetic head could not have been better suited to a world-famous philosopher and mathematician. He was lean and neat, wore a waistcoat, and gave me much more time than I had dared to hope for. It was clear he liked being photographed. He bore himself upright, but relaxed, indicating that he would never slump over his desk.

The walls were lined with books. His eyes twinkled with encouraging intelligence and he was most ready not only to pose, but also to talk. He had written a great deal about education, and I told him that I had been brought up in Berlin and had been successful at school, but that both my children, Nikki and Jon, disliked school and their reports were pretty mediocre.

'The great thing,' the philosopher said, 'is not to force a child into a performance beyond his capability. You can't make a rose out of a cabbage, but you can turn him into a very good cabbage.'

His advice, given smilingly, with remarkably clear enunciation, has stayed with me ever since and has made my life and the lives of those near me better and happier.

Wodehouse wrote a book for each year of his life, and here he is walking on his twelve-acre estate, working out a new plot in his mind.

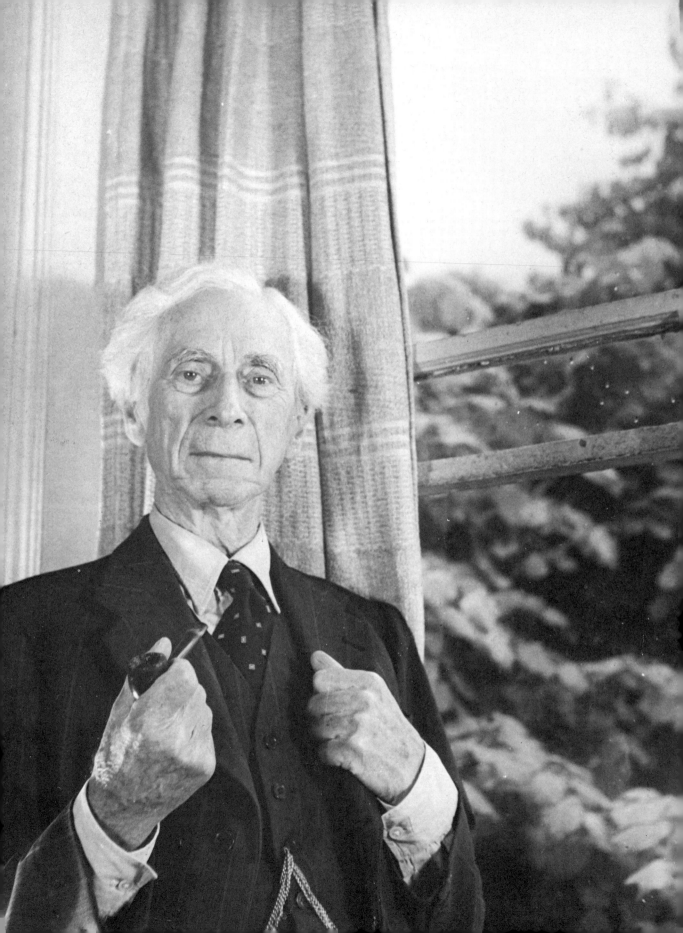

After I had taken the photographs, I discovered, in a secondhand bookshop, a volume by Russell entitled *The Pursuit of Happiness*. In it he says something which I thought most unusual and unorthodox; worth acquiring for one's own philosophy: 'The more things a man enjoys without hurting another, the better.' Whether it is football or philosophy, the more pleasures he can obtain, the more he will enjoy life. Intellectual snobbery or the notion that it is better to read a learned book than to watch a game of rugby on the television screen is all nonsense.

* * *

I photographed Daphne du Maurier at her famous house in Cornwall, Menabilly, near Fowey. Like Somerset Maugham she did her writing in a room far enough away from the main building not to be called to the telephone or have to deal with humdrum activities. In her case it was not a penthouse but a little wooden hut about a hundred yards from the house. In it was a typewriter, a chair and four walls, and through the window you could see the often turbulent sea.

The sitting room of the house was a beautiful, rambling long room with a piano, and once she had grown accustomed to being photographed she allowed me to take a picture of her with her children by her side, singing popular songs in a style that was half way between modern pop and Victorian drawing room.

Her husband, Lieutenant-General Sir Frederick Browning, who played a heroic part in World War Two, slipped in for lunch but half way through it picked up his gun and slipped out again – 'To shoot rabbits,' his wife explained calmly – obviously an ordinary everyday event.

Her hospitality was most enjoyable, direct and without frills; her down-to-earth quality and lack of airs, for one so very famous and with

Daphne du Maurier. In her working hut, her mind at work, a blank sheet on her desk. She wears tough clothes, right for the country. Here no-one will disturb her. As with many writers, the difficulty is to start. The austere simplicity of the setting, and her favourite chair, are important external help.

more than a score of successful books (many turned into Hollywood films) to her credit, struck me as totally, unselfconsciously, English. Had I not known that she was a celebrated author, translated into every language one could think of, I would certainly never have guessed it from her manner.

* * *

Malcolm Muggeridge came to my studio and was a picture of self-assured elegance, worldliness and complete individuality. He smoked incessantly from a long cigarette-holder.

He had been a major correspondent in most of the capitals of the world from Moscow to Washington; had been in the Intelligence Service during the war, and nothing in his way

Bertrand Russell. His silver-white hair, ample for a man of eighty-three, added authority to the lined, severe yet benign features of the great philosopher.

of dressing and speaking indicated that he was a man of profound and profoundly thought-out religiosity. His careful, meticulous speech seemed like a parody or caricature of Bertrand Russell and his sharp, exact enunciation, but it was nothing of the kind. He was relaxed and composed; the studio lights bothered him not at all, and his range of interests was inexhaustible – in his way, personifying Russell's recommendation that the more things a man enjoys the happier is his life. Muggeridge seemed to enjoy a polite but penetrating curiosity, and he absorbed what I told him about the running of my agency like blotting paper, each question indicating that he really had listened to what I had said, comprehending fully an area of journalism that was previously unfamiliar to him.

His smiling, urbane manner combined with religious faith, despite all the wickedness and corruption he had witnessed as a working journalist, seemed to me unique. Where one would have expected cynicism there was a most exceptional saintliness, an Anglo-Saxon saintliness, entirely down-to-earth.

<p align="center">★ ★ ★</p>

A portrait of Pietro Annigoni.

I had not heard of Pietro Annigoni until I saw the beautiful fairytale portrait he painted of the Queen, commissioned by the Fishmongers' Company, one of the wealthy guilds of the City of London. When it was first shown it made Annigoni the best-known portrait painter in Britain – although in his native Italy he had made an impact only on a select few.

I was introduced to him by the court photographer Baron, who, in connection with the portrait of the Queen, had been commissioned to visit Annigoni in Florence, where apparently they had a great time together; for both Annigoni and Baron were connoisseurs of food and drink. Baron told me that on one extravagant occasion he poured a bottle of wine over Annigoni's head. Annigoni, a thick-set powerful man, lifted up the marble-topped table on which other bottles stood and tipped them over Baron. I am not really a man to enjoy horseplay of this kind myself, but Baron spoke so warmly of Pietro Annigoni and he was so obviously a worthwhile subject for photographs that I began a correspondence with him and, after a

little while, he transferred to me the handling of photographic reproductions of the Queen's portrait because he had not been too happy with his previous arrangements. We made a fair amount of money from giving the picture worldwide distribution and such is its impact that it continues to produce revenue from reproduction in newspapers, magazines and books twenty-eight years after the painting was executed, in 1955.

When he had painted the Duke of Edinburgh, Princess Margaret, Margot Fonteyn and the Duchess of Kent, I was asked three times by British periodicals to photograph him at his Florence studio.

It is a marvellously untidy place, with what may well be the most ancient print-making machine in existence, a forerunner of photocopying equipment, on which you have to employ all your strength to turn a giant wheel, but then get a splendid black and white reproduction.

Annigoni speaks very good English, and even

better French, and dresses with total disregard for fashion. His corduroy trousers are unpressed and with them he wears a zip-up jacket and muffler. Leading from his studio is a little monk-like cell which contains his bed, in total disarray and with no attempt at order. When I first met him he introduced me to his beautiful girlfriend Rosi, who had been a fashion model and whom he had met on board ship going to New York. They married in 1976, seven years after his first wife died. Rosi appears in many of Annigoni's allegorical paintings – for allegorical paintings on Biblical subjects are what concern him most.

There is a church near Florence called San Michele Arcangelo, at Ponte Buggianesi, which is decorated throughout with giant canvases by the maestro. I went there to photograph him finishing a fresco of the Last Supper. It was a new interpretation of Leonardo da Vinci's great fresco on the same subject. I marvelled at his courage in daring to follow in the footsteps of Leonardo. He shrugged it off. The fresco was made in the manner of the Renaissance masters. Nobody paid him for it, and I heard about it only by chance when I asked him out of politeness on the telephone from London whether he had any new work on hand that I could photograph. Had I not asked, he would not have told me, nor anyone else.

By now Rosi had become a valued adviser, and it was interesting and almost frightening to see them standing on the scaffolding inside the church, looking at the various apostles, while at Rosi's suggestion he would change a nose here, an eye there, or make a slight alteration to the lips of Jesus Christ. He had brought sandwiches and a flask of coffee with him, and at an improvised table beneath the Last Supper he sat down for a light snack.

An interesting fact about Annigoni is that his fame in England spread to Italy, where previously his Renaissance style of painting had not been appreciated. In the old quarter of Florence where he has lived for many decades he is highly respected, even revered, by the shopkeepers, restaurateurs and the authorities. The proprietor of a large and popular restaurant across the square from where he lives asked him to paint a mural for him. Annigoni did so, painting himself into the picture, sitting with some thirty others, but recognisable by his broad back, on one side of the picture. He charged nothing, but in return can go and eat there and take parties of friends for the rest of his life.

When I had to return home, I asked if I could ring for a taxi.

'There's no need,' he said, 'I've got plenty of cars.' He walked down with me to the street and called across to a man getting out of his private car.

'Giovanni,' he said, 'this is my friend, Tom Blau. He has to go to the airport in Pisa; please take him.'

Annigoni himself does not possess a car but, as in this case, any of his friends and neighbours will put their cars at his disposal without hesitation or any question of money.

Pietro Annigoni tough, rugged, massive. It took a long time before his own compatriots joined the British in regarding him as one of the great Masters of painting in our time. He is a man of kindness and courtesy and speaks excellent French, very good English, but Italian of a quality almost unique in his homeland. He has written several books.

Barbara Cartland looked exactly like the image I – and everyone else – already had of her. She knew exactly what she wanted in matters of photography. The light had to be in a certain position of her choosing, and she would be photographed only with her furs round her neck, smiling with doll-like eyes straight into the camera.

She was a generous hostess and quite unexpectedly provided lunch for my journalist companion and myself at her luxurious home, Camfield Place, at Hatfield, Herts. During lunch she pressed vitamins upon us by the fistful. There was no way of declining. She was so forceful and determined to do us good, and convinced that everyone should take lots and lots of vitamin pills of all kinds ; and equally lots and lots of honey. She steamrollered us into complete subservience and I and my companion, the deputy editor of the magazine *Everywoman*, herself a pretty determined and outspoken lady, simply had to do as we were bid.

Not for one moment did Barbara Cartland cease smiling. She smiled all the time, as if her face was frozen or sculpted into imperious yet slightly condescending kindliness.

* * *

A short, slightly plump lady dressed modestly, inconspicuously and with an apologetic air of intruding – that is the impression Iris Murdoch makes during the first five minutes of meeting her. Once she had settled down, and I tried to bring her into a conversation, she relaxed a little. I told her that when I asked Shirley Williams, who had been to my studio before, about contemporary writers, she mentioned Iris Murdoch as one of her favourites, and on this she thawed. Not that the thaw created a flood of talk; her reserve and perhaps also her distrust must be the build up of a lifetime, and the notion that within the four walls of the studio everyone relaxes, feels comfortable and willing to engage in real talk, is of course the irrepressible illusion of most photographers.

I think Iris Murdoch relaxes only with the typewriter or with very close friends. It would be far-fetched and unrealistic were I to claim that I had the feeling of being in the presence of a great contemporary writer. Many people of depth and imagination have faces and body structures that will not reveal even the most original and profound personality; they hide in the anonymity of appearance. The pudding-basin pageboy hair style which makes her round face look even rounder, seems part of the camouflage to hide her inner self from others, but her eyes are quick, observant, sharp, and powerfully independent and intelligent; and she has not an ounce of arrogance in her.

Among present-day Greats of Literature, Iris Murdoch has succeeded in remaining an intensely private person. I had the impression that if I had had the opportunity of meeting her on five or six different occasions, the wall of reserve she carries with her might have melted a little more. When, after an hour's sitting, she left my studio, I had come to warm to her withdrawn manner, but I felt objectively that I could not have done full justice to her.

I sent her the prints for approval. To my total surprise, she wrote me a most friendly and generous brief letter in which she described the pictures as 'a really good lot'. I would not have quoted so flattering an observation but for the fear that my portrait, might be regarded as sub-zero.

I frequently think what a pity it is that no photographs exist of the heroes of old times; maybe their faces were as difficult to read and hid their true personalities as readily as Iris Murdoch's face conceals her internationally acclaimed genius.

* * *

Robert Graves could either be an ancient Roman gladiator or a poet. His face is rugged with a nose that looks bashed in, blue eyes which readily smile but indicate an impenetrable mind; the ensemble is a head you would expect to see among Greek or Roman exhibits at the British Museum or the Ashmolean at Oxford. He is deeply steeped in knowledge of antiquity and speaks of the Ancient Greeks and the Romans as if they were contemporaries liv-

Robert Graves swimming into a ripe old age.

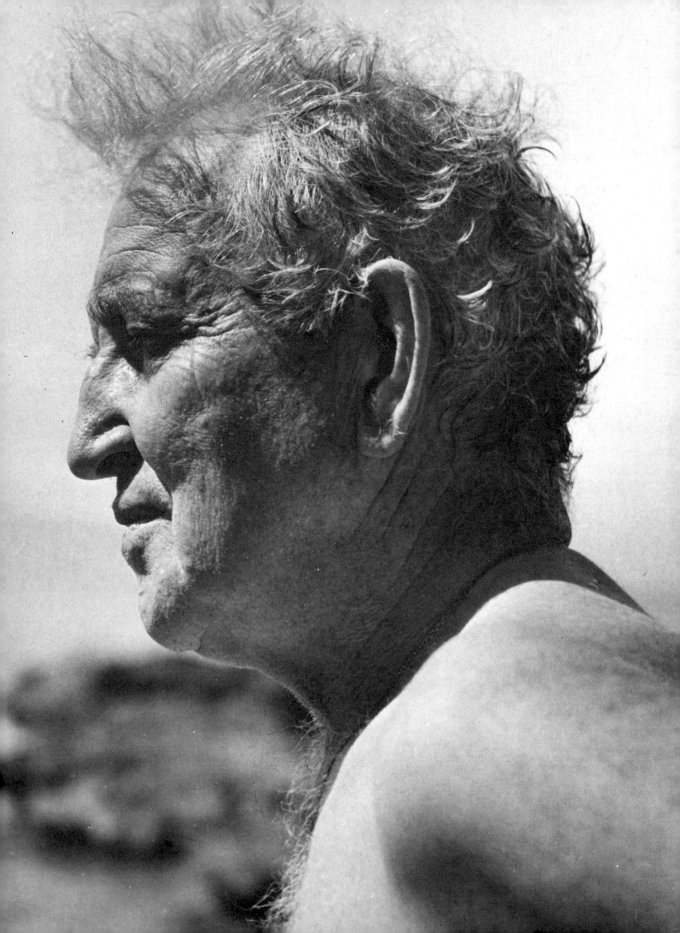

ing just around the corner. His intimate knowledge of things as they were a thousand, two thousand or three thousand years ago, is almost humiliating and made more so by his way of speaking. He mumbles; and having mumbled the first part of a sentence, he thinks it is an insult to your intelligence to complete the sentence as of course your knowledge equals his, and it would be boring at any time to say in full what is self-evident among two civilised people. Thus it is that much conversation with Robert Graves is a monologue. You are trying all the time to catch what he is saying, as he jumps from the Old Testament to civic affairs in Athens or Rome. He dislikes the Romans for their roughness and cruelty, and has a surprising range of observations to make in regard to passages in the Old Testament which he assumed I knew inside out. He referred, with a giggle, to the angel Tobias, which indicated goings-on in the world of Jewish angels I had never suspected.

'It is perfectly obvious, what else could they possibly have been up to!' He then quoted verbatim, but in his polite throwaway mumble, a passage to support a theory that angels are not all they are cracked up to be.

This was on a walk to a pub some miles away from his beautiful spartan house at Deya where he lives, on the island of Majorca. He walked fast, was dressed in shorts and a brief open-necked shirt; I could barely keep pace with the man who was then seventy-one and exuding health and strength. He had asked me and my family to a luncheon at a country inn; it was paella – with sparrows; the sparrows appeared undisguised, simply fried, and diminished all appetites abruptly – except his.

'Don't go back to your horrible hotel, I have a second house where I entertain my guests, come along and I will show you.' We were flattered and delighted and followed him breathlessly up a stony road until we came to a neat little house which, on inspection, proved to have no running water, just a pump in the garden and no sanitary facilities whatsoever. The walls were lined with books, the beds were hard, and the kitchen held an old iron stove and a table with a few chairs. We politely declined; he was not offended but clearly thought us damned silly.

In his study and before he resumed some work that was urgent, he showed me a collection of oddities, among them dried-up Mexican mushrooms, which he explained were the forerunners of modern drugs, and widely known in the Middle East, and of course in South America. Among the odd and rare collection was a little silver bell made in Nigeria. 'What is it for?' I asked.

'It is a rain-making bell.'

I laughed. 'You don't really believe that?'

'Of course I do.'

'Could you make rain now?'

'I could, but I wouldn't. I would if there were a serious drought. These ancient things are not to be trifled with. They have a power we don't understand, outside logic and human comprehension; but they work.'

He smiled at me, forgivingly, then sat down amidst ten opened reference books, and began to write in long hand, stopping every two minutes to check his references. I and my family were still his guests, we could do what we liked, eat what we found (not much), or go to the devil.

He was cheerful, serene, mysterious and powerful; not quite like Zeus but like one of that ilk.

CHAPTER 7

Actors & Musicians

WHEN THE BEATLES became very famous, I was asked to handle photographs of them on which they owned the copyright. A great deal of business developed in the course of which their press officer, Derek Taylor, managed to arrange for me to photograph John Lennon and Yoko Ono, and later on Ringo Starr. These were intriguing encounters with people who had then the most famous English names in the world, apart from William Shakespeare and the Royal Family.

John Lennon and Yoko Ono had an estate near Ascot, Berkshire, an hour's drive from London. I arrived with my assistant. There were a dozen people in the kitchen, eating and drinking in an atmosphere of chaos and affluence. For a long time no-one took any notice of us. Finally a message was sent up to John and Yoko, who were still in their bedroom at noon. Back came the reply, 'No thanks.'

Fortunately Derek Taylor arrived and produced the couple, after a further hour's delay. They were completely indifferent to the camera, in fact John said, 'Stills? I'm not sitting for any f . . . stills. I thought you said it would be a film!' But eventually we got going.

I had my light fixed in a large empty room with only a piano near the far end. Above the fireplace, there was an enormous life-size photograph of Lennon, Yoko and a friend posing in full frontal nude; and along a high ledge on the walls all round the room were starkly erotic and pornographic drawings of sexual activities. I asked the couple to sit at either end of the longish seat in front of the piano, then (by

now they were quite obliging and responsive) I told them to look at each other, fall in love and move closer together, inch by inch, until they met and, on meeting, kissed. A very strange thing happened. They so entered into the spirit of this tiny 'plot' that their excitement and anticipation as they got nearer to each other became electric. She gazed at him with devouring devotion and when they were nose to nose in sharp profile to me, she was stunningly beautiful, although she is not beautiful at all under normal circumstances; the lights and the creeping excitement simply transformed her. She looked not only beautiful but noble, with an air of Japanese aristocracy and, for the first time, I could understand what had puzzled millions of Beatle-worshippers: why it was that this immensely talented and by now immensely wealthy young man should be the husband of this little Japanese woman who was clearly a good deal older than he, and devoid of that easy charm so many young Japanese girls have. The secret was that he was her total master; she was his total slave. Her face reflected the truth that nothing mattered to her but his wishes. It was clear in the photographs that he was her god and that she revelled in being his slave.

They then, after a suitable cool-off of five minutes, did all manner of crazy but photogenic things; they walked, ran, lay on the grass, stood against a wall, fired by a weird fascination. This went on for another hour and then, without a word, they vanished into the house. The only words spoken throughout were my requests for them to do this or that. They obeyed without

acknowledging my presence by so much as a smile or a goodbye.

The picture sequence of the kiss produced more publications than almost anything else I had ever done, and I felt elated that from such an unpromising start after a long and apparently hopeless wait, such useful and intriguing results should have developed.

* * *

Ringo also had a large mansion with a lot of ground surrounding it, called Brookfields, near Elstead, Surrey. He was vastly more co-operative and entirely natural. There was unmistakable elegance, even dignity, in this slight, bearded figure who, from having been a plumber's mate, had become the world's best-known and most highly paid drummer, eventually composing Beatles' songs of his own. He was relaxed in conversation and told me he wanted to become an actor when all the Beatles fuss had died down; and he undoubtedly had a remarkable range of facial expressions. I put him into many situations, for example: 'You are about to be received by the world's most beautiful woman;' 'You are wearing a priceless ring given to you in appreciation of your music by the Aga Khan;' 'You have grown a rose named after you, and are now delicately breathing in its fragrance.' To each suggestion he reacted promptly and by no means always foreseeably; it was clear that acting came to him naturally.

Ringo Starr. Formerly a plumber's mate, then the world's best known and most highly-paid drummer. Ringo has refinement, sensitivity and acting talent in his blood.

BELOW
John Lennon and Yoko Ono. Slowly, unhurriedly, their faces draw closer.

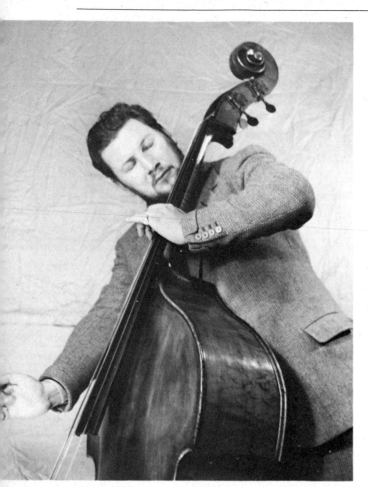

Peter Ustinov on the double bass – the delicate touch for the pizzicato.

trombone, smiling obliquely like a fat Bavarian peasant who has just outwitted a rival. He played the piccolo flute with such delicacy, as if he would float away. For each instrument, and without a moment's hesitation, he found a wonderfully funny and typical expression that was his own interpretation, quite unpredictable and totally irresistible. I then asked him to act the part of the conductor, which he did, with drama, diplomacy, persuasiveness, contempt, utter satisfaction and total dejection. Finally, I suggested he should be a music critic. For this he sat astride a chair, one arm leaning on the back of the chair, expressing delicately and venomously how he despised what he had heard and seen and how he was physically offended and wounded by every note of music played: comic, totally novel and unrehearsed reactions which came with effortless ease. He was so funny, it was difficult to control the camera.

* * *

In order to photograph a conductor at work, you must have permission to sit in with the orchestra and I was able to do this when the great Furtwängler came to London.

As he conducted he swayed himself hummingly into a trance which, at the Wagnerian crescendos, actually produced foam on his lips. When the rehearsal was over he all but collapsed; very different from his great contemporary, Bruno Walter, who appeared in front of his orchestra in a black pullover and was a Mozart specialist. He was especially devoted to delicate pianissimo sequences and as his face and his baton implored the players to play yet more softly his expression was of sublime happiness – but there remained always just a tiny frown of discontent. It was said of him – though I didn't witness it – that on one occasion the orchestra, tired of his demands for a particular passage to be played softly, more softly and still more softly, all stopped making a noise at a prearranged moment, though they appeared to continue to play. Walter rapped his baton on the rostrum.

'Gentlemen,' he said, in that slightly guttural Viennese accent, 'that was superb; but once again, just a little more pianissimo.'

* * *

But when one talks of acting and range of expression, no-one can be more expressive and side-splittingly funny than Peter Ustinov. I met him at a time when I was doing a number of assignments for *Everybody's Weekly*, a periodical which was enormously popular in England for many years. They wanted pictures illustrating the 'range' of Ustinov and had hired the instruments of an entire orchestra from the Guildhall School of Music, where the photographs were taken.

In front of the camera he became First Violinist, Second Violinist and Third Violinist. The first soared with ambition, the second was eaten up with envy of the first and the third was downtrodden and resigned. Then he blew a

Among great actors I met Anthony Quayle first when, by invitation, he came to my studio. He is a big, well-built man with a strangely baby-like face and that obvious actor's ability to react to every suggestion made to him in precise detail. He was in his element when I proposed to him that he was a Roman general on horseback on a hill overlooking the city where battle was about to be joined. He narrowly observed the scene from his point of elevation, then saw where there was a chance of unopposed onslaught for his cavalry. His nostrils flared, he reined in his imaginary horse and turned to the horsemen massed behind him, imperiously giving the signal to advance. His face, from being that of a discontented baby, completely changed to that of an imperious, fiercely determined warlord, in which cunning mingled with drive and willpower.

'That felt good,' he said when I had taken the picture. His face had relaxed, this time not back to the discontented baby but to that of a little boy of about three.

Shortly afterwards he became a director of the Royal Shakespeare Theatre at Stratford-on-Avon, and I took a series of photographs of the theatre and some more pictures of Mr Quayle. His hobby in his spare time was to take a canoe and paddle along the delightful River Avon and I accompanied him on this day. The canoe was lodged in a locker from which we had to pull it, and then drag it perhaps thirty yards to the edge of the bank.

While we were doing this the telephone rang indoors and he said, 'Just hold on to it for a minute' – and left me holding the little boat, which was so heavy that its weight made me wobble at the knees. He was gone for some time, and when he came back saw my suffering written all over my face.

'Oh, I'm sorry,' he said, and took the ten tons off my shoulders, tucked them under his arm and, at a leisurely pace, carried the canoe down to the river himself. Not only a great, but also a very strong, actor.

* * *

Peter Sellers was a fascinating subject to photograph and to represent as a photographic sales agent.

As a result of many letters of application, he finally agreed to let me visit him at his flat in Clarges Street. I hardly recognise him in the descriptions I have read in books and articles since his death. In Alexander Walker's book he seems to have been a most appalling person – moody, unpredictable, liable to spend enormous sums of money on the spur of the moment, and completely insecure. He did not strike me like this, although there is no denying that alongside his amiability he could be difficult and, on one occasion, surprisingly unreasonable.

When I met him in his luxurious flat he was excruciatingly funny. I asked him to show me how he kept fit. It turned out that he had a portable, collapsible outfit that could be fixed up in any doorway, and enabled him to do exercises, pulling himself up a dozen times or so. He also did press-ups and then, in comic

Peter Ustinov after the concert – the musical critic.

despair, threw himself upon his double – almost triple – bed to illustrate his exhaustion.

He showed me a fantastic array of cameras and photographic gadgets, and then allowed me to visit him on the set at Boreham Wood Studios, where I photographed his then four-and-a-half-year-old-daughter Victoria, dancing on the bonnet of his Rolls Royce. She scratched it with her shoes; he came out to watch me taking pictures and spotted the scratch immediately, but was simply too nice to say anything about it. He was charmingly and delightfully in love with Victoria. But I think his forbearance was also due in part to the fact that only a week or so before I had obtained for his own photographs a full front page on the *Daily Mirror*. This, he told me, was up to then the highlight of his photographic career – and he was jolly lucky that this particular publication occurred.

He had been invited to photograph the Royal Family who, it appeared, were fond and appreciative of him. He took several spools of pictures and when he got back to his flat rang me in great excitement. Would I come over in an hour and a half, by which time both black and white and colour films would have been processed?

When I arrived he was in a state of ecstatic excitement and gave me a shot-by-shot account. A ring at the door, and the processed films had arrived. The black and whites were hopelessly under-exposed (like Tony Benn's pictures of China, see page 104) and practically transparent. The colour, on the other hand, was almost entirely black, and you could see the pictures only by holding them close to an electric light bulb. His disappointment was heart-breaking. I showed him that we could convert the colour, despite the density, into black and white, and three hours later returned to his flat in Victoria with the black and white conversions. Fortunately it had gone fairly well and from deep depression his mood changed to jubilation. He was convinced the Royal Family would love them, but two days later he was

Peter Sellers. When I asked him to show me how he kept fit, he fell into wonderfully ludicrous attitudes and here is one.

informed, ever so gently and courteously, that the pictures had given much pleasure and one – only one! – had been approved for press publication. This one showed the Queen Mother with Prince Charles, and was the one that the *Daily Mirror* printed on the front page, with generous acknowledgement to the photographer. The occasion was the Queen Mother's seventy-fifth birthday, and the picture was in competition with some splendid photographs of her taken by Norman Parkinson. To have achieved so prominent a publication against one of the great masters of photography was a triumph indeed.

I was of course delighted, especially as on a previous occasion he had sent me some pictures from Switzerland with imperious instructions, conveyed by Theo Cowan, his personal representative, that these photographs of Julie Andrews should appear on the cover of *Queen* magazine (which later became *Harpers & Queen*). He also intimated that he was a personal friend of Jocelyn Stevens, then owner/editor of the magazine; but when I looked at them I saw that the chances of success were absolutely nil for a cover and very slight for use inside *Queen*. None the less, I took them myself to Jocelyn Stevens, the marvellously enterprising and good-humoured editor, who functioned so decisively among people of languor and elegance. He looked me full in the face and said, 'How can you possible offer these for use on the cover? Are you mad?'

I passed this on, via Theo Cowan, to Sellers.

'He won't like it, you know,' said Theo, shaking his head despondently. 'He's very keen to see them on the cover, and he'll be very angry with you.'

Peter was, and it was a long time before he came back to me. By then he had become a very competent photographer indeed.

* * *

Cary Grant was staying at the Connaught Hotel with his third wife, Betsy Drake. He was quite remarkably fit-looking and handsome, but like other actors and actresses I have encountered, very clear about how he would not be photographed.

'You mustn't photograph me from below, looking up,' he said firmly and, with that, took up a kneeling position so that the camera could look down on him. 'It's the bags under my eyes,' he explained with smiling candour. He also hated the notion of my wanting to take a formal portrait, but finally yielded when I promised to show him all the pictures I took.

He enquired about my work, and I told him that when I photographed people of interest and importance like himself I gathered my wits and mustered my resources by saying to myself silently during the last three or four minutes before the appointment, 'I'm going to make a *superb* job of this!'

'What was that?' he cried excitedly. 'What is it you say to yourself?'

I repeated it. 'Betsy,' he cried, 'come in here, meet Tom Blau. Do you know what he told me? Before he goes on a big assignment he says to himself, "I'm going to make a *superb* job of this!"' He turned to me, his eyes shining with appreciation and admiration. 'That's *fantastic!*

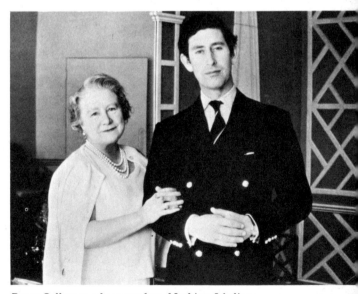

Peter Sellers as photographer. Nothing I believe gave him more pleasure than to see this photograph of the Queen Mother and Prince Charles on the cover of the Daily Mirror. *The great Norman Parkinson had portrayed the Queen Mother in some splendid new close-up studies but Peter Sellers got the cover! Technically the picture did not do him justice, it was a conversion into black and white from a badly exposed colour. But nothing succeeds like success.*

Would you mind very much if I use the same formula?'

'Be my guest,' I said; and all went well and ended happily.

* * *

For a run of five years I took my wife and two children to a delightful hotel in the north of Majorca, the Formentor. There, as it happened, I met and photographed quite a number of interesting people, among them Tom Jones, hairy-chested and handsome, with his pleasantly uncelebrated wife and his huge son; and also Norman Wisdom, at that time a most popular and active film star, often described as a new contemporary version of Charlie Chaplin. He played 'underdogs' – characters who were disadvantaged by fate, mainly because they were so small.

Norman Wisdom, however, was not merely small, he was also very athletic and kept himself in very good trim by doing physical exercises, especially weight-lifting, on a platform provided on the hotel's private beach. He would go there for a work-out every morning.

I had taken some photographs of him and his family and we had struck up enough of a friendship for me to ask if I could go along and watch him lifting weights. He had no objection and, out of curiosity, I tried to lift one of the weights myself. To my amazement and I think to his slight chagrin, I managed quite well. My son Jon, a big strong lad then aged eleven, watched us, came over and without further ado picked up the heaviest of the weights and effortlessly raised it above his head. All I could do was ask Norman to come and have a drink with me; the delicious pure orange juice available at the restaurant bar soothed his vanity a little.

* * *

I had first met Laurence Olivier when he was married to Vivien Leigh and lived at Durham Cottage in Chelsea. She was unbelievably beautiful, with the elegant fragility of Dresden china.

The photographs I took then were conventional, but that was what the women's magazine had required and there was not much else that one could achieve because they had been very reluctant to be photographed at all. So I moved the couple from the fireplace to the desk where she was consulting him about a script, and then to the staircase, with her looking over the balustrade of the minstrels' gallery, which was a pleasing feature of the house, and him looking up to her in a sort of Romeo and Juliet pose. Then I had them looking down into the camera from a flight of steps above the sitting room.

It had been agreed that nothing should be used without their consent, and two days later, by appointment, I arrived to submit my photographs. I was ushered into the sitting room, by the fire, but it was ten minutes before Sir Laurence appeared. He was coming downstairs, obviously extremely shaken and perturbed. He sat down, tragically, and I enquired about his wife. It was clear that she was ill and to judge from his face her illness seemed most serious and dangerous. He leaned towards me, his face and voice filled with despair and hopelessness.

'She has a sore throat.'

I dared not smile until I was outside.

I met Sir Laurence again, this time at the Formentor Hotel in Majorca. He was now with his third wife, Joan Plowright, and as I approached him he recognised me and said, 'No photographs, my dear fellow, I have already sent away half a dozen photographers from *Paris Match*, *Life* and *Epoca*. I'm really here privately and on holiday.' And that was that. But my dear wife, who was very skilful in such matters, met him on her own at the bar, and as we both had our children with us there was some conversation on the beach. I observed Olivier in the water playing with his children, and it looked really delightful. He would carry his little daughter on his shoulders and then sink down and come up, spewing water at them amidst much laughter in a truly relaxed family atmosphere.

Sir Laurence Olivier with his son Richard, aged three and a half. The occasion, the beach at the Formentor Hotel in Majorca, year 1964. Olivier was then fifty-seven years old, relaxed and utterly happy in his third marriage to Joan Plowright. I promised to use the photograph only for one publication, and obtained Sir Laurence Olivier's permission for it to appear in this book.

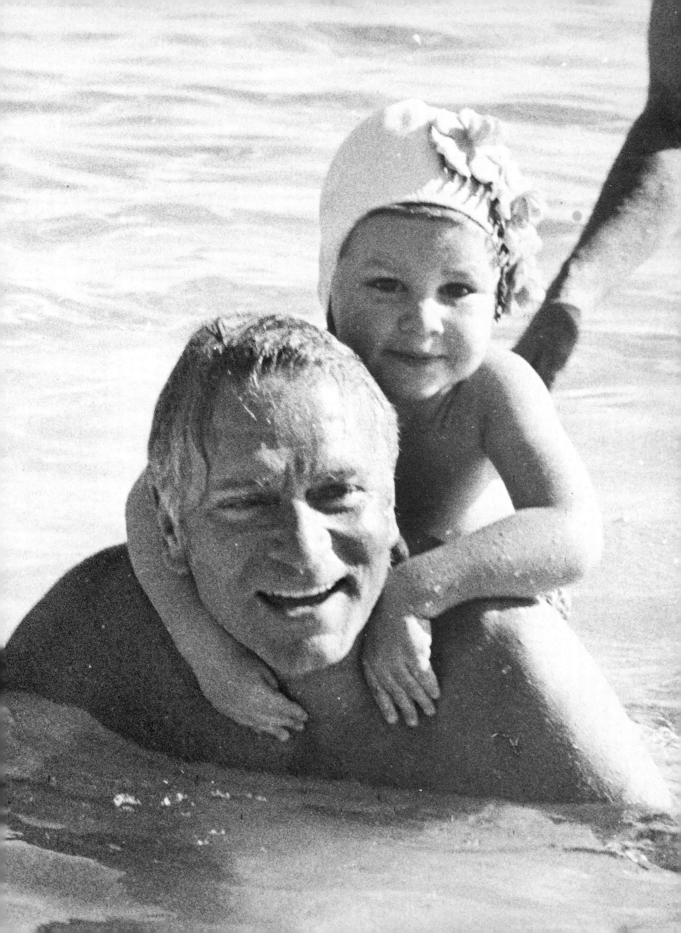

I plucked up the courage to go over to him and say, 'There will never be an occasion to take photographs of you again with your children so young and attractive. Do please let me take some pictures – not for publication, but for your own family album. What was happening while I was watching just now was too charming, photographically, to ignore.' I repeated that I really only wanted to take the pictures and give him the undeveloped films. There was no question of publication. He was quite incredulous, but Joan Plowright supported me, and I took four spools of pictures. Then they came out of the water, and I passed him the films. He hesitated.

'That's very generous of you. Look, we'll just go over to that boat and pose for a few pictures you can use for the papers.'

But of course, though they tried, I could not match the atmosphere of the earlier pictures, and after three or four exposures I told them I didn't really want to take posed pictures and that I was delighted he had let me take the ones which, I stressed again, I was happy to give them for their private collection. His wife spoke to him, and he turned to me and said, 'Oh, heck, I don't know why I should be so severe. I think these are likely to be very nice pictures – go ahead and use them.'

Of course I was overjoyed and told him they would more than pay for my family holiday, and that the pictures would go worldwide and produce a lot of publications.

Had I been wise I would have packed and flown home right there and then, but we had two more days to go and it just didn't occur to me. An hour later he strolled across to me again. 'You will let me see them first, won't you. My waistline isn't exactly what it ought to be, and I mustn't let my followers down.'

I took the four spools to the airport immediately by taxi, to send them to London by air-freight. I telephoned my office and by great good fortune had contact prints and enlargements back the next afternoon. Sir Laurence was impressed and pleased. He passed them all except one, but in passing them said, 'But only for one publication, not for distribution throughout the world or else I'll have no end of trouble shaking off other photographers. The pictures are very nice, but please promise, only one publication in one newspaper or magazine.'

What could I do but agree?

He stopped a little longer. 'Where do you think they might appear?'

'Anywhere,' I said, 'Life, Paris Match, the Sunday Mirror.'

'The Sunday Mirror?! They don't even know I exist.'

I laughed.

Next day on our return to London I took the pictures to the editor of the Sunday Mirror and told him that I could offer the set for one publication only in all the world, and I doubted if he would be willing to pay as much as Life or Paris Match. We made a deal for 1,500 guineas – it was 1960, when that was a very respectable sum of money, and certainly at least four times as much as the Sunday Mirror had paid for anything from my company before. To Sir Laurence's great and astonished amusement, the pictures were published on the front cover and two centre pages two weeks later.

For the picture published here I obtained Lord Olivier's special consent.

CHAPTER 8

Lord Snowdon

WHEN, RECENTLY, I bought a bottle of apple concentrate at the Danish Food Centre in London I was intrigued by the claim on the label that one part of it required nine parts of water to make an agreeable drink. Concentration of this magnitude is rare; it made me think of Lord Snowdon.

Snowdon is the most compact and single-minded person I have ever come across – not that it shows immediately. You have to know him fairly well before you realise the astonishingly steely willpower hidden underneath his kind and friendly manner. The unusual compactness of his personality must be in his genes, because both his children from his marriage to Princess Margaret and the little daughter of his second marriage look very much like him, and not like their mothers.

There are many self-made men who succeed. Tony Snowdon, in his way and field, has outdone them all, and continues to do so. It has been said of him that his unique standing in the world of photography is due indirectly to his having suffered a severe attack of polio while at school at Eton at the age of twelve. Polio at that time, in the early 1940s, was often deadly; the medical profession had not found an answer to this terrible disease. It must have been sheer determination that enabled Tony Armstrong-Jones (his name until 1961, when he was created first Earl of Snowdon) to recover. The only indication left was the slightest of limps, which he concealed amost entirely.

No-one who worked with him could – or can – work as hard and continuously. His assistants secretly complained to me about his driving

Tony Snowdon behind the camera.

The Earl of Snowdon and Tom Blau. This was taken when I flew out to Cologne where Tony had an exhibition – the Fotokina Exhibition in Cologne in 1972. He was evidently quite pleased that I had turned up to give him moral support but he needed none; his show was the triumph of the huge international exhibition. No other photographer there had put in anywhere near as much personal care. Tony held back a huge crowd in order to remove a blemish from one of his pictures.

With his toughness of purpose, attention to detail and refusal to accept anything less than what he regards as perfection goes a most urbane manner. He is witty, entertaining and has a near-professional gift for imitating the voices of other people. When he does this he can carry on for minutes, improvising the kind of phrases that person might use. He and Peter Sellers were close friends and would amuse each other endlessly by improvising dialogue.

I first met Tony when he was a photographic apprentice at the studio of Baron, at that time the favourite photographer of members of the Royal Family. I recall a party at Baron's studio in Brick Street, off Park Lane, with many distinguished people, mainly actors and actresses, as guests. Some, among them Peter Ustinov, improvised entertainments, and Tony had been asked by Baron to take a few flash pictures for possible use in one of the Society glossy magazines. It was a tough job because the place was so crowded, people were sitting all over the floor, but Tony, who was then in his early twenties, brazenly walked into the thick of the crowd using an open flash. His artfully innocent smile was so disarming that those who wanted to protest were simply unable to do so. This ability to do a job in difficult circumstances and yet remain friends has stayed with him. There is nothing he dislikes more than pomp and pretension and he is quite expert at puncturing it.

While he was still Tony Armstrong-Jones, known for his enterprise and boldness, he achieved a unique scoop. Being at that time on a loose retainer with the *Daily Express*, on election night in January 1957, he rang the bell at No 10 Downing Street, where to gain audience with the Prime Minister one must overcome the tough and sceptical opposition of two policemen outside the door and then a variety of hurdles inside. Few manage it. Tony, then twenty-seven years old, browbeat them all, by sheer personality and firmness, to be conducted to the Prime Minister's study, where he found Harold Macmillan slumped in the corner of a sofa and clearly a good deal the worse for drink, watching his electoral triumph on television.

perfectionism, which never accepts second best. He drives himself even harder than those who work with him.

One of his first overseas exhibitions was in Cologne in 1972. It was called 'Assignments'. Overall the huge exhibition contained intriguing displays of the work of many photographers and cameras but Tony's section, which he had himself designed, was far and away the most successful part of it. I flew to Cologne to be present at the opening, and hoped to have dinner with him the night before. He was not at his hotel, but at the exhibition hall, hanging every picture himself, retouching there on the spot large prints where there was the slightest blemish, and sweeping the floor; and when the public was admitted every aspect was in a state of perfection.

Snowdon in Venice. The graceful shape of gondolas.

Tony entered the room, photographed him and ran back to the *Daily Express*. They didn't want the picture! It was beyond belief, and I sold it easily later that night to the *Daily Mirror* for an impressive fee.

I well recall another occasion in November 1961 when Tony rang me around midnight to ask, tongue in cheek, if I thought anybody would be interested in a picture he had taken earlier that day of Princess Margaret and their baby son – the first to have been taken. It was of course a major sensation, but much too late for general distribution to all the papers, which are normally printed by 11 p.m. at the latest. A cab took me to the *Daily Mirror*; they had just moved into their new skyscraper building at Holborn Circus. I had, of course, warned them, and in the traditional manner they 'held the presses' and cleared a big space on the front page. I ran from the cab straight into the new plate-glass door which, in the excitement and rush, I had not noticed. The doorman rushed out because he heard the thud, but stunned, and on the point of collapse, I managed to stagger to the lift and up to the Picture Department on the third floor, where all at the Picture Desk were waiting for the picture, literally with bated breath. The collision with the glass door had left me bereft of speech and pale as a ghost, but no-one took the slightest notice – all they wanted was the folder containing the print. I sank into a chair and after repeated efforts was able to murmur, 'Water!'

Long before his marriage to Princess Margaret he had aroused and intrigued gossip writers. He was in fact so popular and well known that I was commissioned by a magazine to take a series of photographs of him at work, and did so at his studio in Pimlico. It was a particularly opportune moment because – and this is an indication of his artistic gifts – Tony had designed a whole collection of women's clothes, all in leather, long before it became chic, and then commonplace, for women to wear this originally somewhat unwieldy material. He drew all the designs and Kiki Dee, who had a boutique in Chelsea, produced the clothes from them. I took pictures of Tony photographing these fashions of his own design. He then became too busy with photographic assignments to pursue his unmistakable talent for fashion design any further.

When his marriage showed signs of breaking up Tony came through almost unscathed. His loyalty to friends who had *not* sold snippets of information about him was tremendous. Throughout the marriage he continued his life as a professional photographer; he had never been overawed by palatial surroundings. Once, shortly after he moved into Kensington Palace, he observed, 'I used to eat much better without all that cutlery they have here.' He occasionally asked me to lunch there and we usually had scrambled eggs in a room adjoining the kitchen.

From his study at Kensington Palace a door led to his private toilet where, to my astonishment, I saw a picture on the wall of Tony stripped to the waist as a member of the Cambridge University boxing team. It turned out

Tony Armstrong-Jones was a most likeable young man. His face reflects intelligence, boldness, enterprise. In addition he had a mocking wit and an extraordinary gift for speaking in tongues – namely the tongues of well-known people especially anyone pompous and ponderous. Underlying all this was a strong sense of reality and of loyalty to his friends.

that, as well as being cox of the Cambridge rowing crew for the annual Oxford/Cambridge race, he was also a competent boxer. With the limp he had from boyhood, due to polio, that seemed to me a great achievement.

But he likes to use his hands, not only in boxing and photography. His mechanical and engineering skills, the desire to make things himself, to invent and work out the practical details of his inventions, have always been a major characteristic. Some time after Tony had left his premises at No 20 Pimlico Road, in May 1961, we agreed that I should take them over. He left me a marvellous studio with a system of powerful but soft lighting (a grand battery of about fifty photographic floods which could be softened by degrees with layers of transparent paper) and also a most unusual spiral staircase. He had built the lighting equipment and the staircase with his own hands.

At times he would invite me to breakfast, with his enchanting Trinidad-born Chinese girl-friend, the actress and dancer Jackie Chan, whom he treated with affection and tenderness. She had the extraordinary gift of sitting motion-less, knees pulled up to the chin and folded arms around them, without making a sound. But if anything was needed she sprang into action instantly. She was petite and beautiful. She could have made a fortune talking to the press when Tony married the Princess. Not a word did she ever utter.

I was unable to keep the studio for long because it was being watched from a pub across the road, and from a flat. Every time anyone of note came to the studio these paid informers would telephone a daily newspaper to say that so-and-so had just entered the Armstrong-Jones studio. It was an indication of how much he was in the news, and a favourite subject of London gossip columnists. When, after a year or so, I moved out, Tony made it a condition that I return his hand-made staircase to him.

Snowdon photographs, whether they are in the form of a reportage or portraits of interest-ing people, are of quite extraordinary appeal throughout the world, and his masterly studies of Prince Charles and Lady Diana Spencer before their marriage, of Princess Diana's twen-tieth birthday and of the Prince and Princess of Wales with their baby were world scoops of

Snowdon as photo-reporter. He visited Japan where he took this remarkable picture of the Sumo grand champion having his hair washed by apprentice wrestlers.

almost unprecedented magnitude. But he was world famous already through the much earlier photographs he took of Prince Charles and Princess Anne and their parents, the Queen and Prince Philip, on a bridge overlooking a stream in the garden of Buckingham Palace, and nine-year-old Charles and Anne, aged seven, on the bank of the stream. The composition of this picture – and also another showing Prince Charles and Princess Anne beside a giant globe

– entirely broke the mould of previous royal photographs, and made Tony Armstrong-Jones instantly respected and admired everywhere.

Over the years Snowdon has evolved a classical simplicty, and the gift of lighting his subjects with exceptional skill. If it were not for the fact that he has an exclusive contract with the *Sunday Times* his photographs would be on the covers of the entire magazine press in Britain. Only his royal photographs are available for general distribution. The one exception to the *Sunday Times*'s exclusivity is *Vogue*, who often assign Snowdon and publish his work on many pages. Whenever he has work that he wants me to distribute worldwide he shows me the pictures and asks timidly, 'Do you think anybody might be interested?' Of course I reassure him, and the publication results invariably reflect how highly he is regarded by top magazines everywhere, even in deepest South America. He has achieved an economy of means somewhat similar in style to that of the great twentieth-century French painter Matisse.

He made a most impressive success in invading the world of TV films. The first, in particular, entitled *Don't Count the Candles* which dealt with old age, showed how deeply he felt for the handicapped. Another enchanting and unusual film was *Born to be Small* about midgets. It showed a community of some 2,000 people who only grew to Lilliputian height but nevertheless pursue an astonishing range of occupations: a surgeon, a solicitor, a pop-singer and a tiny button-maker who had to climb up steps to be able to sit on an ordinary chair. These films, including a third one, *Life of a Kind*, about eccentrics and lonely people, gave vivid expression to Tony's sensitivity and compassion.

His inventive skill was exhibited when he designed a novel wheelchair for invalids, which he had produced, with many practical ad-

The work of Snowdon. Lady Helen Windsor. This was another sensational departure from Royal portraiture. It was published all over the world and had a revival in 1983 when a totally unfounded romantic rumour linked the name of Lady Helen Windsor with that of Prince Albert of Monaco.

vantages of his own devising. Another time a close friend of Tony's, Harold Keeble, had suffered a serious car accident and had to lie in bed unable to move. Tony invented a marvellous reading stand which, through ingeniously applied light magnetic plates, enabled Keeble to turn the pages and keep them firmly in place while he was reading lying flat on his bed.

Snowdon is not always easy to work with. I recently had an offer for him to take a portrait for a European magazine, and it was an exceedingly generous offer. It was also an interesting job. 'Sorry,' said Tony immediately when I mentioned it to him on the telephone. 'I'm working on a new book and until it's finished I can't accept anything else.'

The work of Snowdon. An engagement picture like no Royal engagement picture ever taken before. A smiling Lady Diana has her arms round happily smiling Prince Charles. It broke a tradition for Royal photographs established since the beginning of photography itself.

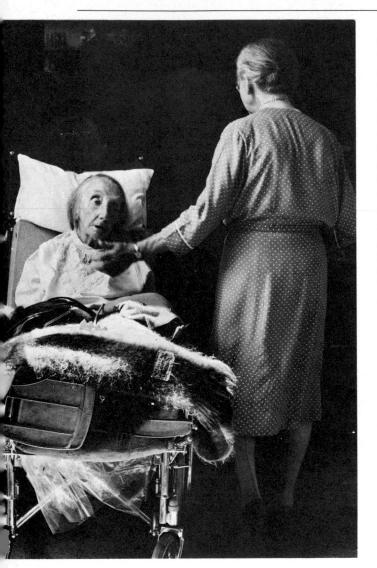

In appearance he has grown to look more ascetic, and when one studies his face it is clear that he has suffered much pain. He doesn't talk about it but he is human enough to ask me, whenever we meet, what people think of his work and what is going on in photo-journalism in general. He has a remarkable gift for not saying all he knows and has on occasions drawn me out to speak at length on subjects on which, as I discovered later, he already knew much more than I did. This talent for self-containment and self-control is almost unique among photographers, who normally will inundate you with little inanities and titbits of gossip. Tony just won't; he treats himself with iron discipline which has not relaxed one iota over the many years that I have known him. The only exception to this is the occasional comment on his fellow earl and photographer, Patrick Lichfield. 'I wish,' he will say, tongue in cheek, 'Patrick would make up his mind whether to be an earl or a photographer.' Snowdon looks upon himself purely and simply as a photographer.

When I now visit him, even on an ice-cold winter's day, he will see me out in jeans and an open-necked shirt, freezing but unbowed.

The work of Snowdon. His active sympathy and compassion is illustrated in this photograph taken at the Royal Hospital and Home for Incurables in London. It is a moving image of impending death with the patient resigned and almost beyond human reach.

CHAPTER 9

Royals

EVERYBODY KNOWS THAT, in a sense, the British Royal Family doesn't only reign over Great Britain and the Commonwealth. The way that France, Germany, Italy – three great republics – absorb new photographs of the royals, is almost beyond comprehension. They don't much care for the rest of the European royalty, and other countries with royal families – Sweden, Denmark, Holland and Belgium – are frequently indifferent, and at times hostile, to their own monarchs. But when it comes to the Queen of England, her son and in particular her son's wife, Princess Diana, the picture press of the whole world goes mad, and every incident of their lives, true or invented, will every day fill scores of columns.

As distributors of photographs taken by several of the major photographers invited by the Queen and members of her family to portray them, I have, over the past thirty-five years, had quite a lot to do with the Press Office at Buckingham Palace, and I have in fact been permitted to photograph many members of the Royal Household. They are, I think without exception, a most skilfully selected staff; but it must be hard for the royals to remain in touch with reality when, from private secretaries down to footmen, every man and woman is quite extraordinarily well-mannered, positive in their approach and as a rule good-looking. The people you meet at the Palace look like an Anglo-Saxon super-race, the women blessed with grace and charm, the men with manliness and gentleness – real gentlemen. I don't think a voice is ever raised in anger in those corridors lined with busts and paintings which rival one another in their splendour, and in collectors' value.

On one occasion I had to call at the Press Office quite early in the morning, around nine o'clock, and outside the french windows, underneath the royal breakfast room, a Scottish Highlander was slowly marching up and down, playing the bagpipes. I had heard that this happened, but was very delighted actually to see and hear it.

I have also been told that dinner parties at the Palace are organised with faultless perfection and that the timing is always exactly thought out to the smallest detail in advance. It was once said by a diplomat that the internal organisation of the Palace in regard to festive functions has no equal in the world.

For no particular reason I had photographed Princess Alexandra on several occasions, once when I was taking pictures at her school, Heathfield in Surrey, where, in common with other pupils, she had a little plot of garden in which to plant flowers and vegetables. Then I photographed her and her two brothers at their country home at Iver, Buckinghamshire, and, again, some years later, at Iver, I had a chance, on a general press call, to photograph Princess Marina, then Duchess of Kent, with her daughter Alexandra. At an opportune moment I photographed mother and daughter together, and told them of the earlier pictures I had of Princess Alexandra. Princess Marina listened with an impish sense of sarcasm and when I had finished she turned slowly towards me, paused and then said, smilingly, 'Fancy!'

I have also photographed the Queen Mother.

I had set up my lighting equipment at Clarence House, and every five minutes a courteous courtier came in to tell me I would not be kept waiting much longer. I was quite content to look at the rich array of Victorian treasures all round when I heard a lady talking outside. Clearly, I thought, she had come to tell me to be patient a little longer. The voice was that of an educated and relaxed lady of about thirty; in fact it was the Queen Mother, then seventy-six years old. It seemed to me that she had mastered the art of putting people at their ease very well indeed, but her level, light, young voice was truly surprising.

I once photographed the Duke of Edinburgh being painted by Anna Zinkeisen, who in her day was a very successful and popular artist. Prince Philip came in, wearing RAF fatigues. The painting was intended for an RAF Officers' Mess. He was bristling with businesslike efficiency and while sitting on the platform he fired questions and instructions at his secretary, who stood by at a respectful distance, wooden clipboard and letters in one hand, making notes incessantly. They were going over the week's programme and, during the twenty minutes' sitting he must have dictated a dozen letters and given dozens of instructions. At the end of the twenty minutes he rose, Miss Zinkeisen curtsied, I bowed, he nodded and disappeared from our sight.

As the agent of photographers who were known worldwide for their portraiture of the Royal Family – Baron, Dorothy Wilding, Beaton, Karsh, Lord Snowdon, Patrick Lichfield, Peter Grugeon, Norman Parkinson and others – I could not very well hope or even try to portray the Royal Family myself, but I was once invited, at short notice and because other arrangements had failed, to photograph Prince Edward and Prince Andrew at the Palace. They were then eight and twelve years old respectively.

Close-up of Prince Philip, Duke of Edinburgh, taken for Anna Zinkeisen, who was painting the Duke for the RAF, to assist the painter in finishing her study.

The Duchess of Kent (later Princess Marina) and her daughter Princess Alexandra. 'Fancy!' said the Duchess, with her famous lop-sided smile, when I mentioned the many photographs I had previously taken of her daughter. I laughed and felt cut down to size.

The contrast between these two boys was very noticeable. Edward, with his long, sensitive face and large eyes, finely shaped nose and mouth, seemed like a porcelain figure compared to Andrew, who seemed to be made of tougher stuff. Where the younger boy smiled the older one would laugh aloud. I thought they got on very well together, considering how different they were. In essence, now that they are grown up, the difference remains, but it is my notion that a great deal will yet be heard about the Queen's youngest son, with his poetic features and seeming lack of addiction to horses and horseplay.

For a number of years, when they were children, I was invited to Barnwell Manor the country home of the Gloucesters, where I photographed the Duke and Duchess and their two sons, Prince William and Prince Richard. The Duke himself was always ill at ease. I think he hated being photographed and made his get-away as quickly as he decently could. The Duchess was invariably charming, yet curiously

The Duke of Gloucester as, in my view, he really looks. The official poses tend to show him smiling innocuously. I was given the opportunity of portraying the Duke and this was among those I liked best. Alas it was not passed for general publication but I got special permission to use it in this book.

many years there were from time to time new portrait studies of Prince Richard, now the Duke of Gloucester. They always seemed to me a little innocuous. He smiled in a manner so bland that I felt that they could not possibly do justice to the man.

I applied, and to my great pleasure was given an opportunity to photograph him at St James's Palace. The pictures showed him in a variety of ways, in uniforms and in civilian clothes; some of those in civilian clothes struck me as being much more true to him than anything I had previously seen. Five minutes of conversation made it quite plain that he is decisive, critical and extremely well-informed. Although I thought my portraits brought out these characteristics, to my utter amazement the few pictures approved for press distribution were similar to all the other official portraits of the Duke of Gloucester previously approved – bland with the beginning of a smile, and, as I look at them, not really strong enough to convey the true character of this energetic and active cousin of the Queen. I obtained special permission to use the photograph in this book.

Princess Margaret, then the wife of Earl Snowdon, occasionally came into Snowdon's study mainly to help decide which new photographs by her husband of herself and her children should be released to the press.

She really does use one of those long 1920s cigarette holders, and on one occasion surprised me by referring to photographs by her husband which my company had placed with *Paris Match*. She was very well informed on the details of his work. She and Lord Snowdon entertained me to tea in their lovely rambling sitting room which contained, among other things, large albums. They proved to contain photographs taken by Princess Margaret, some of them pretty good; all the Royal Family use cameras with skill and experience. As she turned the pages, I said to her, 'Want a good agent?'

'Alas,' she replied, puffing out a little smoke, 'I can't, but I'd very much like to.'

embarrassed or nervous. Often, when I arrived at Barnwell (near Peterborough), she would come to the door and say, 'Ah, Mr Blau – we are just off for our morning ride' – and then nothing would happen for at least forty-five minutes. I think the most imaginative picture I was able to take there was of Prince Richard, then about thirteen, with an enormous army of tin soldiers. He had arranged them in a kind of victory procession and stood, Gulliver-like, on a table, with the army marching ankle-high through this human Arc de Triomphe.

As Camera Press had been handling photographs of members of the Royal Family for

CHAPTER 10

Patrick Lichfield

A MOST ATTRACTIVE looking young man, shy, well dressed and of perfect bearing walked into my untidy office and said he was Lord Lichfield. He came to ask me to act as his sales representative and to advise him in general on photographs. I was delighted; he was so pleasantly courteous and willing to take advice. His connections, as first cousin to the Queen, offered such tremendous scope that I felt certain he was a major acquisition. He was indeed, and ever-increasingly so.

The year was 1964. Since then Lichfield has become one of the top names in international photojournalism.

Nobody would have guessed that this seemingly timid young man had been a professional soldier for seven years, but when he began photography in earnest and as a professional, his insatiable appetite for work proved how fit he was and that must have been due, in part at least, to his soldiering. He set up with two fellow aristocrats, Lord Enscombe and Lady Elizabeth Ramsey. He decided early on that he would be called Patrick Lichfield; and there isn't a picture editor of consequence anywhere in the Western world who doesn't automatically associate the name of Patrick with his surname. His popularity is such that quite recently the editor of the very major Spanish magazine *Lecturas* came to visit me, requesting that I should speak on his behalf with Patrick to carry out an assignment on beautiful women of the Spanish aristocracy at a fee which had not hitherto been paid by any Spanish publication for any subject under the sun.

But when Patrick started, I took photographs

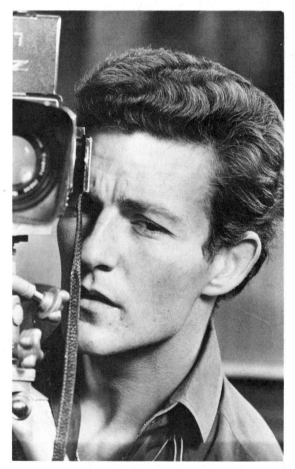

Lichfield behind the camera at the start of his career. Extremely good-looking, sensitive but determined to succeed. Whereas the directives he gave to his sitter then were tentative and experimental, they are now authoritative and clear; both then and now they had none of the hectoring, almost bullying, manner some other prominent photographers employ.

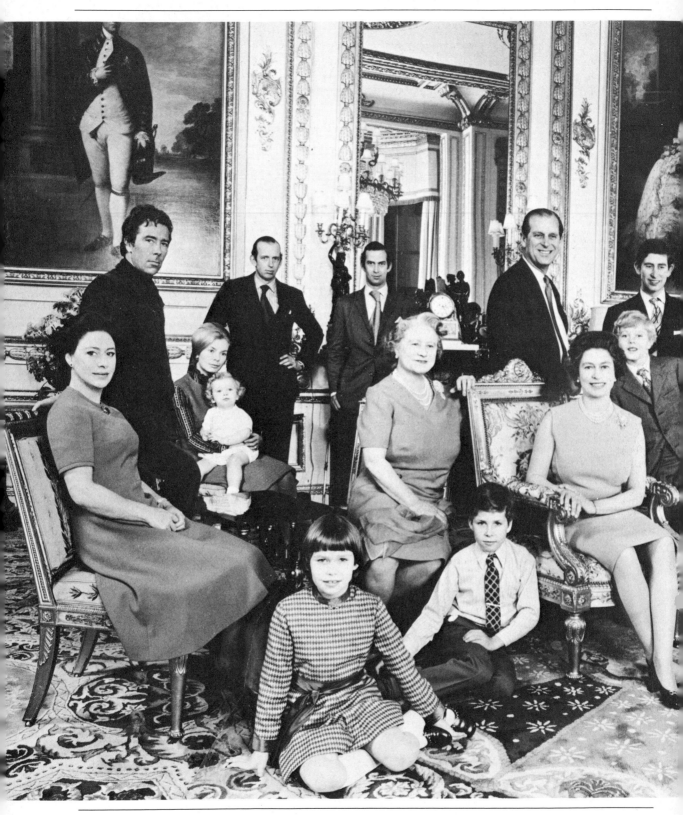

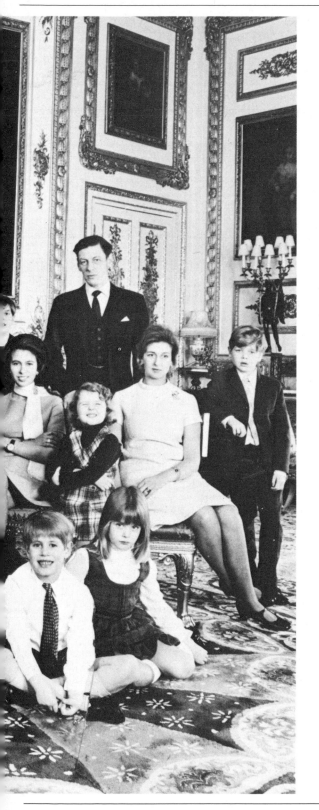

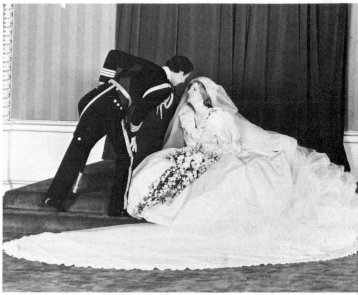

The Royal Wedding group. Prelude to a kiss. Prince Charles bends over towards his bride. Photograph by Patrick Lichfield.

LEFT
The Queen surrounded by the entire Royal Family. It was taken by Lichfield in 1972.

of the studio where blue blood almost took the place of photographic developer. It consisted of the three aristocrats and no-one else. They worked from morning till night. Patrick took on any job that was going. At first there was a feeling about him that, though working hard, he lacked the visual inspiration of his fellow earl, Lord Snowdon, and it took Lichfield a few years to eradicate the impression that he was worth employing only because of his royal connection. His willingness to tackle often highly complicated editorial or advertising jobs was remarkable and consistent, and the fact that he was a most active member of that section of high society described as 'the most eligible young men in the country' kept him busy on a variety of fronts for twenty-four hours every day. Gossip columnists began to pursue him; his every association with a beautiful or famous woman was avidly followed by the gossip-loving readers of newspapers and magazines.

The Earl of Lichfield and Tom Blau. This was taken during the 1981 Lichfield Exhibition at the Olympus showrooms. Lichfield, who has more hair than I, is tremendously successful with exhibitions. It is a miracle how he can manage to supervise them as carefully as he does with all the other work he undertakes.

All the time he kept growing up. I recall his early appearance on a television quiz show confronted with a flood of questions on general knowledge. He did miserably, seemed to know few of the answers and what he said sounded like a mixture of embarrassment and ignorance. Ten years later he had grown eloquent, knowledgeable, witty and had acquired poise and self-assurance. He was now an asset to the TV screen, gave lectures on photography, and his life became a continuous sequence of flights all over the world on photographic assignments. Not only did he become one of the most experienced British photographers of fashion and personalities, he also became an entrepreneur who would try his hand at, and lend his name to, an extraordinary range of enterprises – an exclusive eating club called Burke's; a Szechuanese Chinese restaurant; clothes, cloth and shirts were named after him in America. He even exploited his growing popularity by permitting male window dummies to be made of him wearing fashionable clothes à la Lichfield.

To engage Lichfield to photograph a fashionable wedding became *de rigueur* in wedding photography. He developed enormous skill in photographing happy (and wealthy) brides and their grooms and wedding groups which looked both traditional and were yet kept alive by his ability to take the tedium out of the occasion.

When he photographed the wedding group of Prince Charles and Princess Diana the group had already been taken twice by cameramen, one working for British newspapers and the other for periodicals; and the distinguished members of the wedding group were of course getting a bit restive. Lichfield had anticipated this. After he had rearranged the group slightly he mounted a chair, pulled out a football referee's whistle and blew it hard. Everybody stared at him, amused and attentive, and he got a picture vastly superior to those of his immediate rivals.

Early in his career he took some group photographs which were astonishing for their composition; he then worked a great deal for *Queen* magazine. The best and most imaginative group, which by common consent only he could get under the same roof, was of the twenty top characters in London: authors, financiers, jockeys, boxers, film stars – it was a masterpiece of organisation and the faces of his sitters reflect their enjoyment of the occasion.

He then conceived the idea of photographing the entire Royal Family in one picture. This had never been tried by anyone, but Patrick tried and succeeded. By a most remarkable coincidence which, in its way, illustrates the Lichfield luck, the only important members unable to attend were the Gloucesters. This proved to be fortunate because Prince William of Gloucester was killed in a flying accident within a week of the picture's release date. Had he been in the group it would have dated the pictures immediately and perhaps added a touch of sadness.

Lichfield's looks have changed markedly over

The work of Lichfield. Kate Bush, British singer and songwriter and a major internationally-acclaimed British pop star.

a few years. The shy, aesthetic and almost ethereal-looking young man who was lionised by society has actually acquired an impressively lion-like head.

At one time there were rumours that he might marry Princess Beatrix of the Netherlands; his association with Britt Ekland, the Swedish film star, made headlines. When, after having been rumoured to be on the point of marrying about a dozen different girls, he finally did get engaged to Lady Leonora Grosvenor, daughter of the Duke of Westminster, the choice was welcomed as an unsurpassable illustration of Patrick's good taste and good sense.

I was at the wedding at Eden Hall, near Chester. The whole village, at the expense of the Duke of Westminster (Britain's wealthiest man), took the day off, and it was an occasion of feudal splendour, attended by the Queen and other members of the Royal Family. Patrick was relaxed and beaming with contentment and good humour. It was a climax to his career and his standing in international society. Stability and happiness on the domestic front added impetus and further self-assurance to his work.

Patrick Lichfield, with all the assurance of a major figure in world photography, occasionally invites me to lunch, or I invite him, at his eating club in Clifton Street, off Bond Street. Normally we lunch at one o'clock or earlier, as almost invariably he has to be at Heathrow Airport by four.

He has the gift of taking advice and following it up literally and punctiliously. He is one of the few photographers I know who become embarrassed and apologetic if they haven't done something practical within a few days of our discussing it. He has become a devoted family man with three young children; most of his weekends are spent at his fabulous country house, Shugborough Hall, in Staffordshire. It illustrates his basically serious nature that he will at times quote to me from conversations or letters I had sent him years ago; and at times, when I am impressed with pictures he has taken and congratulate him he will say, 'But it's you who suggested I should photograph these people – only it took a long time to get a satisfactory appointment.'

On his suggestion I wrote a foreword to his book, *A Royal Album*, and weeks after publication he rang me up to say that he had only just had time to read carefully what I had written, and that he was most grateful.

It's not widely recognised how much tact it requires to be known worldwide as a genuine first cousin to the Queen of England, and to combine this with an enormous range of photographic work without ever putting a foot wrong. There is a pleasant sense of dignity about the man which prevents even the most vicious of newspaper gossip writers from saying unpleasant things about Patrick; but it is dignity, and not pomposity. It takes some doing to retain dignity when photographing pretty explicit nudes for commercially sponsored calendars; it is highly paid work and fairly hot stuff. Lichfield takes it in his stride and is in no way abashed at changing, perhaps in the course of the same day, from this type of pin-up work to the taking of new photographs of a member of the Royal Family. He is internationally accepted as a true professional who has learned to use skilful lighting, the right kind of persuasion and technical know-how to work his way through the whole gamut of editorial and commercial photography.

Worldly, elegant, good-humoured, high-priced and aristocratic, Lichfield will not walk under a ladder; for with all his professionalism and military training he confesses to be profoundly superstitious. After all, a man must have some weaknesses.

CHAPTER 11

Politicians

R. A. BUTLER – Rab to his friends – was Home Secretary when he agreed I should take photographs of him in his vast, gloomy office at the Parliament Square end of Whitehall.

He had a most remarkable face, with wide, fleshy lips and the woeful expression of a St Bernard dog. Although I had of course read up as much as I could about him, I was not aware that his right arm and hand were withered but, in the same way that Somerset Maugham totally ignored his occasional severe stutter, Mr (later Lord) Butler paid no attention to his handicap.

At my request he moved away from his desk near a corner of the cavernous office to sit astride a chair. He did as I asked but his mood seemed melancholy. Our conversation was pleasant enough, and when I said I wanted to take a picture that did not give him such a woebegone expression he turned to me plaintively and, in the injured tone of a child, said, 'I wish you would ... I'm quite a merry fellow, you know,' and momentarily his eyes lit up.

He made his name as the originator of a thoroughgoing reorganisation of education in British schools. As Minister of Education in 1944 he evolved and published the historic Education Act and greatly influenced all thought on education in post-war Britain. Some diehard Tories never forgave him; and it might have been the reason why he never became Prime Minister.

⋆ ⋆ ⋆

I had taken photographs at the Foreign Office quite frequently and became well known to the people at the News Department – marvellously easygoing, well-informed, personable young people with first-class public school and university careers behind them. I had paid many visits there for a major story that was meant to take the reader behind the scenes of what was then, in the fifties, still a very major power centre of the world. I had noted with delight how a typical London milkman, complete with trolley and milkman's apron, would push along the hallowed Romanesque corridors and put down pints and half pints outside the doors of dignitaries, including that of the Foreign Secretary himself.

But when I came to photograph Sir Alec Douglas-Home, the young man from the News section gave me to understand that the Foreign Secretary was a very busy man who could not spare more than three to five minutes for what was, after all, the somewhat frivolous performance of posing for a photograph.

I had set up my light equipment when Sir Alec came in and, completely relaxed, sat down and asked me what I wanted to do. It was clear that the News section were overawed by their boss and expected me to be equally overawed. I began portraying HM's Secretary of State for Foreign Affairs in a variety of more or less traditional attitudes at his desk and leaning on his chair. Then I said, 'I've been told you can only give me a very little time, but there is one picture I would dearly like to take.' He encouraged me to explain. I said, 'The window in the far corner of your office overlooks Horse Guards Parade; this is the time when the

Mounted Life Guards are about to ride across in single file. It would, I think, make a good and unusual picture if you stood by the window with the Guards down below, crossing the square.'

The news chappie at the door began twitching with impatience, but Sir Alec said, 'Yes, why not? It's a good idea.'

When we got to the window it turned out that the outside sill was covered with pigeon-droppings and, to avoid having them in the photograph, the Foreign Secretary had either to be taller or to stand on something so that his shoulders would block out the sight of the accumulated bird-droppings of many years. He looked around and said, 'Telephone directories!' and carried over some six heavy volumes. I was standing on a chair in front of him and had to manoeuvre him into the right position in time to photograph him and, in deep focus, the mounted guard which happily by then began to file across the Horse Guards Parade. I had far exhausted the time allotted to me but Sir Alec (who is now Lord Home of the Hirsel) was quite unconcerned.

'You will let me see the pictures, won't you, before they go to the papers?'

'Of course,' I said – and he passed them. But it turned out ironically that the window shot was not nearly as effective as a portrait I had taken at his desk within the first five minutes of the session.

* * *

Harold Wilson at 10 Downing Street was an ideal sitter, and had a phenomenal memory. I had photographed him before at the House of Commons, as Leader of the Opposition. He must have been photographed by hundreds of cameramen, but he recognised me at once and apologised for having suffered from a bad eye on the previous occasion. This time he was in good form and would I please tell him how I wanted to photograph him?

I had arranged my lights in such a way that he could sit in front of an elegant fireplace. He told everyone to leave the room – the best thing a man can do when he is about to be photographed; with anyone else present one cannot talk candidly and it becomes an impertinence to give instructions to someone like the Prime

Harold Wilson, Prime Minister, at No 10 Downing Street. To photograph at No 10 is always a great honour to a photographer, but in the case of Mr Harold Wilson it was a great pleasure also. He put me at my ease and with a sensitivity unusual in a politician he arranged himself and his facial expression exactly as I asked.

ABOVE RIGHT
My assistant took this picture of me photographing Harold Wilson.

Minister. Not so with Harold Wilson. When I said, 'A little more grit, sir,' he set his face almost imperceptibly more firmly. I asked him to put a foot on his chair and lean on his knee. His face immediately assumed the expression I was seeking.

With many people, to obtain a photographically satisfactory response one resorts to little tricks; I like to say something like, 'One hundred and four: take away seventeen,' and while they work out the small arithmetic task they look as if they are wrestling with a major world problem.

'Soften your eyes, with just the beginning of a

smile, but don't smile with your lips.'

No actor could have done it more convincingly than the Prime Minister of the United Kingdom. He did me the honour of ordering 150 size 8″ × 6″ copies, which were awarded with his signature to hosts and guests both here and abroad.

* * *

It was different with Edward Heath, who allowed me to visit him when he was Lord Privy Seal with Foreign Office responsibilities, in 1961.

He sat at a magnificent Renaissance desk. With my camera on a tripod and portable lights in position, I asked him to turn towards me (I was standing in front of the window) and to lean his right arm on the desk and his left on the arm of his chair. This took a little rehearsing because the desk was too far from the chair, but finally he was comfortable. I then said, 'Please soften your eyes.' He looked at me uncomprehendingly.

'What do you mean?' he said, harshly. I explained that I wanted him to smile with his eyes,

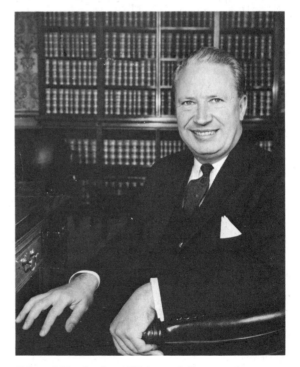

Edward Heath, then Minister of State at the Foreign Office.

as if he were welcoming a child at a function who was approaching him with a bunch of flowers. He thought it over and then flashed on a shark-like grin, displaying two rows of teeth almost from ear to ear.

'No, sir,' I begged. 'Please just narrow your eyes a little, keep your lips together, but put warmth into the expression of your eyes.'

No luck at all. It then occurred to me that perhaps he would look better in another pose which forms part of a repertoire I have evolved over the years. I asked him to stand against a wall of Hansard volumes, which filled a bookcase, put a foot on a chair and lean on his knee, reading from Hansard. This he did with good grace, and when I said, 'Now, will you raise your head and look into the middle distance as if absorbed by what you have just read.' I saw immediately that I had hit upon an attitude and expression which suited him well and which he could go along with without feeling a loss of dignity.

* * *

I had known James Callaghan for some time and photographed him at his house in Blackheath, digging the garden, walking away with his spade over his shoulder; but now he had become Chancellor of the Exchequer, and the Treasury is an awe-inspiring place to visit. As in the Foreign Office with Lord Home, the private secretary is always forbidding and warns you not to take too much of the Chancellor's time.

'How very good of you, sir, to find time for a few photographs,' I said.

'Sir? I call you Tom and you call me Jim, as we have done for many years. Now, what can I do for you?'

We spent an agreeable and profitable half hour. I noted that in the Chancellor's room there was a sofa with slippers beside it. The only thing he wouldn't do was lie down and pretend to take a nap. Otherwise, he was most obliging and when I asked him what was the worst part of his job he said, 'Foreign financiers. You have no idea what a trial they are to anybody sitting in this chair.'

* * *

On another visit to the Treasury I photographed Denis Healey who, with his heavy and untidy eyebrows, is of course a photographer's dream. I had photographed him before, when he was Secretary of Defence: but that was not particularly successful as he was then greatly preoccupied, his cheeks red, and he paid scant attention to my efforts. My lion-tamer's trick of looking him straight in the eye with the beginning of a smile just didn't work. But on the second occasion he welcomed me – in Hungarian! I could not have been more surprised. He beamed back at me and said that at the end of the war he was one of a mission of the Allied Powers whose job it was to deal with the finances of Hungary. He had picked up and retained a vocabulary of some sixty words, which he pronounced extremely well.

To a photographer, and especially in these circumstances, he was smilingly helpful and willing even to pose half-sitting on his desk with his arms crossed – though always retaining a sense of dignity and presence. You have to guard against too much informality on these occasions, for fear that it will damage the dignity of the subject and the position he holds.

* * *

Barbara Castle was Minister of Labour, and her hair was as carrot red as one often hears it described. Her make-up was a little too pale and I could not break through a sense of something artificial about her expression as she endeavoured to do as I asked her. Then I said, 'For a Cabinet Minister you have very pretty legs. Would you mind sitting on the edge of your desk?' This pleased her and she smiled affectionately and, with relaxed ease, made herself comfortable and allowed the camera a good look at her shapely legs.

* * *

Denis Healey – a gift for photographers and a man of encyclopaedic knowledge, good humour and determination.

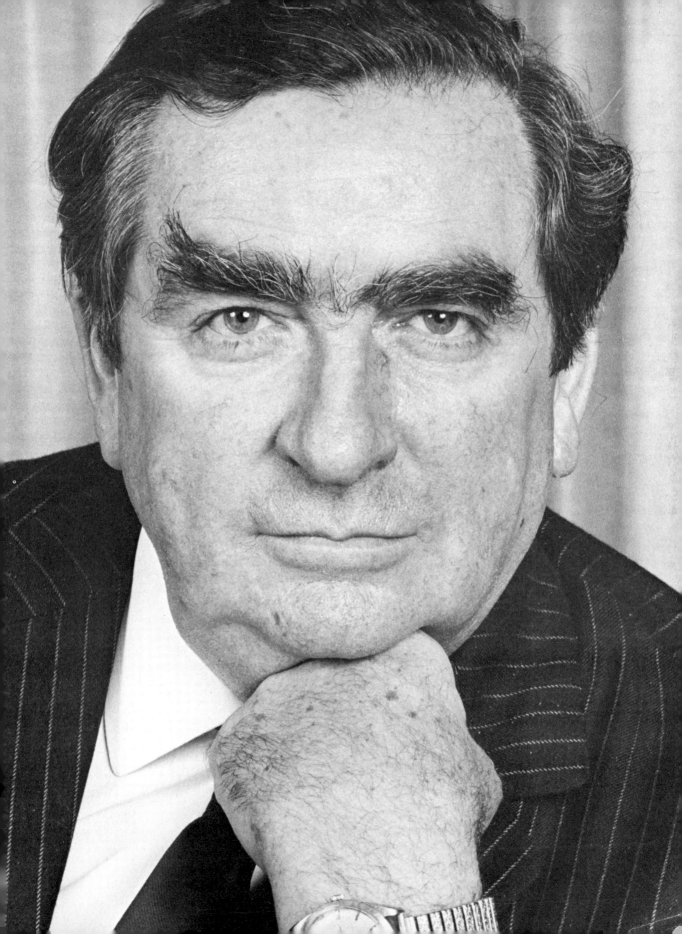

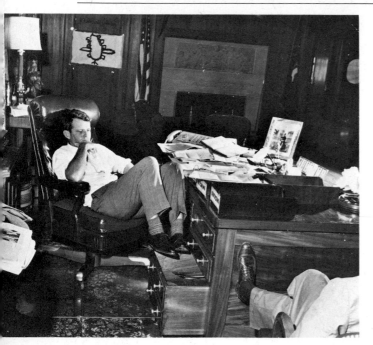

Robert Kennedy. The President's brother was being interviewed. His armchair, almost like a dentist's, can swivel round and tilt forward and backward. As he pondered a question he sank deeper into the chair, his feet resting on the top of a desk drawer. As the photograph indicates the interviewer himself was also quite relaxed. On the desk before the Attorney General were an internal telephone, a diary, letters and silver-framed photographs of his family.

I photographed Sir David (now Lord) Eccles when he was Paymaster General with responsibility for the Arts.

He had the fine, slim, greyhound-like aristocratic features of an English gentleman, was easy to portray and charming to talk to. He told me about the visit to London of Mr Krushchev and Marshal Bulganin, respectively head of the Soviet Government and of the Communist Party, and the President of the USSR.

'We offered them the choicest sirloin steak at a beautiful dinner party the government threw in their honour at the Guildhall. The meal was served on the famous heavy gold service, reserved by the Lord Mayor of London for the most important visitors only. I watched Krushchev just toying with his steak, and eating next to nothing.'

Sir David looked at me expressively,

eyebrows raised, and shrugged his shoulders.

'Later on I learned that Krushchev bred rabbits and ate rabbit stew every day of the week ... How can you do business with people like that!'

* * *

A thoroughly surprising and enjoyable occasion offered itself in 1962, when I received a reply from Robert Kennedy, then Attorney-General in the administration of his brother President J. F. Kennedy.

I have often sent out 'long-shot' applications for photographic facilities, which usually do not receive favourable replies, or in fact any reply at all. But Robert Kennedy's office said OK, and I arrived at the impressive building on Pennsylvania Avenue, a few doors away from the White House, at the appointed time. A taxi put me down at an entrance where there was no-one on duty. I thought a commissionaire would appear at any moment, but as he didn't I walked in, carrying two cases full of equipment, and waited in the hall; nothing happened. On the right was an office with 'FBI' printed on the door. Weighed down by my cases I walked in, explained that I had an appointment arranged by a Mr Goodman, and asked if they would kindly tell me where I could find him.

The man I spoke to eyed me with professional suspicion. 'Siddown!' he said. After a while he came back and said, 'Fifth floor, room 1113.' I thanked him and walked out, my bags untouched by probing hands or eyes, took the lift and on the fifth floor walked along endless corridors until I found room 1113, with Mr Goodman's name on the door. I knocked twice and went in. The reception room and office were empty, open correspondence was lying all over the desks. I stood respectfully by my bags until the door opened and a man came in and exclaimed, 'Who the hell are you?' I showed him the telegram he had sent to me in New York, and he went off to see if Kennedy was ready to receive me.

'He can give you ten minutes, no more.'

I said I needed to set up my light equipment – two portable flashguns on collapsible stands – and that would take almost ten minutes. He turned away and repeated, 'Ten minutes, no more,' then took me across to Kennedy's office

and announced, 'The photographer from London.'

I walked into the Attorney-General's office weighed down by my two heavy cases which could have contained dynamite for all they knew. It was a large, panelled, somewhat gloomy room enlivened by the drawings and primitive colour sketches made by Robert Kennedy's seven children, which were stuck on to the panelling. In the corner was the flag of the Stars and Stripes. Kennedy sat comfortably at his desk, relaxed and reclining in his swivel armchair, feet on the edge of the desk. He was talking to two visitors on his left, and beyond a cursory 'Hi,' took no further notice of me.

I plugged in my equipment and started taking pictures. The President's brother was a handsome young man with curly fair hair, wearing an open-necked shirt, the sleeves rolled up to the elbow, and talked in the drawling, leisurely way of the South.

When the visitors had gone another man arrived and when he had gone Kennedy got up and walked to and fro with his hands in the back pockets of his jeans. It was clear that without visitors he had no programme. Then someone dashed in: 'Bergman has escaped!' Kennedy remained unruffled. 'Well, tell 'em to go and get him,' and he sat down again. All the while he was chewing gum.

More visitors. The heat was oppressive. Then black servants arrived who set up chairs in a half-circle around the Attorney-General's desk. While this went on I was photographing him from every possible angle. I climbed on to a leather chair right next to him to photograph him as he was studying a document.

Now the room began to fill. The men who came in were all remarkable for their burly presence and it turned out that they were chief law enforcement officers from each of the States. One of them introduced the others to Kennedy, who had sunk even deeper into his swivelling chair. He was now drinking a glass of Coca Cola, and trays of this and beer were taken round and offered to these top policemen by white-coated black servants, putting one in mind of the novels of the Deep South. The rapporteur introduced the officer in charge of Tennessee.

'Good fishing down there,' mumbled Kennedy, and he made similar encouraging and friendly remarks to others of the representatives from the various states. Each of them rose, gave his name and state, and began to report on law enforcement in his area of responsibility. The summer's heavy heat, the drawling voices, reduced the Attorney-General to a kind of somnolence, amiable but clearly sleepy.

At the beginning of the conference I had stepped down from my perch on the armchair next to Robert Kennedy – not without some difficulty. One foot got stuck, it seemed, on some discarded chewing gum. I took pictures left and right and, finally, no-one even looking at me, I gathered my equipment together and, slightly limping from the chewing gum under my shoe, left the room after having respectfully bowed towards the chair. No-one took a blind bit of notice. Two hours and twenty minutes had passed. I went back across the corridor to Mr Goodman's office, which was empty and untidy as before, dismantled my equipment and packed it up into my bags, walked back unaccompanied down the long corridor to the lift and back to the ground floor, past the FBI and out into Pennsylvania Avenue to call a taxi. The security arrangements were nil. I could have blown up the US Department of Justice a dozen times. Lucky for them I wasn't a terrorist.

* * *

The main purpose of my visit to Washington DC was to photograph Henry Kissinger. He was at that time in charge of National Security and lodged in the north-west wing of the White House.

I had stopped over in New York on Camera Press business and had lunch with the then picture editor of *Time* magazine, Joe Durniak.

'Why are you going to Washington?' he asked me suspiciously. I told him I had an appointment to photograph Henry Kissinger. He was astounded and did not believe me until I showed him the letter I had received, signed by Kissinger's private assistant, a Mr Lord.

'You must promise me first sight of what you take. We desperately need a good cover picture – but desperately!'

'How much will you pay?'

'Look, I want this picture badly. I'll pay $2,000!'

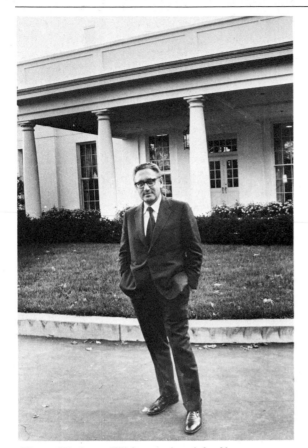

Henry Kissinger. With proprietorial self-assurance, Dr Henry Kissinger stood outside the West Wing of the White House where his offices were then situated. It looked as if he owned the place.

At that time, in 1971, this was more than double the usual rate.

I had a pretty rough reception at the White House. The outer guards opened my two cases, took out every item and made a hell of a mess of the careful arrangement of my equipment, worked out over the years, to fit into two cases. They stared hard at me and with a kind of contemptuous suspicion then gave me a tab with my name on it which I had to wear until I left the premises.

Inside the outer door leading to Mr Kissinger's suite was a super-gigantic black police officer, bristling with weaponry, but soft-voiced, pleasant and courteous, and he let me into the Presence.

There he was, in the flesh; of medium height, quite corpulent, with the face of an innocent, well-meaning, Jewish medical practitioner or small-time lawyer, smiling owlishly behind heavy glasses. He shook my hand while talking into the telephone, and during the hour that followed the telephone rang many times. Once he screamed at the top of his voice because an Indian diplomat had been received with honours out of proportion to his status; but when a call came from a lady-friend he sank back in his heavily upholstered swivel-chair and, like Robert Kennedy, put his feet on his desk, smiling broadly, if not actually lecherously.

'No, baby, all the time in the world – just tell me when and where.'

I congratulated him on his reputation for being a ladies' man. He was flattered and pleased: 'Just perks, you know.'

I was amazed to hear his gravelly voice (which however could change to a screech) speaking English with such a strong German accent. The fact that he used a vast vocabulary made it, if anything, even harder on the ear.

I took pictures from every angle and when I had finished asked him why it was he had so kindly responded to my request to photograph him; after all, he couldn't possibly have known of me.

'I'll tell you why. In your letter' – and he pulled it off his desk – 'you did something nobody has ever done in America. You offered to show me the pictures before their release to the press. I trust you won't forget this promise.'

I left elated by the good job I felt in my bones I had done. Oddly, after all the security of getting in, there was none as I came out. But when I got back to my hotel it occurred to me that none of the photographs indicated that they had been taken at the White House. It was just a large room, painted blue, that could have been anywhere. I rang Henry Kissinger's secretary and explained my predicament. Was there any chance at all that he would permit me to come back and photograph him outside with the White House in the background? To my utter delight he rang back to say yes, next day at 10.30 in the morning.

The great Kissinger marched and posed in the open, very much like a Surbiton houseowner

proudly offering himself to the camera in front of his villa. He stood there in a proprietorial manner, one smallish foot stuck out in front, emphasising the notion that the house belonged to him. At my behest he walked up and down so that I could take both black and white and colour pictures, and his soft, somewhat pudgy hand pressed mine with a final reminder that I had promised all the pictures would be shown to him.

I returned to New York and spoke to Joe Durniak, who bade me rush to his office so that the films could be processed there and then. I said, 'Are your people good at processing? I think some of the pictures are not quite right and will need individual attention.'

Durniak reassured me, with a touch of sarcasm: there was no laboratory anywhere in the world that exceeded the skill of his. The processing was done by the afternoon. I didn't think it had been done terribly well, but it was too late to complain. He pointed to one of the colour pictures.

'I must have this one for our next cover,' he said, decisively. I then explained that nothing could be done until I had submitted them and obtained approval, and told him why it was that Kissinger had given me a sitting.

'Oh, rubbish! What is it, after all, but a close-up of his head? How can he object to it?'

I had to force him to return all the pictures to me as, of course, I had to stand by my word; and I wouldn't let him forward the photographs from his office. I flew back to England and immediately air-freighted enlargements and the colour to the White House; but three weeks went by before I obtained a decision. Generously, Mr Kissinger had approved of all bar three, and the one which *Time* magazine wanted was OK. I rang Durniak from London.

'It is too late?'

'No, no, of course not. Rush it to our office in Bond Street. I need it desperately.'

Another three months later the picture appeared on the cover of *Time*, but it was offered as an 'acrylic' portrait by someone called Plaut – a name not unlike my own but sufficiently different to be irritating. I rang the *Time* office in London to complain.

'Don't worry, they'll pay you all right.'

Next day they came back to say that, with

exceptional generosity, the picture editor of *Time* would pay me $200 for artist's reference. I exploded and demanded the $2,000 we had agreed, threatening to sue *Time* and tell other newspapers about the outrage.

The cheque for $2,000 arrived next morning.

* * *

On the occasion that I photographed Henry Kissinger I naturally enquired whether there was a chance of photographing President Nixon or his wife, Pat. Mrs Nixon responded immediately; yes, I could come to a reception she was giving for deserving ladies from many women's organisations throughout the country.

They lined up in a seemingly endless queue and as they moved past her, curtseying, she shook their hands, looking them full in the face. As many of them were hefty, jovial and exceedingly democratic, they squeezed her hand in such a hearty manner that after the first twenty she had to massage her fingers behind her back; but she remained imperturbably friendly, a martyr to a job which, at least on that occasion, had few benefits. She stood for about sixty-five minutes and pressed at least 600 hands, making small talk conversation. Finally she withdrew, again rubbing her hands in a way that conveyed satisfaction, but barely concealed the fact that she would not be able to use her right hand for a couple of days. Those ladies from the midwest are powerfully built.

I was permitted to take pictures of President Nixon himself, but only on the porch of the White House and alongside other cameramen. It was on the occasion of a visit by Mrs Gandhi, the Indian Prime Minister. All photographers were under instructions to wear tuxedos, but it was so bitterly cold that the dozen or so who lined up for the occasion were huddled into heavy overcoats, stamping the ground as the temperature fell and fell.

When the President was informed that Mrs Gandhi was about to arrive he came out. His cheeks were rouged, as were his lips, and his dark eyebrows were even darker; all of this to accommodate his appearance on television. There were two television cameras on either side.

While we waited the President moved to his

Pat Nixon. Her smiling face conceals the pain she feels in her wrist.

left and spoke to some of the cameramen.

'I hope you boys wear longjohns; I do, and I don't know what would happen to me if I didn't.' He nudged and winked, but in his thermal underwear was able to stand out in the cold without an overcoat.

When Mrs Gandhi got out of her car her brown skin had changed to a ghastly blue.

* * *

I had photographed Tony Benn twice, on the first occasion with the traditional politician's pipe, in my studio, but the anecdote I want to relate has nothing to do with my photography, but with Mr Benn's.

I had read that he was about to visit China, which at that time (1971) was still greatly under-photographed. I wrote to him, as Minister of Technology, and asked whether he would be interested in taking photographs for my company, as no doubt he would have many opportunities denied to ordinary visitors. I would lend him films and a Rolleiflex camera which, in case he was not conversant with it, I could explain fully and sufficiently in half an hour.

He came to my office, I lent him the camera and plenty of film, showed him how to use the camera and also how to use a light meter; there was then no built-in registration of light. He declared himself competent, promised to make a number of test exposures before leaving, and I heard nothing further until a week after his return. He sent me twenty-three exposed spools, which he asked us to process, and then he would supply captions. We duly made a test, which was disappointing because the film was badly under-exposed. We made two more tests, with identical results, so the head of the darkroom took over and processed each of the twenty-three films carefully and individually.

There was hardly anything on any of the films taken by Britain's Minister of Technology. We made contact prints as well as it was possible to do; they were almost uniformly blank, with some slight indications of light here and there. I returned the material to him almost apologetically, saying we had tested the camera and that the camera was all right, but unfortunately he must have overestimated the available light, and so the result was rather thin.

When he had sent the films he rang and said, 'Please pay special attention to the photographs I took of the Princess in Jade Armour. No-one has seen this important figure before and it's going to be brought to London for a forthcoming exhibition, where it's sure to be a sensation.' Seeing the results of his labours, he was very pleased with the pictures and wrote reams of captions for things that were scarcely visible. There were perhaps eight exposures which one could enlarge, and we enlarged them and captioned them in accordance with the masses of information supplied. Lo and behold! *The Times* published them. Mr Benn, his optimism justified, rang me up: 'There you are – they look perfectly splendid. I told you so.'

CHAPTER 12

Photographers

OCCASIONALLY A PHOTO agency is approached by someone entirely unexpected with good, unusual material. (Much more frequently one is approached with almost totally useless photographs and then one must be careful not to hurt the well-meaning sender; I usually say, 'The best one can hope for is to be sixty per cent right. That leaves the large margin of forty per cent for having judged wrongly, so please don't lose heart if I reject what you offer – try elsewhere.')

I received a letter from a tall, fair young English explorer who had spent a long time with the Eskimos. His name was Colin Irwin, and he had a beautiful and movingly illustrated story.

While he was still relatively new among the northern Canadian Eskimo group he had joined, he travelled Eskimo-fashion on a journey by sledge, pulled by Huskies. The Huskies, a fierce, tough, almost inexhaustible breed of dog, always had a principal, the sharpest, most intelligent dog, which controlled all the others. They would obey him without question and it was to him that all commands were addressed; but he was a force to be reckoned with – not a slave or serf, but the dog in charge, a kind of regimental sergeant-major.

Mr Irwin was inexperienced in the handling of these animals and, when something went slightly awry, spoke roughly to the top dog. He thought he might even have cursed or abused him. On account of an error which he attributed to the dog they were obliged to halt and make arrangements to stay the night. When the dog was abused, however, he stopped, turned round and eyed his master with what was obviously astonishment. The other dogs also stopped. The telling-off went on, but the dog howled only once at this humiliation in front of the other dogs. When the tent was set up the dogs huddled closely together for warmth – except for the top dog, who normally would have supervised and guided all the other dogs in his role of leader of the pack. Instead he kept apart from the pack, intentionally exposing himself to the harsh Arctic elements during the night. So deep was his hurt that he deliberately stayed by himself, defying the killing cold which the dogs can only survive by crouching together. He com-

Top dog. By sitting deliberately alone, the offended, insulted dog committed suicide and was found frozen to death in the morning. Photograph by Colin Irwin.

mitted suicide because his position had been undermined, he had lost face with his under-dogs and with his master. He did not want to live any longer, and in the morning was dead.

The explorer brought me the story and photographs, and also his attractive Eskimo wife, who was working as a nurse in Surrey. I photographed the two of them together, made coffee, and then produced two tins that I had bought a year earlier in Ottawa – an Eskimo delicacy called muk-muk – which greatly de-lighted the young Eskimo lady. She had long given up hope of finding muk-muk again until she might perchance return to northern Canada.

<p style="text-align:center">⋆ ⋆ ⋆</p>

Original, true and well-illustrated stories of such a poignant nature are pretty rare, and I thought myself lucky to have come across this one, but one's dealing with photographers are often other than expected, and at times unpredictable.

A very successful American photographer, Lawrence Schiller, with whom I had corre-sponded, walked into my office and looked about him in an arrogant, distrustful manner. He had barely introduced himself before he was complaining about the extraordinary untidiness of my desk.

'Christ!' he said loudly. 'How can you work in such a mess – how can you ever find anything?' He picked up half a dozen envelopes dismis-sively and went on, 'You have a good name in the States but I bet no-one has been here to see the working conditions.'

This was not so, but it was true my desk was in a terrible state.

He kept it up for several minutes until I said, 'Well, Mr Schiller, all you say is true, but the untidiness is due to our having more business than we had ever anticipated when we took these premises. Everyone who sends us work here is dealt with fairly and squarely and although it doesn't look like it to you, we are reasonably competent. The muddle is merely superficial.'

He was not subdued, and finally I got up and said, 'Obviously, we cannot work together. Thank you for visiting me.'

'Wait a minute,' he cried. 'You haven't seen my work yet,' and he opened his bulging brief-case, taking out a handful of photographs, which he put in front of me. They were stun-ning. Some were of a fantastically beautiful and exciting Hollywood as I had not seen it depicted before. There were some elegant and persuasive studies of Deborah Kerr and her husband at their chalet in Switzerland which were so stylish and *Vogue*-like that you would not have thought it possible for this man to have taken them. His physical presence was not prepossess-ing; although young, with an interesting (if aggressive) face, his body was huge.

'What do you think of them?' he said in a hectoring voice. 'I've got hundreds more like them.' And he had. His work was so impressive that I felt it would be idiotic to turn down the opportunity of representing him although he was so utterly disagreeable and critical, and seemed impossible to work with. His imagi-nation and technical skill, and the self-evident fact that he got on extremely well with the sub-jects he photographed forced me to change my mind – happily, for when, after some two years of working together (to our mutual and con-siderable advantage) I visited Hollywood, I called on him at a particularly suitable moment.

He had just returned from a photographic session with Marilyn Monroe in which she emerged, practically in the nude, from a swimming pool set up at a film studio. The photographs had tremendous impact – sexy, lively, exciting and artistically beautiful. From his office – a converted shop – I telephoned the picture editor of the *Daily Mirror* and sold him the photographs sight unseen for £750. This was in 1962. Schiller had a unique combination of ultra-quick perception of what made a good picture, and equally amazing business acumen.

The swimming pool sequence had been pro-mised to him exclusively, but when he arrived another photographer was there – William Read Woodfield, oddly of similar huge build. They worked side by side and obviously took photo-graphs which were nearly identical. When

Marilyn Monroe photographed by Lawrence Schiller.

Monroe indicated that she had had enough Schiller immediately got hold of his rival and pointed out to him that jointly they had a world scoop, but as rivals neither would get much out of it. He persuaded Woodfield to go to his, Schiller's, lawyer, where they formed an *ad hoc* company which would market the photographs through Schiller, both photographers getting equal shares from all returns.

Schiller had been an *enfant terrible* in Hollywood since the age of seventeen. His father owned a photographic store where young Larry helped and got to know cameras of all kinds. He became the favourite photographer of many

stars, among them Barbra Streisand, whom other cameramen feared to confront. The entrepreneur in Schiller made him expand in a great variety of ways. When Monroe committed suicide he, having at her invitation taken a whole series of further pictures of her at home and become one of her intimates, rounded up some eighteen photographers who had all taken excellent pictures of MM, then engaged Normal Mailer to write her biography (Mailer had never met her). Schiller packed the book with the best photographs taken throughout her life, and Mailer and all the photographers reaped rich rewards, all thanks to Schiller's drive and business energy.

He also photographed Gary Gilmore, a man sentenced to death; hired a writer to produce Gilmore's autobiography and recently made a major film production out of the story. He has

Raquel Welch. Looking for a needle in a haystack: that's what Raquel Welch says her search for true love and a lasting relationship is like. Photograph by Terry O'Neill.

now grown from being a great photographer into a major force in Hollywood films.

* * *

In a very different manner the English camera-man Terry O'Neill was also a tremendous photographer whose work I had the good fortune to handle.

He began as a drummer in a jazz group, then became a photographer on the *Daily Sketch*, and gave that up to become a photographer of film stars, pop stars and anybody else of consequence in the world of entertainment.

Terry has extraordinary good looks and talks with a soft and most acceptable Cockney accent, which gives the deceptive impression that he is an artless, well-meaning and somewhat innocent young photographer. His success with major stars like Raquel Welch, Frank Sinatra, Tom Jones, Britt Ekland, Peter Sellers and Elton John was phenomenal. Once they had been photographed by Terry O'Neill they turned down all other photographers. He was most pleasant company, witty, well mannered, never pushy – and his pictures were always published on full and sometimes double pages, and film companies began to vie for his services by paying him huge sums for daily attendance, on the specific understanding that he would place his pictures exclusively and with first right of reproduction to top publications, country by country, often at considerable sums. He was the most successful film photographer of all time, equally well known in every European country as in Hollywood and London, and his smiling, *sotto voce* approach opened doors for him wherever he went.

Terry and I were good friends and I once asked him, 'How can you photograph these seductive beauties so seductively without being seduced yourself?'

'Oh, no, Tom, you never allow yourself to get entangled personally. It doesn't matter what the opportunity, you have to stay remote.'

In the course of his work he met Faye Dunaway. The gossip writers found out that Faye Dunaway had fallen in love with him and he with her. Terry was married with two children. He divorced and married Faye. Some gossip writers claimed that this was not the first of his

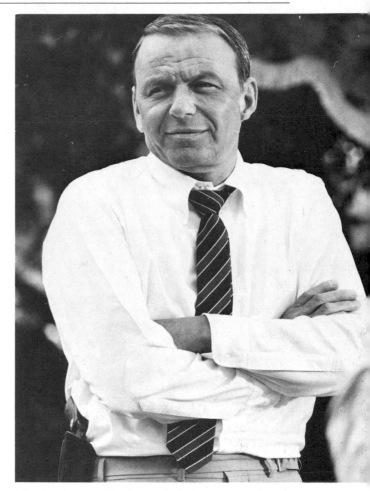

Frank Sinatra with the wry look that entranced millions. Photograph by Terry O'Neill.

affaires, and that his popularity with big star names was not due simply to his photographic skill.

At the height of his fame in London Terry told me that what he would really have liked best was to have become a professional footballer.

* * *

Great and famous photographers like Terry O'Neill often have surprisingly close and friendly relations with other photographers of remarkable success.

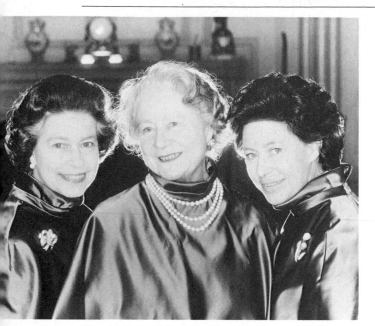

*Her Majesty Queen Elizabeth the Queen Mother
Celebrating her eightieth birthday on 4 August 1980.
Photographed by Norman Parkinson at Royal
Lodge, Windsor, with her two daughters, Her
Majesty the Queen (left) and HRH Princess
Margaret.*

One of Terry's close pals was (and is) David
Bailey, another Cockney boy with an astonish-
ing sense of beauty and elegance. David how-
ever, who for a long time wore his hair long,
made no bones about his relationships with
models. He lived with Jean Shrimpton, the
most famous fashion model of her time. When
that relationship ended he married Catherine
Deneuve, the French film star, and now he lives
with a girl of fantastic beauty, Marie Helvin.

I represented his work for a short time, but
he made so much money by dealing directly,
mainly with *Vogue*, that what we could earn
him additionally seemed like chickenfeed to him
and, though he always remained most friendly
and always said he was willing at any time to
resume our co-operation, it just didn't happen,
but I'm still waiting for him to return and be
represented by Camera Press.

Bailey shares O'Neill's penetrating quick
perception; and his natural and effortless self-
assurance, combined with an unashamed

Cockney accent, make him a most attractive
contemporary figure.

A hundred and fifty years ago people with
such talents would have become painters or
musicians. Whilst cameras are relatively easy to
handle, men like Bailey can produce works of
art with what is, after all, only a mechanical
instrument. Just as owning a typewriter doesn't
turn anyone into a Graham Greene or a
Somerset Maugham, so with a Nikon or Olym-
pus. The great photographer is the happy
possessor of co-ordination of eye and hand
which can produce images of immense impact.

Early in his career Bailey was reputed to
break down any inhibitions in his sitter by hav-
ing music played at top volume throughout the
sitting and yelling at them in crude and pretty
profane terms to 'give him all they had.' It
worked, and the models loved him, though they
would probably have stalked out of anyone
else's studio.

* * *

Charm of a quite different kind is the weapon of
Norman Parkinson, *doyen* of English pho-
tographers. Born in 1913, he is as active in his
seventies as he has been for the last four de-
cades. Tall and spare, immaculate and fastidi-
ously dressed, he dons a Pakistani rimless cap,
embroidered with beads of many colours when
he takes photographs. The cap, he says, brings
him luck.

After more than a lifetime in fashion pho-
tography, mostly in exotic settings all over the
world, admired by readers of *Vogue* and of *Life*,
and the now-defunct *Look* and *Queen*, in *Town
and Country* and the *Tatler*, he was quite re-
cently invited to photograph members of the
Royal Family. His pictures of Princess Anne,
taken on her twenty-first birthday and on her
engagement and marriage, were enormously
successful, and he photographed the Queen
Mother on her seventy-fifth birthday with
resounding international success. When he

*Elizabeth Taylor at fifty. Latterday Eve: and who
could resist an invitation from Elizabeth Taylor to
the Garden of Eden? Photographed by Norman
Parkinson.*

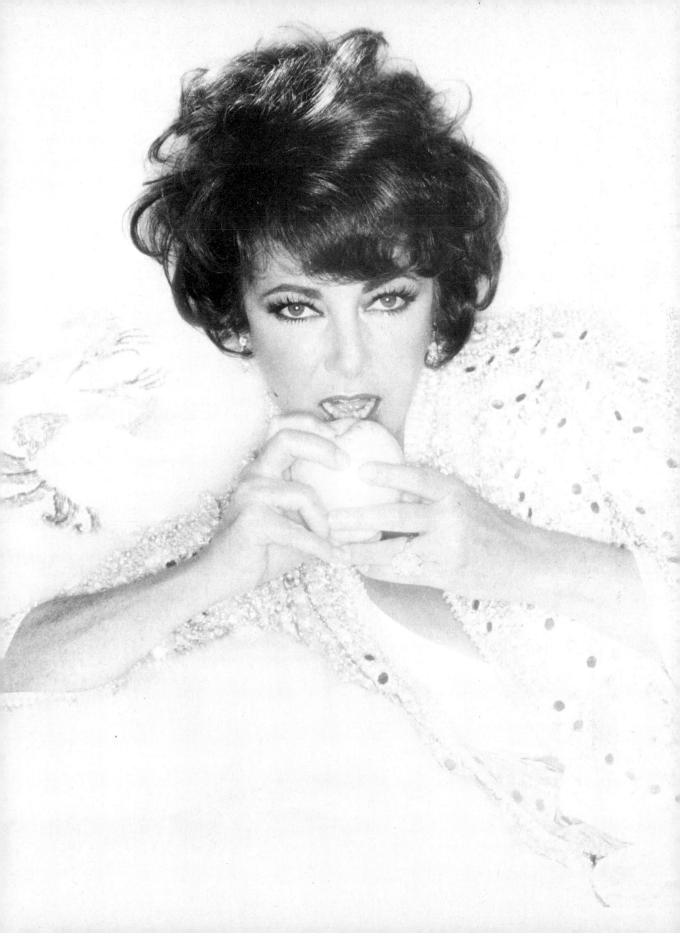

was again invited to photograph her for her eightieth birthday, the Queen Mother's two daughters, Her Majesty the Queen and HRH Princess Margaret, were also present to be photographed.

Parkinson had prepared for the occasion and had obtained – who knows how – the measurements of these royal ladies. When he had taken many pictures he produced from his case cloaks, made to measure in royal blue, which he persuaded the royal trio to put on. Such a photograph had never been taken before and deserved – and obtained – a double-page publication throughout the Western world. There was a minor backlash; some people tagged this stunning portrait study 'the Beverley Sisters'. But of course, as is the case with all royal special occasion photographs, it was submitted for approval, and was approved.

Parkinson leads a double life. He has a large estate in Tobago, in the West Indies, where he spends all the time he can, but rarely less than four months each year. He also breeds racehorses and pigs and has produced a delicious type of sausage known as 'Porkinson Bangers'. When he is in Tobago he can only be reached by cable or letter and in *Who's Who* refers to this by stating: 'Telephone: none, fortunately.'

* * *

When the Queen approached the Silver Jubilee of her accession to the throne in 1977 there was some speculation as to who would be called upon to take photographs for the auspicious occasion. Buckingham Palace appointed a man totally unknown nationally, but well established as a private portraitist in Reading, Berkshire – Peter Grugeon. Rumour had it that the Queen's Private Secretary, Sir Philip

Moore, recommended him on the grounds that it would be a good idea for so popular an event to employ a photographer from the provinces.

Grugeon, in his early fifties and a former schoolteacher who had set up as a studio portraitist in Reading some years ago, was delighted and utterly taken aback, but he grasped the opportunity without being overwhelmed by it – he might well have been, because he had previously suffered a severe heart attack and was obliged to avoid all stress in case another should occur.

The pictures were taken at Windsor Castle, where Grugeon was given an opportunity to reconnoitre first, so as to select the best settings for the photographs.

It turned out to be a long sitting, during which he portrayed not only the Queen but all the members of her family, as a group and singly. When it was Prince Philip's turn – so Peter told me afterwards – he wasn't quite happy about the background, so he asked His Royal Highness to move a little, then to move again. At the third request Prince Philip, growing slightly impatient with the rearrangements, protested, 'But now we're practically where we began.' Grugeon kept his cool and replied, 'Oh no, Sir, not when you view the position from where I stand,' and calmly carried on.

Small incidents like this can undermine the confidence of a cameraman but Grugeon, who had never anticipated that such a chance would come his way, dealt with it skilfully and with dignity, although he admitted he was rather shaken.

He had the good sense to build up considerable business by printing posters and big enlargements for sale all over the country; the year of the Queen's Silver Jubilee proved a golden year for Peter Grugeon.

CHAPTER 13

Incidents & the Unexpected

WHEN WORKING ON an assignment things often occur that are unforeseeable. I had occasional jobs from the *Nursing Times* and one of them took me, with the editor of the magazine, to Friern Barnet, the famous London hospital for the mentally ill. On arrival we were received, as is usually the case, by a principal member of the staff who insisted – also as usual – that we should first take a look round to get the general idea and then return to wherever the journalist wanted to put questions or I wanted to take particular pictures. This procedure is fraught with danger; you see an incident and by the time you have finished the grand tour it is over and cannot be re-enacted.

We had been walking round for some ten minutes when I stopped to glance through a window into a ward and called to our guide that I would like to take some photographs immediately. She starchily replied, 'Oh no, that's of no interest – come along now,' and continued walking, accompanied by the obedient journalist. I looked through the window again. People in green overalls were sitting and standing about in the weirdest attitudes, obviously indicating advanced insanity, and I wanted to take the immediate opportunity, so I protested loudly to our guide, who was the secretary or registrar, and who said: 'I told you, there's no point in taking photographs of this room. This is the nurses' common room!'

* * *

I was photographing Stowe, one of the great public schools, when I mentioned to the head boy, who was conducting me round, that I should very much like to take pictures of a sea of faces. Was there any occasion when this might be possible? The job was intended to take two days, and the head boy (who is invariably a personification of all the school aims to produce) answered briskly, 'Yes, it can be done tomorrow morning at assembly.'

In due course next morning he led me to the assembly hall, a charming eighteenth-century folly built in the round. The boys all foregathered on the ground and the floor was densely packed. Was there a point of elevation, I asked, perhaps a pair of tall steps?

'Oh, much better than that – I'll take you up there.' This disciplined, gymnastic young man ran ahead of me up some stairs three at a time, then up a dusty spiral staircase until we came to a tiny door, opening on to a narrow ledge which overlooked the scene. He boldly stepped on to the ledge – it was no more than one foot wide – and I followed him in trepidation.

I looked into my camera, a Rolleiflex, which requires you to look down into the reflex mirror. The boys spotted us, and all looked up. It was an ideal shot, but, perched on the ledge I was certain that in another thirty seconds I would crash down among the upturned faces. The head boy stepped back through the door and caught hold of the back of my trousers to stabilise me. I was pleased with the picture but more pleased when I could honourably come down the staircase again. One is sometimes shamed into situations requiring more daring and physical courage than I, at any rate, am equipped with.

* * *

Another instance of this kind happened to me in Johannesburg, where I was told it was worth while to go to the tribal dances which took place at the goldmines every Sunday morning. The different tribes who normally worked deep underground would dress up in their tribal costumes and perform rhythmic dances. Before the proceedings opened they stood around in little groups, chanting and stomping, and I made my way through a crowd in the centre, where a handsome young Zulu was rehearsing a spear dance. The crowd formed a ring around him and although we had not spoken, he seemed quite pleased to have me photograph him. His movements accelerated, he stamped the ground more vigorously, shook his spear more menacingly – and, suddenly, my previous reassuring eye-contact with him vanished. He was looking straight through me with a cold, deadly, big-cat-like expression. He had obviously danced himself into a trance, and I was the enemy. He swung his spear upward, forward, sideways, coming nearer and nearer, and the crowd chanted in unison with him, and I could see what might well happen if I stayed still a minute longer. I pushed my way out of the crowd as fast as I could, and the young Zulu chief, still in a trance, called after me in an educated Oxford-type voice, 'You will send me a copy, won't you?'

* * *

An odd situation of a very different kind occurred when, for the German magazine, *Der Spiegel*, I visited the London home of a spiritualist, Rosemary Brown, who had acquired television and newspaper fame through claiming and demonstrating that she was a go-between for the great composers of the past. Franz Liszt, the Hungarian composer and pianist, was her guide, and through him composers like Schubert, Schumann and occasionally Beethoven dictated new compositions to her which she took down at the piano.

She lived in poor circumstances in Leytonstone, a London working-class suburb. As a child she was taught to play the piano, with lessons once a week, for two years, and she had of course forgotten most of it; but she claimed

African chieftain turns to menace. As I left, he called after me in refined Oxford tones: 'You will send me a copy, old chap, won't you,' and from somewhere in his timeless African outfit, he produced a visiting card.

her fingers were guided when playing, and were also guided 'from Beyond' when she wrote down the notation – a skill of which she knew nothing. The pieces of music were played on radio and television and musicologists claimed that they were indeed characteristic of the composers, although not equal to their best work.

The *Spiegel* reporters were sarcastic in an especially Germanic and wounding manner, but they didn't disturb Mrs Brown, who said she could no more explain why she had been selected and how she came to be able to do this work than anybody else.

When I had finished taking photographs and the interview was completed, but everyone was still present, I said to her, 'Like Franz Liszt, I am Hungarian by birth; would you mind if I asked him, in Hungarian, to bring into your presence my dear mother?' My mother had recently died and I had been deeply devoted to her all my life. I was intrigued and fascinated to see whether what I asked was

really possible. I put the request in Hungarian.

Mrs Brown came back: 'Franz says his Hungarian is very rusty. He never spoke it well because he was brought up and educated in Vienna.' But she answered in what sounded like total gibberish. I had to reply that I could not understand the answer, but then my own Hungarian was my no means perfect as I was brought up in Berlin; so I repeated my request in German. Rosemary Brown turned to me.

'Your mother is here now. Would you like me to describe her?' Of course I would. 'She is a small lady with shiny black hair, parted in the centre; she has a shawl over her shoulders and her hands are joined in her lap. She looks a little grave, but her face lights up when she smiles.'

That certainly sounded like my mother, but it also sounded as if it might fit many other mother-figures. Then Rosemary added, 'She is particularly proud of having such very tiny feet.' Now that really was a remarkable observation because my dear mother, so vain of her small feet, often bought shoes that were half a size too small which she would then, thinking herself unobserved, slip off under the table. How could Rosemary Brown have possibly guessed? I wondered.

I left and then sent Mrs Brown some of my photographs, and asked if she would grant me a private sitting, for which I would pay. She telephoned back; she liked the photographs, and would certainly give me a sitting, but could not take payment for it. We made an appointment for an early afternoon.

It was high summer and the sun shone into the neat, if poorly furnished, sitting room where Mrs Brown gave me tea and biscuits. Then she said, 'Well, we'd better get down to business.' She didn't close the curtains and there were no mysterious lights; all was normal and ordinary.

'Your mother is here now,' she announced, 'accompanied by a man. Can you guess who it might be?' Stupidly, I said no. 'It's your father,' said Mrs Brown. 'He is very popular on the Other Side, and is known by the name of Little Ludwig.' Ludwig, the German version of Lajos, was my father's first name.

I had not guessed the obvious, that the man with my mother would be my late father. They had not been happily married, and he ended his own life in 1924. Here we were, in 1957, and apparently my parents had made it up, and were now the best of friends. She said they were observing my progress in life and were happy and pleased that things had gone well with me.

How could she have known my father's first name?

One expects to read about such occurrences, but I lead and have always led a busy life and, fascinated as I was, I came to the conclusion, as a working hypothesis, that maybe the medium could read my subconscious mind, although what she was reading here was many layers below the surface, and to be able to do that was mysterious enough in itself.

In 1970 my wife died. It was a terrible blow; we had been more happily married than I had ever seen anyone else. When she died I was lost and lonely. I went to the headquarters of British Spiritualism in Belgrave Square, where on Saturday afternoons there are public demonstrations of spiritualism. You pay a modest entrance fee and join a crowd of about a hundred people in a half-empty hall.

The medium appeared, a short, middle-aged robust Scotswoman, who climbed on to the

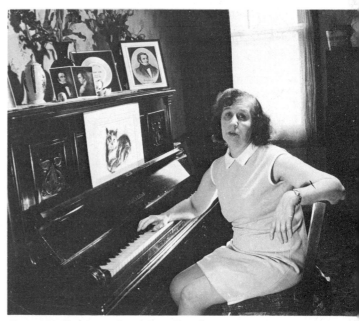

Rosemary Brown at the piano where her many composers reach her from the other life.

platform, explained at length why she was late and then began bombarding the audience with the most unremarkable observations.

'I have somebody here called George. He wants to be remembered to you.' She pointed. 'You were such close friends and he wants you to know that he is now very happy.'

Once or twice she did not simply refer to 'George' but to a full name like Robert Steadman, and that shook me and many in the audience. The person concerned began to weep, but the message was quite insignificant, and all the messages seemed to do little more than establish identity.

As I left I asked if it was possible to arrange a private sitting with the same medium. It was, and it was quite cheap (£3 in 1971). At the appointed hour I was shown into a little cubicle and, again a little out of breath, the Scottish medium arrived. She sat down opposite me and instantly began: 'She doesn't want you to be depressed, she wants you to go out more and not be so sad. She is quite well and happy but' – here she paused and turned her face a little upwards into the unknown – 'what was that, dear? . . . Your wife says she's worried about all the clothes she left behind as they may go out of fashion. She wants you to give them away, particularly to Hilda Taylor.'

She had been talking without interruption for about five minutes and when she came out with the name of Hilda Taylor, my late wife's widowed sister, she brought tears to my eyes. How could she know such a name? If it was telepathic, that was remarkable enough by itself, but I had no more been thinking of Hilda Taylor than of Winston Churchill.

CHAPTER 14

Setting up a Picture Agency

THE GENERAL PUBLIC doesn't know, and isn't supposed to know, that there are such things as photographic press agencies. Every newspaper and magazine, both here and abroad, prefers to convey the impression that the photographs it publishes were taken by its own photographers and, where they are imaginative, that it was the picture editor's or the editor's imagination at work.

In fact there were in London in the thirties some twenty or twenty-five photo agencies. There is now a slightly smaller number, but there are three times as many, mainly minor, organisations which call themselves photo libraries. The photographic press agencies exist for the purpose of supplying newspapers, magazines, books, television, and anyone else who needs photographs. Whilst in some countries, especially in the United States, an acknowledgement is almost invariably printed underneath each picture naming its source, this is not so in Britain except in cases where it is felt that acknowledgement does as much honour to the publisher as to the photographer. Even when there is a credit line, it is to the individual photographer and so the agency that acts for him remains unknown and in the background. But I don't think it matters or that it is unfair.

To work in a photographic press agency is demanding, lively and all-absorbing to people who are right for this kind of job, and it is by no means very difficult to set up such an agency of one's own. The first requirement is sufficient financial stamina to last six months without any money coming in, while you are producing and distributing photographs all the time.

When I set up Camera Press in November 1947, I did so with a sum of £2,000; now it would probably cost £20,000. My capital came from my wife's family. They were all individualists who had painstakingly saved up a nest-egg. They lent it to me smilingly, with no conditions attached, but I of course volunteered to double their money and repay it within twelve months. I did, but they could easily have lost it all. They, without much ado or fuss, just trusted me. They asked for no receipts but I gave them all an IOU. I well remember the dear old lady, my wife's mother, lifting out the flowers and the earth contained in a flowerpot and handing over to me £200 she had been hiding there, crumbs of earth still clinging to the notes. She had no other resources in ready cash. It was touching and encouraging in the extreme. I cannot think that it could have happened anywhere else in the world than in England, for here I was, almost entirely alien to them, setting up in business at a time of great economic hardship. But they trusted me.

Of course everybody I knew tried to dissuade me.

'This is the worst possible moment for a new business.'

'You must be mad to think you can succeed where there is so much competition.'

'It's going to get much worse before it gets any better . . .'

And so on and so forth. Were I to start again today the reaction of all well-wishers would without doubt be identical. The world's opinion is always, 'Don't do it!! Or if you must do it, don't do it now!!' This of course is sheer

I use a Nikon now but always carry a Rolleiflex as well. It is in my view the greatest all-around camera with a marvellous lens. This type of Rolleiflex (and there are now many others) will see you through thick and thin, close-up and long distance, and I happily made do with it, and nothing else, for the first twenty years of my photographic work. I was compelled to take up photography as none of my friends had enough trust in the enterprise, and I didn't have enough money to pay them.

nonsense. All depends on your own determination, single-mindedness and stamina.

To launch a photographic press agency it is best if you are yourself a photographer or at least come from a working background that has made you familiar with pictures suitable for the press. You need a first-class secretary who will answer the telephone and help in building up a photographic library from scratch. After a few weeks you will need somebody to take charge of sales and foreign dispatch. I have always found that if you pay these few helpers well and give

them some direct participation in profits it helps to arouse and to maintain their enthusiasm in a small firm which is setting out to deal with the papers not just around the corner or in the provinces but also throughout the world.

There are two types of picture agencies: those that merely handle photographs and those that produce them themselves, in addition to handling the work of freelance photographers. I am only concerned with the productive type of agency and, while I don't want to detract from the other category, which are selling what has been produced by others (and only very occasionally by themselves), I think the productive organisation is not only much more fun but has also the merit of being able to expand, and expand, and expand.

To have the best possible photographic darkroom and perhaps a little later, when you have enough money, the best possible colour laboratory of your own, you need the very best equipment. That is what will absorb most of your initial resources. Cameras, enlargers and any other equipment, including typewriters, should be the best you can obtain. You have no chance of success if you kid yourself that these are not all that necessary – they really are. You don't need elaborate staffing or equipment, but both, especially at the outset, must be the best that money can buy. In setting up a photographic press agency (and no doubt the same goes for any other kind of business), the owner cannot watch the clock.

In my particular métier letter-writing is of the essence. You must write truthfully, without making unrealistic promises, and you must perform exactly as you have promised. There is no need to advertise; recommendation by word of mouth from one photographer to another is not only cheaper but more effective.

After a few months money is likely to begin to arrive and a good book-keeper will be needed. A thriving photographic press agency will be anchored on a superb darkroom, a superb sales organisation, photographic library, accounts department, secretary (with special emphasis on accurate and always up-to-date filing and correspondence) and, of course, on the person at the head, who is in constant easy touch with every part of the growing organisation. What he must have above all is the unerring ability to go

for quality in every aspect of his business, and he will do this successfully only if he breathes, dreams, thinks and devotes all his being to the job. This may well make him a great bore to his friends and to his wife – so it's best to employ your wife in the business as well!

The business of letter-writing is generally underestimated. Most people think that at the point where they enter the business everything is more or less fixed: every photographer has his representation sorted out, all magazines and newspapers everywhere have efficient re-sales organisations – but this is far from being the case. I found that in at least two-thirds of all instances where I wrote to establish a connection with a photographer there was a chance of doing business; even firms of long standing often proved quite unsure about their foreign representation or had none or, more often, they had tried once or twice, lost patience and, having been suspicious from the outset, had given up the whole thing to continue by living off their home market alone.

In photography such an attitude is foolish. The fact has always been that a good photograph, like a good painting, is appreciated not just by the readers of local papers or national newspapers and magazines but in all probability by picture-minded publications in just about every country where there is an illustrated press.

I discovered one of the most successful photographs my company ever handled, whilst looking at the results of a picture competition in a highly-respected Swiss periodical, *Schweizer Illustrierte*. The photograph had won the second prize. It showed a penitent in a confessional box. It was taken in such a way that you saw both the man confessing and the priest hearing the confession; the priest, a plump, jolly man of middle age, was yawning his head off while the poor chap on the other side, guilty and contrite, whispered his confession through the grill that separated him from his confessor.

I wrote to the photographer, Jan Svab, who lived in Prague. I had little hope of a reply, but it arrived within three weeks, together with the original negative. We printed the photograph for worldwide distribution. It was published on almost a whole page in the *Sunday Times* in London, and this proved such a powerful ad-

vertisement for it in other countries that both Mr Svab and I made a gratifying amount of money out of it. Eight years later *Life* magazine, discussing religious problems, rediscovered it and though they knew of the previous widespread publications gave it a full page, producing fresh demands from all parts of the Western world. Had the photographer not heard about the competition in Switzerland the photograph would have remained in a drawer in Prague; and of such photographs, which remain untouched or only partially exploited, there are millions in every country. It is a photo agent's work to sniff them out and get them.

Part of my work in building up my company involved travelling. This usually included meeting picture editors, checking and possibly changing our representation in each country I visited, and taking photographs of my own. The sale of photographs I took in most cases paid for all the overheads. I also followed up personal contacts, which of course included meeting photographers to whom, wherever possible, I had written beforehand or who were recommended to me by local picture editors, in order to strengthen, and add to, our supply lines. I travelled in this way for at least fifteen years and went abroad three or four times a year.

I found, especially in the United States, outstanding photographers in the act of throwing away cases full of photographs because they could not find room for them; it had not occurred to them that many, or any, of their pictures would have publication appeal abroad. Others thought they would be cheated if they dealt through photo agencies. Many photographers I met needed a lot of persuading that I and my company were honest, and that they could drop in unannounced at any time to look at our accounting books, in which we would show them complete up-to-date evidence of transactions with their photos.

The role of confidence-building is important, for it is quite true that the running of an international press agency is not always done in a straightforward and dependable manner. I have had photographers relay to me well-documented instances in which some shady photo agency had made a deal in, say, Colombia, and had not reported it to the photographer, who was of course entitled to his

commission share. But, unhappily, ethical standards are no longer as high in Britain as they were when I arrived in 1935. It was then a matter of course that, on publication, the publisher would automatically pay the fee without having to be invoiced; the possibility of error or oversight was so small it would have been ridiculous to try and set up machinery to monitor and invoice publications. Unfortunately things are not as reliable now. I say this with some bitterness because I have always had complete trust in British fair play. But then the following, sadly instructive, incident happened.

In August 1980 my company had the good fortune to distribute splendid new photographs of three prominent members of the Royal Family. The Queen Mother on the occasion of her eightieth birthday (4 August), of Princess Margaret, who was fifty on 21 August, and of Princess Anne, who was thirty on the 15th. It is the only occasion I can recall when three such photographically major events occurred in the same month (round-figure birthdays of members of the Royal Family are invariably a major event!). These photographs were taken by outstanding photographers – Norman Parkinson, Patrick Lichfield and Lord Snowdon. It occurred to me to check up whether we had in fact been paid for all reproductions of these three, or part of the three, by all the newspapers and periodicals to which we had sent them. It turned out that a very sizeable number of publications had published but not paid.

The explanations were that they thought their London contacts had paid; or that the photographs were free of charge; or that acknowledgement of the photographer was sufficient reward; or that there had been some changes in their accounts department at that particular time. I was alarmed and wrote again to all those that had not paid, sending them lists of other royal photographs we had supplied to them during the period 1 January 1970 to 31 December 1980. An astonishing number of errors came to light, and, I am sad to say, would never have come to light had we not enquired.

Another surprising part of this disagreeable discovery was that only a very few of the culprits felt there was any cause for their apologising. One, however, the *Hull Daily Mail*, extended the enquiry and sent me a list of Royal photo-graphs distributed by Camera Press, published but not paid for, which went back to 1956. They did apologise and promised to pay promptly and automatically in future, but meanwhile they paid in 1981 at the rates that were applicable at the time of publication in the fifties, sixties and seventies – rates which were completely out of date and nowhere near their purchase value when they were due.

I was advised by Lord Goodman, then my company's legal counsellor, that despite the seeming injustice I was only entitled to charge, in this and similar cases, the interest that would have accrued had I banked the fee at the time of publication – although reproduction fees in newspapers, which are properly negotiated from time to time between photographic press agencies and the Newspaper Society, had gone up from about 10s 5d in 1956 to £9 in 1981!

In running a photographic press agency it is of the greatest importance that caption writing should be dealt with efficiently. I have found that a photograph poorly captioned can lose at least thirty per cent and sometimes a hundred per cent of its sales value, whereas a competently and informatively captioned photograph can become saleable just because of the caption. It is almost a law of nature in press photography that the better the photographer the worse is his caption writing; and the same applies in reverse – the best caption writers usually produce very poor pictures. It is necessary therefore, from the outset, to impress upon your contributors that the supply of comprehensive facts and figures with each photograph is a must. And the agency must employ on their staff one or more caption writers who are willing, keen and able to undertake the often quite arduous task of discovering the information needed. Most photographers, especially prominent ones, take the view that captioning is not part of their business, that the commission we retain implies that we will do all the necessary research. This is possible in many

Confessions, Confessions! Near the end of a long day in the Roman Catholic church of the Virgin Maria in Czestochowa, Poland, and photographed by Jan Svab.

instances, but rarely so when the picture comes from far away.

I have often used as an illustration the case of a photograph being sent to us from, say France, showing a young man in an armchair, with a caption saying, 'M Guillaume Lebrun.' How different, I pointed out, was the publication appeal if the caption read: 'Guillaume Lebrun, aged twenty-three, illegitimate grandson of Sarah Bernhardt, seated in an armchair recently auctioned at Sotheby's for £74,500.' Everybody would look at the picture again and a high percentage would, because of the caption, feel inclined to publish it.

In building up a photographic press agency you must be constantly on the alert for the discovery of photographers new to you. That means a lot of letter-writing and a lot of follow-up letters. In my experience follow-up letters produce twenty-five per cent of answers; they are well worth the effort and the postage.

I discovered the world's greatest portraitist, Karsh of Ottawa when, early in the war, I had occasion to visit the Press Department of Canada House in London. A copy of the *Toronto Star* was lying on a table, open at a full-page portrait of John Buchan, who had been raised to the peerage and, as Lord Tweedsmuir, was then Governor-General of Canada. The photograph was acknowledged to Y. Karsh. I had not come across the photographer's name, nor had I ever seen a photographic portrait of such tremendous impact. It seemed to me like the work of Rembrandt, and I wrote to Y. Karsh, care of the *Toronto Star*. As I could not imagine a first name beginning with Y as being other than Yvonne or Yvette, I addressed it to 'Miss Y. Karsh'. The photographer replied, explaining many misgivings over previous dealings with photo agencies who had apparently been less than honest; but my letters were persistent and persuasive enough finally to cause Y. Karsh to send me some work from stock. It had a great, almost a triumphant, reception in London. The portraits were published full-page in *Illustrated London News* and many other glossy magazines of the time; the upshot was that *Life* discovered Karsh through the publications in *Illustrated London News* and commissioned him to visit wartime London and take portraits of top wartime leaders in Britain.

Thus it was that I first met Karsh in 1943. We agreed that I should meet 'Miss' Karsh by one of the Landseer lions in Trafalgar Square. I was standing waiting when somebody arrived who looked to me like my own image in the mirror, and it was not a lady at all. Karsh had been amused at my assumption that he was a woman and had looked forward to the great denouement. He was equally astounded by the astonishing similarity in our appearances when we met face to face. We have been the closest friends ever since.

But I haven't stuck to the theme of this chapter – setting up a picture agency. To the previous observations I ought to add this advice: be near, if you cannot be in, Fleet Street. It is true that the big publishing houses all employ dispatch riders, and if you have important work they will collect it happily from Neasden but, on the whole, picture editors regard it as 'a bit much' if the product to be collected turns out to be rather ordinary and in the life of a photographic press agency it may be only once a year that you have work worth picking up if your office is more than a mile away from the centre of newspaperland. It's worth paying a higher rent to be close at hand, making daily visits to picture-buyers an easy and convenient matter with minimal expenditure of time.

Another important thing is to have enough room for expansion. The office space you hire should be large enough to accommodate the production for the first six years. That gives you time to look around for better premises, larger and nearer to the publication centre of Fleet Street. It also enables you, from the start, to be methodical in filing and to build up a thorough cross-indexing system.

Filing and indexing are of the essence. One's memory is overwhelmed and doesn't recall accurately. In my own case I frequently find that what I imagine is a photographic memory includes photographs which at one time I had intended to take, but in fact never took. For example, when I photographed Barbara Cartland, her almost equally famous daughter Raine, now Lady Spencer, appeared. I was convinced afterwards that I had photographed them together because I had seen and talked to them together. They were, I recall, uniquely oblivious to my presence, talked in animated

voices and took no notice of me until I raised my camera, when they took enough time off from their chatter to tell me again they didn't wish to be photographed together. Yet for years I fancied I had taken such photographs.

A really efficient, exhaustive and dependable cross-index would have shown me that my subconscious mind was kidding me. Lack of effective cross-indexing can cause hours of search when, in the end, you have to tell your librarian, 'I could have sworn I took this picture, but it was taken only in the mind.'

Another major principle in building up an agency is to engage staff only under sustained pressure. If you take on people after finding that once or twice you are short-handed you will finally be occupied in finding work for them to do – which is plainly foolish.

I have so far resisted the ever-mounting pressure of advertising to install a computer, both for the photographic library and for the accounts department. As to the accounts, we now receive a lot of faulty bills and statements and when we complain, I dislike the smugness of the standard reply, 'computer error', which has the same sound as 'Act of God.' The moment you have a computer it – or should I say he? – takes over, and your accounting staff loses the ability to add or subtract, let alone divide or multiply. It also robs your relationship with the clients you represent of a personal touch.

As to the library, the argument is that no one can remember two million photographs – whether you have on file a particular event, scene or personality, and where it might be at the moment when you need it. It's bad enough to have a comprehensive photographic library without a photograph of the President of the Republic of Mali, but it is infuriating to have a computer tell you that you have such a picture and that you sent it to the *Daily Express* on 4 December 1976, when the *Daily Express* librarian will either deny ever having received it, or swear he sent it back to you within forty-eight hours. The computer will positively sneer at your incompetence and your client will think you are mad. Build up a good cross-reference library with reference cards written in block letters or typed, and then, with luck, you know where you are.

CHAPTER 15

Conclusion/Observations

OBSERVATIONS FORCE THEMSELVES upon anyone who handles a continuous influx of photographs, and who helps to produce them. Some may sound a little obvious and trite, but that perhaps does not make them any less true. Foremost among these is a principle in life which one might call the underlying Law of Photography:

ABOVE LEFT
The defensive stance of soldier ants when danger is near. The ants stand up on their two back pairs of legs, hold their feelers and the front part of their bodies erect, spread their powerful upper jaws, bend the back part of their bodies forward between their legs and spray at the enemy a fine stream of venom from the opening at the back of their bodies. In this 'shower' the ant sprays an average one milligram of poison, which consists of one half formic acid and also contains certain aromatic substances which immediately put other ants in the area on their guard. Photographed by Hans Pfletschinger.

LEFT
The life and love-life of the snail. The snail is a hermaphrodite, producing both sperm and eggs. When the breeding season begins (mainly in May and June), a mature animal looks for a mate, whereupon courtship commences immediately. The couple stick firmly together by means of their crawling 'soles', stand upright and make curious rocking movements with the front part of their bodies. During this phase of mating, they each gouge down into the 'foot' of the other with a sharp, four-sided piece of chalk up to twenty millimetres in length which is termed the 'Cupid's arrow', formed in the sex organ. Photographed by Hans Pfletschinger.

The brighter the light, the darker the shade. There is hardly a situation in which it is not useful to bear this in mind, and photographers ignore it at their peril, especially when they work in sun-drenched countries at hours when the sun is right overhead.

It is however not the technical photographic aspect but the philosophical truth it is well to bear in mind. Some aspects of ancient religious beliefs are strangely supported by photography. Photographs taken from satellites, or from high-flying spy planes, are capable of such sharp resolution that a square yard photographed from several miles up in the air can be shown with quite extraordinary clarity. Thus the notion that a Deity can observe in exact detail all that goes on finds unexpected support; just as the phenomenal memory capacity of a computer lends support to the religious doctrine that on the Day of Reckoning all deeds committed, good or bad, will be found to have been recorded in detail. If a modern computer, properly programmed, is capable of retaining what is inside a photographic library of two million pictures, and how each of them is being handled, then a divine arrangement of this nature, referring not to photographs but to mankind, comes much closer to realistic acceptability.

There is also the near-miraculous and far from complete investigation open to microscopic and electro-microphotography. We have the good fortune to have handled the work of a master of microphotography, the German naturalist Hans Pfletschinger. He has shown with startling clarity the astounding order of

things among tiny insects. His, and similar work by others, show that the miracle of life in every back garden is every bit as fascinating as what might be happening on Venus or Mars, and there is no end to what may yet be brought to light in the way of nature's ingenuity and variety of invention.

I find it quite shattering, but also awe-inspiring, to see how the larvae of wasps are kept tidily in a kind of cabinet until they mature; or to see how an ant can carry a weight seventeen times larger than its own body weight; or to observe how soldier ants have invented defensive chemical warfare: they line up in formation, with bottoms up, and shoot into the area of attack a substance produced in their own bodies which will stop an enemy in his tracks.

The educational value of photography cannot be overestimated, and I think we are only at the edge of the beginning of what lenses can reveal of the infinite intricacy and beauty of our surroundings. Dewdrops skilfully photographed on spiders' webs with sunlight fractured into rainbow colours on them cannot be appreciated or even seen except through microscopic photographic investigation of life.

The camera cannot lie; it can only reproduce what is there, just as a computer depends upon its programming. But in photography, though it does not lie, truth is a many-faceted thing. The selectivity of the eye, which has as many gradations and variants as there are people using a camera, can in the same face discover dullness, ordinariness or, in the hands of another photographer, beauty and intelligence. It's the same when several witnesses of an identical incident describe it differently.

There are a fortunate few whose gift, talent, even genius, can convey in the human face subtleties and profundities not previously suspected by anyone, not even by the person photographed. Thus a positive approach to portraiture, one that seeks what is good, great and memorable, exceptional or unusual, might actually develop these qualities in a person who had not previously thought of himself in such terms. My friend Yousuf Karsh has turned mean-faced, thin-lipped, red-eyed, despotic big business bosses into wise, far-seeing captains of industry; and I have little doubt that these por-

traits must have an extraordinarily improving effect on the sitters if they put such portraits on the wall above their desks.

The *New York Times* has a good motto which it has for generations printed in the paper: 'One picture tells more than a thousand words' – and so it does. In the most ordinary street scene there is an enormous amount of internal evidence; how people are shod, what kind of window displays are used in different places and at different times, how drivers react to being overtaken, how well fed or otherwise are children photographed on the way to school. A careful analysis of such documentary photography invariably tells a great deal about the sociological conditions of people and places. Television has of course made everyone much more picture-minded. While its first onslaught destroyed many magazines because it seems more dramatic to see a thing moving than to see the same thing in a static state, it has also caused a revival of high-class publications because the fleeting image creates an appetite for looking at things at greater leisure and in closer detail. But it cannot be denied that, at least in theory, it makes for less reading and therefore less mental effort. Many successful photographers take the view that black and white photography is superior to colour because the individual can use his own imagination in 'fleshing out' the black and white image with whatever colouring he chooses. Once a thing is photographed in colour it becomes finite, defined, unchangeable – a bit like processed food.

Colour, as a serious photographic medium, entered the market in the fifties. At first it was very difficult to use because its sensitivity to light was very much inferior to that of black and white film; and whoever wanted to take worthwhile colour photographs had to learn a lot about filters. Gradually colour film became 'faster' – that means it would respond to light more readily and exposure times could be reduced. By now Ektachrome, and its various international competitors, can be used almost exactly as is black and white, and although the use of filters is desirable for very good results, mostly there is no need of it. So photographers can more or less interchange from black and white to colour and back to black and white by using two cameras.

But that really isn't the problem. Many photographers, and I among them, take the view that black and white is a vastly more interesting way of taking photographs. It leaves more room for individual imagination. When you have a colour picture it is a final statement, nothing can be changed. If a face is grey, colour will show it as grey; if it is rosy, then it is rosy. In black and white you can imagine that the girl, whose portrait you are looking at, has green eyes and red hair; in colour if her eyes are light brown and her hair mousey, then that is that. The scope for the viewer's imagination seems to me of importance. Many major magazines like *Paris Match* and *Stern* which both have immense circulations use colour sparingly and publish mainly in black and white and, like the great Karsh of Ottawa, I am for black and white – hence the pictures in this book.

Photography is a little like going back to Egyptian hieroglyphics – a form of comic strip of history which might well produce generations quite unwilling or too lazy to read Dostoyevsky or Dickens. Much the same thing must have happened when printing was invented and the art of personal story-telling died out. It might be legitimate to wonder whether life might not be more romantic *without* photography: assume that Homer was not a blind poet, but a photographer, and that he had photographed the Trojan War instead of writing the *Iliad*. Would Achilles and Hector, Paris and beautiful Helen herself be as romantic and thrilling if one saw them as they really were? I once went on a Hellenic cruise and stood on the walls of Troy. It spoilt the whole drama of the Trojan War for me because the walls were real, thick and heavy and not very different from the walls built nowadays. The myth and mist of antiquity, both glamorising and alluring, evaporated for me, at least in part.

But there are other aspects which keep one fascinated. If you were, say, 5,000 light years away and had a camera to penetrate such a distance, you could today actually see the Trojan War and the Wooden Horse being pushed through the open gates of the deceived city. I know it's a theory that can't easily be proven, but I'm assured by scientific friends that light and images travel on and on eternally and could be intercepted at any stage to make visible again the Battle of Waterloo, if one were far enough away.

Is photography an art?

I am totally, even vitriolically opposed to pompous, bumptious, spurious claims by photographers to be 'artists' and not photojournalists or skilled craftsmen. Of course in the hands of people of exceptional talent photography can be an art; but I know of only one definition that helps to establish whether or not it can lay claim to such a title, and that is – and I hope I don't sound pompous myself – the definition Aristotle is supposed to have made of art: 'The aim of art is to stir the emotions.' When a photograph does this, in depth, it qualifies as a painting or a poem would.

It is in connection with this thought that I often wonder why so few women make photography their career. Women, if anything, seem better suited than men to using the camera, and first-class modern cameras present no physical difficulties regarding weight or indeed mechanical complications. There ought to be the same number at least of female photographers as there are males, but the fact is that at best fifteen per cent of photographers are women. Very puzzling.

I think I'm in a good job. I have done a fair amount of active photography myself, but since my firm grew I have been increasingly concerned with the trade in photography. Trade is not a very satisfactory term; it doesn't do sufficient honour to the fact that it can take interesting and worthwhile images from a place where they exist in abundance to another where, but for your efforts, they would not be seen at all – and personal effort in running a photographic agency really does count. It means writing a lot of letters and travelling a lot. Whenever I have been abroad in America, Japan or South Africa, but equally in France, Sweden or Holland, I have always found gifted photographers quite sceptical or even unaware of the possibilities of marketing photographs lying about in their files.

The durability and appeal of good pictures is impressive; the beauty of an impala leaping, an eagle swooping or a baby smiling, skilfully caught by the camera, remain marketable commodities practically for ever, and in every country that uses photographs to illustrate magazines, books, news, television, and also for

many industrial purposes. The trade of an agency is to discover such outlets.

There are many foolish notions about which countries it is worth dealing in and which ones will always cheat you. But these are transient matters that can change within five years, and if the photographic agency remains alive and alert to the changeability of economic conditions in different, and, especially, remote, countries, a photograph may earn as much in Ecuador as in nearby Belgium and provide the photographer with useful royalties for an indefinite period of time. That famous 'Bulldog' picture of Churchill taken by Karsh in 1941 has produced for him a minimum of £30/£50 a month, even now, forty-two years later, and there are many such instances.

Jay Scott was a Los Angeles photographer who worked with my company between 1951 and 1953, when sadly and suddenly he died. His work consisted entirely of photographing notables of the Hollywood scene as they dined and wined; to this day his widow receives bimonthly reports and payments – which increased by leaps and bounds when Ronald Reagan became President because he had figured in many of Jay's pictures.

Obituary columns in fact generally prefer to show a man in his prime, and if a photographic agent has seen to it – as is his job – that good photographs of interesting people are spread far and wide and left in picture libraries, then income from something that took seconds to achieve thirty years ago may continue until death and beyond, provided the person or scene were of interest and consequence. A business friend of mine in Geneva, Len Sirman, collected engravings, paintings and sculptures of great eighteenth- and nineteenth-century musicians and writers. There are about a hundred of these in his collection and we syndicated them some ten years ago. It is rare for him to earn less than £100 a month from Beethoven, Schubert, Offenbach and their contemporary dramatists and novelists. Were it not for the work of a photographic agency, this kind of practical, demonstrable value would remain dormant forever.

Of course the value and interest of a photograph depends on its being made available in many, including unlikely places, but also on the way the pictures are displayed. The London monthly magazine *She* had for many years a most ingenious picture editor, Michael Griffith, who would buy in pictures at very low rates. We naturally had many feuds on the subject, as it is my job to obtain maximum fees for photographs taken by people I represent. But Michael in principle bought what he knew had been rejected elsewhere, and he was utterly confident that the effective display of a picture was as important to its impact as the quality of the picture itself; and often it is simply the size of the display that tells. The most experienced picture editor will buy an enlargement, 15″ × 12″, when he might have rejected the same picture in postcard size; while there is much evident truth in the philosophy of 'small is beautiful', this doesn't apply to photographs, where it would be truer to say '*big* brings in the money'.

It is a cliché to say that photography holds a mirror to life, but like many clichés, it is true and it broadens one's outlook to be shown photographically how differently things are done in different places, yet for the same purpose. Look at the abundance of designs for steel helmets; every army with any self-respect has evolved a different shape, yet the purpose is identical. And look at the different techniques of marching in different armies when, obviously, the intention is simply to move from A to B; the Germans goose-step, the French quickmarch, the self-assured British march with relaxed steadfastness.

When a dentist looks at your teeth he uses ingenious mirrors to look at hidden areas that you could never see yourself, but which, when he treats them properly, can make you feel a lot better. So does photography reveal aspects of life delightful, individual and varied. Although it would be foolish to take photography too seriously, I am happy in the choice of work that I have made, and confident that such work can contribute to more and better information, and to a greater enjoyment of living all round.